# MILITARY ELITES

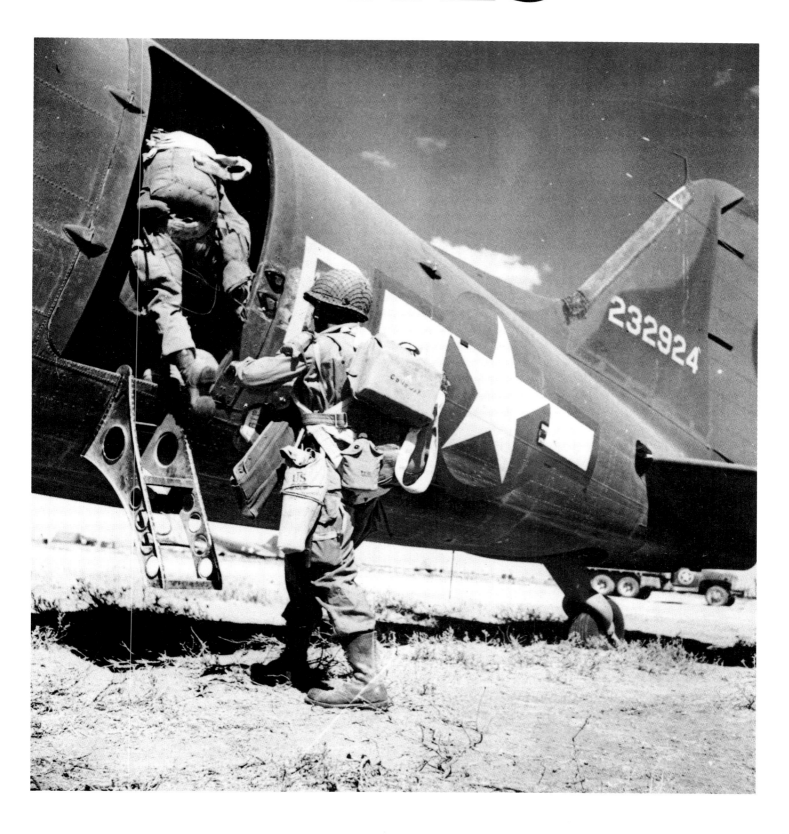

# MILITARY ELITES

## DUNCAN ANDERSON

MAGNA
BOOKS

Published by Magna Books
Magna Road
Wigston
Leicester LE18 4ZH

Produced by Bison Books Ltd.
Kimbolton House
117a Fulham Road
London SW3 6RL

ISBN 1-85422-660-6

Printed in Slovenia

PAGE 1: The paratrooper was the quintessential elite fighting man of World War II. There is a dreadful poignancy about this picture: these young American paratroopers are boarding a C-47 on 8 July 1943, their destination the bloody shambles on Sicily.

PAGES 2-3: British members of 1 Para training in the Brecon Beacons in Wales. British elite forces lack the expensive, sophisticated equipment of wealthier nations, but make up for this by maintaining a high degree of physical fitness and by rigorous training.

BELOW: The twentieth century has seen the proliferation of elite forces, but none can surpass the reputation that the U.S.M.C. has earned as an amphibious assault force. One of its most extraordinary exploits was the landing, using scaling ladders, against the harbor wall at Inchon on 15 September 1950.

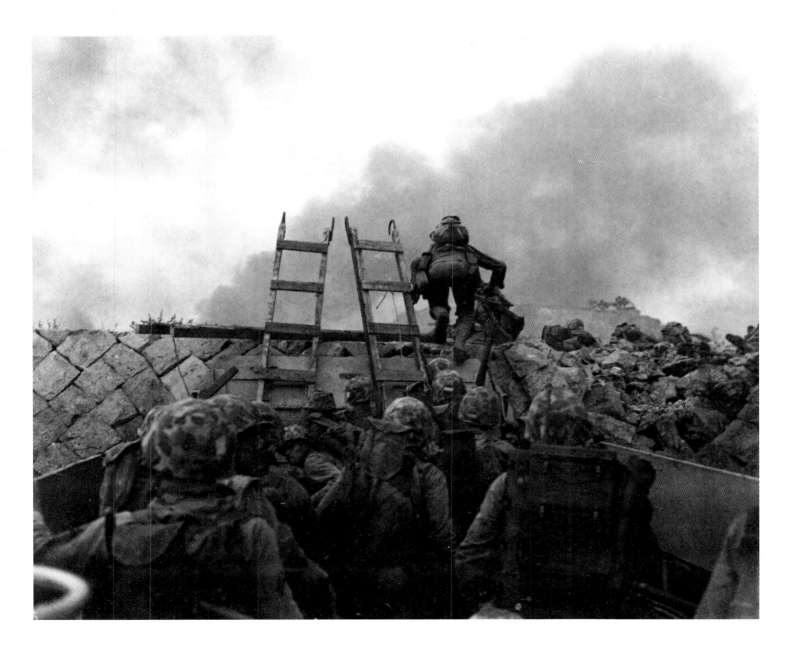

# CONTENTS

# INTRODUCTION

What is an elite military unit? The meaning of the term has changed considerably during this century. Someone living in Britain in around 1900 would have nominated the Brigade of Guards or the Household Cavalry. An American would have said the United States Marine Corps, a Frenchman the Chasseurs d'Afrique, a German the Imperial Prussian Guard, a Russian the Pavlovsky Regiment. The good combat reputation enjoyed by these particular regiments was not the sole reason for this – others had fought just as well. Perhaps more importantly, all had a special function: that of guarding the head of state, be it king, czar, emperor or president, or, as in the case of the U.S. marines, the nation's embassies. Their officers tended to be drawn from their country's social elite (in this the U.S. Marine Corps was a notable exception), and the rank and file was recruited on the basis of above-average height and exceptional fitness. Fine-looking specimens to begin with, their appearance was enhanced by rigorous physical training, intensive drill practice, and well-cut and -fitted uniforms. These elite units were the visible embodiment of the military virtues of their societies.

Some of these "elites" have survived the vicissitudes of the twentieth century and are still "elites," in the sense in which that word was used in 1900. But if one were to ask a Briton today to name an elite unit, he would almost certainly say the S.A.S., an American would say Delta Force, the rangers or the S.E.A.L.s, a German would say G.S.G. 9, while a Russian would say Spetsnaz. The word "elite" has by today developed a much

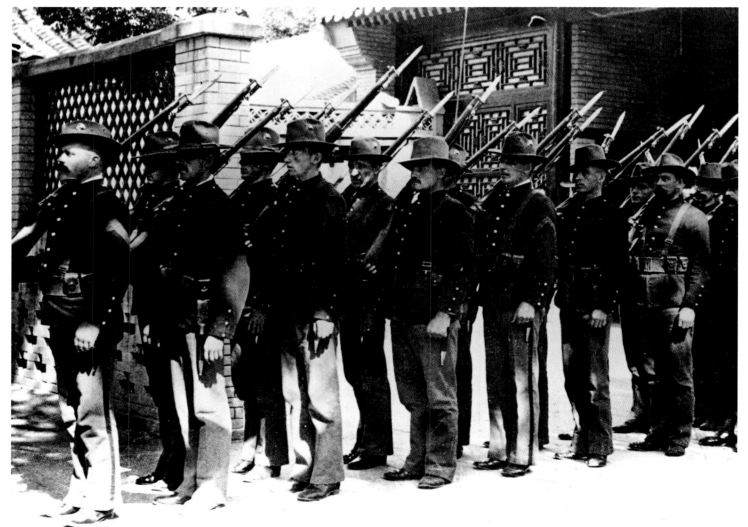

BELOW: United States marines in Peking in 1900. A small contingent of marines played a vital role in the defense of the foreign legations against the Boxer rebels, and also spearheaded the relief force which eventually reached Peking on the fifty-fifth day of the siege.

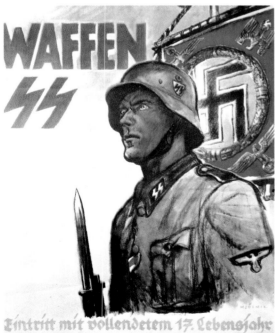

more specific meaning when applied to a military force. An elite is a relatively small, highly trained force specializing in extremely hazardous operations, often of a militarily nonconventional nature.

As recently as 1980, elites of this sort were shadowy and mysterious entities. In May of that year a B.B.C. commentator accompanied live coverage of the S.A.S.'s storming of the Iranian embassy in London with an account of who the S.A.S. were, as though a British audience might never have heard of them. He was probably right to do so. However, since that time the public has been

LEFT: A recruiting poster for the S.S. Leibstandarte.

ABOVE: Two Fallschirmjäger, photographed after the assault on Crete.

ABOVE LEFT: American Special Forces in South Vietnam in the late 1960s.

bombarded with images of specialist elites at work in many parts of the world. On 3 October 1993, for example, T.V. viewers saw a company of U.S. rangers, supported by Black Hawk helicopters, raid a site near the Olympic Hotel in Mogadishu where followers of Somali warlord Aidid were meeting. The following day viewers watched troops of the elite Dzerzhinski Division storm the Russian parliament building, the White House. Watch the television news on any night, and you might well see, among other elite forces, French Foreign Legion paras in Bosnia, British Royal Marine commandos in Northern Ireland, U.S. Navy S.E.A.L.s in Haiti, Russian Spetsnaz in Georgia, Israel's Sayeret Golani in southern Lebanon, and India's 1st Para Commando Battalion in the Punjab.

Throughout history there have been specialist forces of this type, raised for a combination of raiding and/or reconnaissance. Some were quite famous in their day: for example, the rangers raised by the British from among their North American colonists during the Seven Years' War and placed under the command of Captain Rogers; or the company of guides recruited by the British on the North-West Frontier of India. These forces were invariably short-lived. They were raised for a particular compaign and were then disbanded after its conclusion. The difference today is that some elite forces have been in existence for more than 50 years. Moreover, instead of declining in number they are increasing, and the range of activities that they undertake continues to expand all the time.

Three factors have interacted to produce this situation. First, with the breakup of the Warsaw Treaty Organization (Warsaw Pact) and the dissolution of the U.S.S.R., the number of trouble spots in the world has nearly doubled. Old conflicts like those in the Indian subcontinent, southern and northeastern Africa, Israel, the Middle East and the Persian Gulf, and in Northern Ireland and Spain's Basque country, have meanwhile continued unabated. To these

LEFT: The picture that transformed the S.A.S. into a household name. On 5 May 1980, in front of scores of press and television cameras, the S.A.S. launched an operation to rescue hostages held by terrorists who had seized the Iranian embassy in London.

must be added a set of new conflicts in the Balkans, in Moldavia, in the Caucasus, and in central Asia. Secondly, because of the political complexity of many of these conflicts – most are intra- rather than interstate – governments throughout the world have found it expedient to raise and maintain small forces specializing in unconventional warfare. These forces are extremely versatile. They can act as counterguerrilla or counterterrorist units, or as guerrillas themselves; they can rescue hostages or they can take them; they can act as a reconnaissance screen and gather intelligence, or they can spearhead a conventional assault. And their employment carries far fewer political risks for their governments than the employment of more conventional forces. Finally, the light, handheld video-television camera transmitting directly from a satellite dish in even the remotest parts of the world has brought these once faceless, mysterious forces into the news and into the living room.

# CHAPTER I

# The Genesis and Development of Military Elites, 1915-34

In the early 1900s none of the leading military thinkers could have anticipated the role which small, nonconventional forces would later play in the conflicts of the twentieth century. What did seem clear at that time was that future conflicts would be decided by mass conscript armies, in which the individual attributes of soldiers and officers would count for very little. This was to be assembly-line war for an age of the masses.

However, prior to 1914, not even the most pessimistic theorist could have imagined the sheer scale of the mechanistic slaughter of the huge conscript armies which was shortly to ensue. And yet it was in the midst of this epic struggle that conditions for the emergence of the first modern elites began to develop. People hungered for heroes during a war in which the individual seemed to count for nothing, in which the Entente and the Central powers could suffer more than 100,000 casualties in a single day. A more tangible factor, however, lay in the simultaneous development of new techniques and tactics which promised a chance of victory without carnage. Indeed, the new heroes emerged from the ranks of the very men who spearheaded the new techniques: for example, the airmen whom the public glamorized as the lone warriors of the sky, soaring above the muddy deadlock of the trenches. Others, who adopted different means to escape the same trench deadlock, were the men who effectively gave birth to modern elites: the guerrillas and the raiders.

## THE GUERRILLAS

In the spring of 1918 an American journalist, Lowell Thomas, newly arrived in Britain from the Middle East, was lecturing with the aid of film and slide projectors to packed houses throughout the country. His subject was the extraordinary career of Colonel Thomas Edward Lawrence, a 30-year-old Oxford-educated archaeologist, who had raised an army from the tribes of western Arabia and had driven the Turks from the Hejaz. When Lawrence, splendidly attired in Bedouin dress, finally arrived back in England in 1919, he was lionized by both British society and British intellectuals. But, as Lawrence admitted in his own account of the revolt, the famous *Seven Pillars of Wisdom*, Lowell Thomas had exaggerated his role. He more modestly described himself as the brains behind the Arab revolt against the Turks, their adviser rather than their leader. Lawrence wrote that, while hidebound generals were tossing thousands of lives away each day in Europe, he had engineered the destruction of a Turkish army and had liberated much of the Arabian Peninsula without having "any of our own blood shed."

In his writings Lawrence stressed that wars could be won by intelligence rather than force. He had not sacrificed either British or Arab blood. A major problem in the Great War was that

> governments saw men only in mass; but our men, being irregulars, were not formations but individuals. An individual

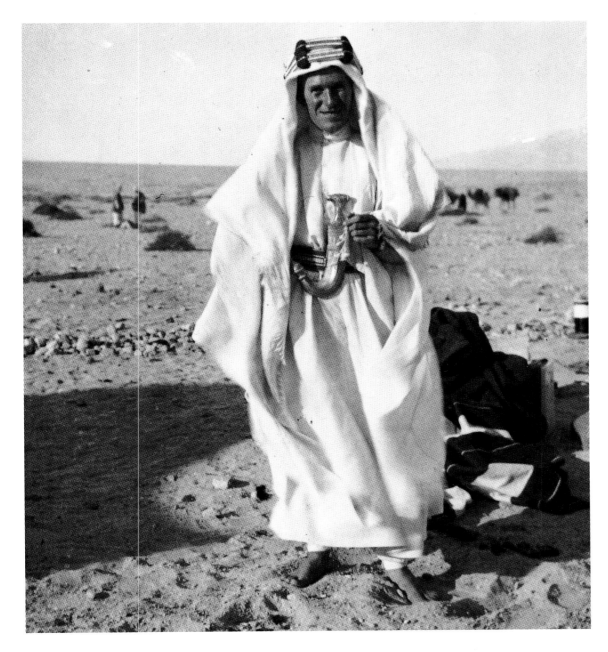

LEFT: Oxford-educated archaeologist Colonel Thomas Edward Lawrence, photographed in characteristic pose by American journalist Lowell Thomas, somewhere in northwestern Arabia.

death, like a pebble dropped in water, might make but a brief hole; yet rings of sorrow widened out therefrom. We could not afford casualties.

The way to wage war while minimizing casualties was to place a premium on gathering intelligence. In this exercise Lawrence's forces took more pains than any regular staff. Lawrence's objective was not the Turkish troops (this would have involved pitched battles, resulting in casualties), but the infrastructure which sustained them in Arabia. Lawrence reasoned that Turkey had large reserves of manpower but was very poor industrially:

Our cue was to destroy, not the Turk's army, but his minerals. The death of a Turkish bridge or rail, machine or gun or charge of high explosive, was more profitable to us than the death of a Turk.

The Arab forces never numbered more than 2000, and yet they raised hob with eight times that number of Turks, eventually driving them from the Hejaz. Lawrence wrote: "Our cards were speed and time, not hitting power." For Britain, a nation that was still struggling to come to terms with the loss of nearly one million men – the largest loss it had ever suffered in war – the notion that a handful of intelligent men operating in enemy-occupied territory could achieve results which had eluded regular armies had a considerable impact. Lawrence's first postwar employer, Secretary for War Winston Churchill, paid particular attention to the young colonel's briefings.

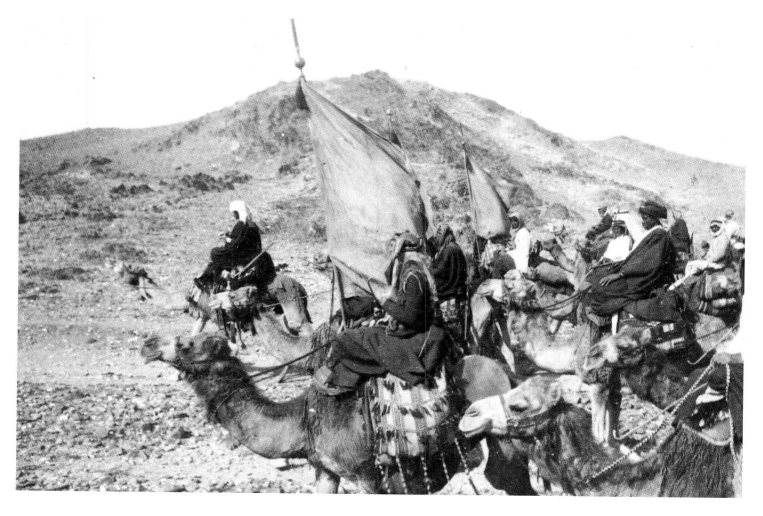

ABOVE: Lowell Thomas's photographs of the Arab revolt, first published in the spring of 1918, set off a wave of "Lawrence mania" in Britain. Lawrence seemed to be fighting a war in which casualties were light and victories were gained by outwitting one's opponent, a marked contrast to the popular perception as to how war was waged on the Western Front.

In March 1919, while London society hostesses inundated Lawrence with invitations, crowds in Berlin cheered wildly as 192 khaki-clad horsemen, the right-hand sides of their bush hats turned up, rode down *Unter den Linden*. These were the surviving Schutztruppen from the German East African colony of Tanganyika – men who, though completely isolated, had fought for four-and-a-half years against overwhelming odds until the armistice came. At their head rode their commander, General Paul von Lettow Vorbeck, shortly to become as famous in Germany as Lawrence was in Britain. Like Lawrence, von Lettow Vorbeck was soon writing about his experiences. Unlike Lawrence's *Seven Pillars of Wisdom*, however, his own *Reminiscences of East Africa* was not a great work of literature. It was, nevertheless, a useful handbook on how to conduct a guerrilla war.

As military commander of Tanganyika in 1914, von Lettow Vorbeck had faced an almost impossible situation. Virtually surrounded by enemy territory, and with no prospect of outside assistance, Tanganyika's

civil authorities urged that an arrangement be reached with the British for the colony to be granted neutral status. Von Lettow Vorbeck was adamant in his refusal to capitulate. In his opinion the best way his 2732 men (260 Germans and 2472 native askaris) could help Germany was by forcing the British Empire to commit forces to East Africa which it would have deployed in other theaters. Von Lettow Vorbeck therefore broke his forces up into 14 independent companies, each consisting of about 16 to 20 Germans and 200 askaris, each in turn supported by about 250 carriers assigned to transport supplies and ammunition. These companies were highly mobile and could either range far and wide or be concentrated at a particular point for a larger action. When the British landed 8000 men at Tanga on the northeast coast of Tanganyika in October 1914, von Lettow Vorbeck concentrated four companies, in total some 1000 men, in the area. Although outnumbered by 8 to 1, von Lettow Vorbeck inflicted a crushing defeat on the British, taking over 800 prisoners. Furthermore, in January 1915 the Germans launched another

full-scale attack against two Indian battalions at Yasini on the Kenya-Tanganyika border, forcing both to surrender.

Tanga and Yasini were spectacular victories. But the Germans had also suffered casualties, particularly among irreplaceable officers and N.C.O.s. Von Lettow Vorbeck, realizing that he could not fight many more such battles, and that his main objective was to draw as many British troops as possible to East Africa, therefore broke his companies into 10-man sections, each commanded by a European. During the first months of 1915, these sections struck deep into Kenya, hitting the Kenya-Uganda railroad. They derailed more than 30 trains, blew up 10 bridges, and virtually cut Uganda off from the outside world.

In time the British reacted. By the summer of 1918 von Lettow Vorbeck's columns were being pursued around East Africa by British, Indian, South African, Rhodesian, Belgian, Portugese and colonial African forces, in all numbering 350,000 men. However, von Lettow Vorbeck's column was nowhere near defeat when its commander received news of the armistice on 17 November. Only after confirming the accuracy of the report did von Lettow Vorbeck's

2000 men finally lay down their arms. The German commander's strategy had succeeded beyond his wildest dreams: by the end of the campaign the forces of the British Empire and its allies had suffered 80,000 dead (mainly from disease). As a result, just as Winston Churchill later sought advice from Lawrence, so the leadership of post-armistice Germany sought advice from von Lettow Vorbeck, particularly as it was now clear that Germany's military strength must remain very weak for the foreseeable future. Appalled by the condition in which he found Germany, von Lettow Vorbeck soon became involved in extreme right-wing politics. Though he did not join the infant National Socialist (Nazi) Party himself, many of his men did, and von Lettow Vorbeck's account of his campaign was widely and avidly read by the early Nazis.

## THE RAIDERS

The writings of Lawrence and von Lettow Vorbeck had a major impact both on politicians and on the public, which was by this time inclined to believe that the European war had indeed been run by unimaginative morons who could not think beyond a strategy of attritional slaughter.

BELOW: Germany's version of Lawrence was General Paul von Lettow Vorbeck, second from right in this photograph taken just before the war. Nearly five years later von Lettow Vorbeck and his surviving guerrillas were given a tumultuous welcome as they rode down *Unter den Linden* in Berlin.

BELOW: By 1917 soldiers of all armies had become adept at "trench raiding." Here a platoon of the 10th Scottish Rifles prepares to rush from a sap, taking advantage of the surprise afforded by the shells bursting on the enemy's forward positions.

The real situation was, of course, rather more complicated. As early as 1915 the trench deadlock was giving rise to a new sort of soldier, the "trench-raider." His emergence at this stage is not hard to understand. The Western Front was, in fact, a siege line, a much larger version of the siege lines that had developed before Petersburg in Virginia in 1864, or before Sevastopol in the Crimea in 1854. In the nineteenth century and earlier, sieges had usually prompted the development of ad hoc assault parties, composed of engineers, pioneers, and very daring (and sometimes very drunk) grenadiers and infantrymen. The pioneers and engineers would drag petards (enormous explosive charges expelled at point-blank range from heavy mortars) up to the walls of an enemy fortification, grenadiers would lob crude hand grenades over the defenses, while infantrymen armed with bayonets and clubs would charge with grapnels and scaling ladders, and would attempt to fight their way over and through the defenses. Once a breakthrough was secured, the mass of the attacking force would advance. In the British

Army, the assaulting unit was traditionally composed only of those who volunteered, and invariably carried the sardonic title "the forlorn hope." In practice, however, the "forlorn hope" usually suffered fewer casualties than the follow-up forces behind them, possibly because the assault party often caught the enemy by surprise. In the British Army, as elsewhere, "the forlorn hope" was thus never short of volunteers.

By 1914 most of the weapons and techniques associated with traditional siege warfare had been forgotten. The infantrymen who dug the first trench systems along the Western Front were equipped with nothing more than rifles and bayonets. Although machine guns existed, these weighed over 120 pounds – more like light-artillery than infantry weapons. By 1915 a variety of new weapons was becoming available. All armies carried light machine guns: the British used a 28-pound, magazine-fed weapon developed by the American colonel, I.N. Lewis; the Germans had an even lighter weapon developed by the Danish designer Carl Madsen. Later in the war, German designer

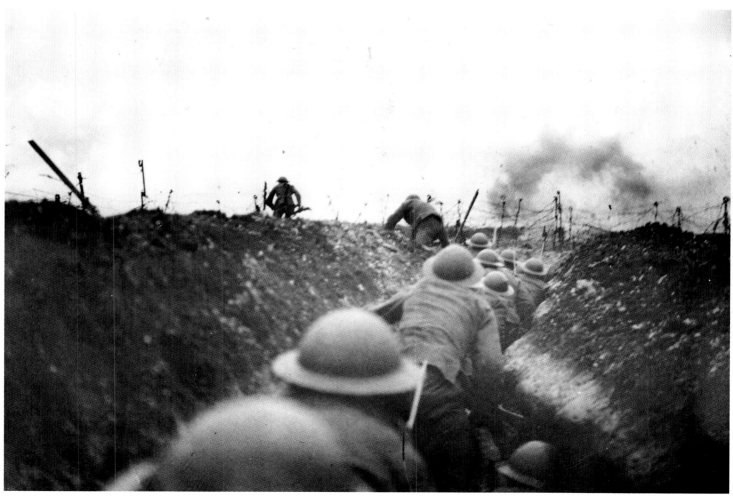

Hugo Schmeiser went on to develop his machine pistol, which the American engineer, Brigadier General J.T. Thompson, countered with a drum-fed machine pistol: the first submachine gun. Because trench fighting was like the siege-line warfare of previous centuries, old siege weapons were effectively rediscovered. By 1915 the infantry had been equipped with grenades, grenade projectors, and man-portable mortars. The infantry also equipped itself with weapons designed for close-quarter fighting: clubs, brass knuckles, and daggers. More notable was the reinvention of an ancient Byzantine naval weapon: the fire projector, or – as it became known in its man-portable variant – the *Flammenwerfer*, or flamethrower.

### *"Stunting" and "Peaceful Penetration"*

All along the Western Front troops were experimenting with the new weapons, usually without any central direction. Battalion and sometimes company commanders took it upon themselves to devise new techniques: techniques which would help them do their job while simultaneously minimizing casual-

ABOVE: A pioneer of Captain Willy Rohr's Assault Detachment practicing with the new man-portable *Flammenwerfer* early in 1916.

LEFT: Although they did not enter the war until April 1917, the Americans quickly devised new weapons which dramatically increased infantry fire power. The Thompson submachine gun and the Browning automatic rifle are two well-known examples. Less well known was a light, recoilless rifle, which was excellent for "bunker busting."

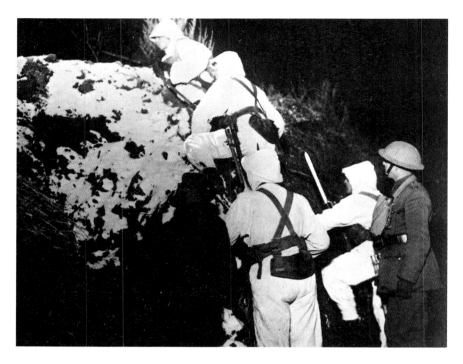

ABOVE: A British patrol prepares to do some "peaceful penetration" on the Cambrai sector on the night of 12-13 January 1917. Their white snowsuits, and the mace hanging from the belt of the second man on the ladder, underline the extent to which they had adapted to the demands of trench warfare.

of artillery bombardments caused all armies to thin out their front lines, and to deploy in much greater depth. This meant that instead of consisting of a continuous line of trenches, much of the Western Front was now a series of mutually supporting strongpoints, sometimes with several hundred yards between each. Small, aggressively-led parties of infantry found it possible to advance deep into enemy positions by avoiding, or worming their way around, enemy strongpoints. There was, as yet, no military term for this phenomenon, although the Australians called it "peaceful penetration."

### Storm troopers and Infiltration

Britain's cobelligerents, the French and the Italians, attempted to formalize these ad hoc assault parties by forming Grenadier d'Elite and Arditi units. German troops also experimented with similar techniques, but these were developed more systematically and were organized along more rigid lines. When first introduced, most of the new assault equipment was initially tested in combat by pioneer battalions. In late 1915, for example, a battalion under Captain Willy Rohr was completely re-equipped with all the latest weaponry – hand grenades and grenade launchers, light machine guns, light mortars and flamethrowers – and given experimental uniforms – a new coal-scuttle-shaped helmet

ties. On the British side the first troops to experiment with trench raiding came from the dominions and colonies – the Australians, New Zealanders, Canadians and South Africans – although by 1918 many British conscript divisions had become equally adept at these techniques. The new name which the Australians gave trench raiding – "stunting" – was soon in widespread use throughout the British forces.

During the course of 1916 the sheer weight

RIGHT: German storm troopers forming an assault squad practice a rush against "enemy" positions. They were trained to take advantage of all available cover, and to shower enemy positions with grenades, which they carried in satchels slung across their bodies. When attacking a position the storm troopers usually carried their rifles over their backs.

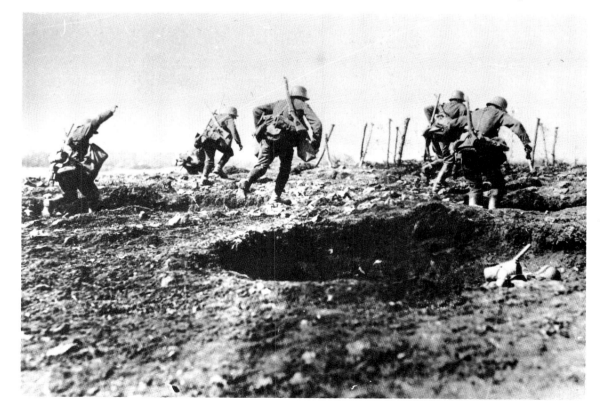

to replace the *Pickelhaube*, half-boots and puttees to replace the jackboot, and a variety of body armor to protect against shrapnel. This unit, known as Assault Detachment Rohr, was the first true force of storm troopers to be created.

Assault Detachment Rohr's first major deployment was in the Battle of Verdun in 1916. Here the German artillery had forced the French to thin out their front line, and the storm troopers found that they were able to advance deep into French positions while avoiding contact with the main French forces. This maneuver was identical to the Australians' "peaceful penetration." The storm troopers did not as yet have a word for it, but the French described it with their verb *infiltrer*. Within a year all armies were alert to the possibilities of "infiltration."

### Spoiled by Success: the Expansion of the Storm-Trooper Concept, 1917-18

In 1916, General Erich von Ludendorff, Quartermaster General of the Imperial German Army, paid a brief but significant visit to the Western Front. It was here that he first watched Assault Detachment Rohr in action. He was so impressed by what he saw that a few months later (in early 1917) he authorized the expansion of assault detachments and the retraining of entire divisions in storm-trooper tactics.

The Germans reaped considerable short-term advantage from their new policy. In September 1917 storm-trooper divisions, assisted by "hurricane" artillery bombardments, defeated the Russans at Riga. In October they beat the Italians at Caparetto, and in November they drove the British back at Cambrai. However, growing confidence after this spate of victories then prompted a fatal policy error. During the winter of 1917-18, experienced officers and N.C.O.s and fit young soldiers were transferred out of many units and were concentrated in assault divisions – a process which absorbed roughly a quarter of the entire German Army on the Western Front. But these assault divisions were not, and could not be, of the same high standard as the original Sturmtruppen, who

BELOW: Like the Western Allies, the Germans developed a variety of infantry-support weapons. The 7.6cm *Minenwerfer*, the equivalent of a heavy mortar, allowed storm troopers to reduce some pockets of resistance which might otherwise have slowed their advance. Because of the primitive nature of radio communication, storm troopers could rarely call on artillery support, except at the very beginning of an assault.

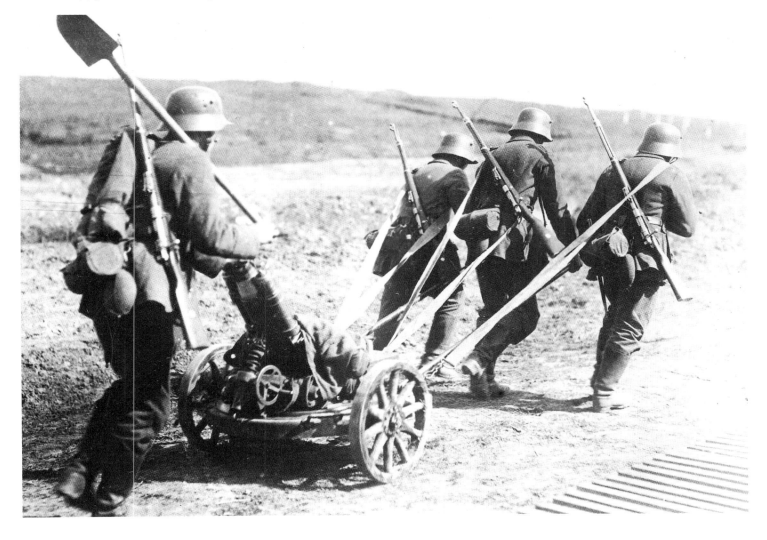

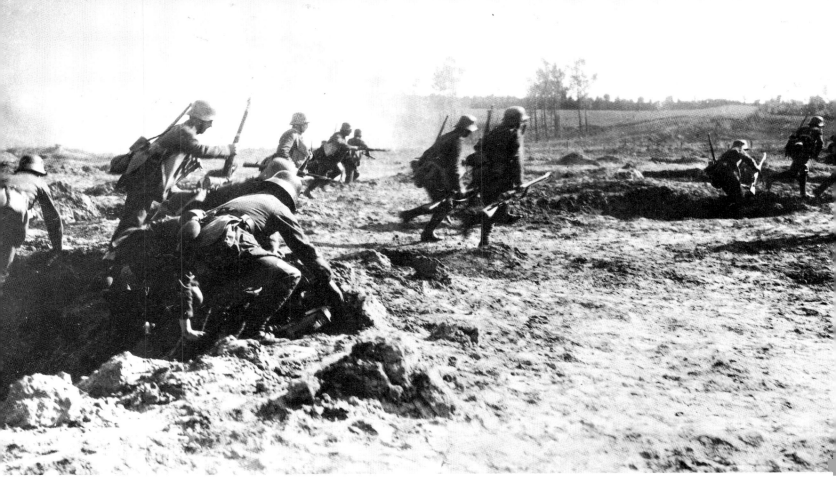

ABOVE: Storm troopers in the early phase of the "Victory Offensive" of March 1918, rush forward in their assault squads.

OPPOSITE PAGE, TOP: When this photograph was taken at the end of April 1918, the five weeks of constant offensives had taken their toll on the German assault forces. The troops were now dirty, unkempt, and exhausted.

OPPOSITE PAGE, BOTTOM: A British aerial reconnaissance photograph of the entrance to the Zeebrugge canal at Zeebrugge, taken on 24 April 1918. *Thetis*, *Intrepid* and *Iphigenia* block the passage, but a German dredger is already at work.

now numbered some 10,000 and remained a distinct elite in their own assault detachments.

On 21 March 1918 the Germans launched their so-called "Victory Offensive" against the British Fifth Army. The concentrated fire of 11,000 guns suddenly smashed down on British positions and lifted just as unexpectedly. Within minutes squads of Sturmtruppen were swarming around the surviving British positions, pushing ever farther west. During the next four months Ludendorff launched repeated offensives of this kind, and each time the Sturmtruppen divisions took disproportionately heavy casualties. The British line buckled, but did not break. By the end of July Germany had run out of Sturmtruppen, and the offensive finally petered out. In August the British, spearheaded by Australian and Canadian troops, counterattacked, discovering in the process that the German Army had lost much of its fighting spirit.

Ludendorff was the first commander in the twentieth century to have paid the price for misusing elite troops. On the basis of their performance in relatively small actions, Ludendorff had tried to convert a substantial part of his army to Sturmtruppen units. But by concentrating the very best soldiers in assault divisions, he depleted the effectiveness of the bulk of the Germany Army, and after the Sturmtruppen divisions had battered themselves to pieces on the British defenses, the collapse of the remainder of the German Army was all too predictable.

The storm trooper had been Germany's last hope for victory. It was therefore not surprising that, in the bitter and humiliating defeat which followed, the storm trooper lived on in people's minds as a legend to inspire the youth of the new generation. Indeed, veterans flooded Germany with written reminiscences in the 1920s; of these, Captain Ernst Jünger's *In Stahlgewittern* became a classic – on a par with *Seven Pillars of Wisdom*. Published in an English-language edition in 1929 as *The Storm of Steel; From the Diary of a German Storm-Troop Officer in the Western Front*, it soon became a bestseller in Britain too.

## THE SEA RAIDERS

As Ludendorff launched entire storm-troop divisions against British defenses on the Western Front, the Royal Navy was training its own variety of storm troopers. On 24 November 1917 the commander of the Dover Patrol, Vice-Admiral Roger Keyes, laid a plan before the Admiralty for a marine landing to destroy the German U-boat bases at Zeebrugge and Ostend on the Belgian coast.

The plan involved using assault forces to sink blockships in the main channels leading to both harbors. The assault forces were

drawn from volunteers from the 4th Battalion Royal Marine Light Infantry and from various ships' companies. They were armed with a formidable array of weapons – light machine guns, flamethrowers, grenades and grenade launchers and, for close-quarter fighting, knobkerries, cutlasses, knives and brass knuckles. Some 70 ships set sail on 23 April 1918 and, shortly before midnight, reached the Belgian coast. The ships destined for Ostend cruised along the coast looking for the buoys which marked the entrance to the harbor; however, being unable to locate them, the commander was forced to abort the operation.

The picture at Zeebrugge was different. Shortly after midnight German lookouts on the harbor wall were astounded to see a large British warship emerging from a fog bank and heading straight for them. With superb seamanship, Captain Carpenter, commander of the old cruiser H.M.S. *Vindictive*, brought his ship broadside to Zeebrugge's

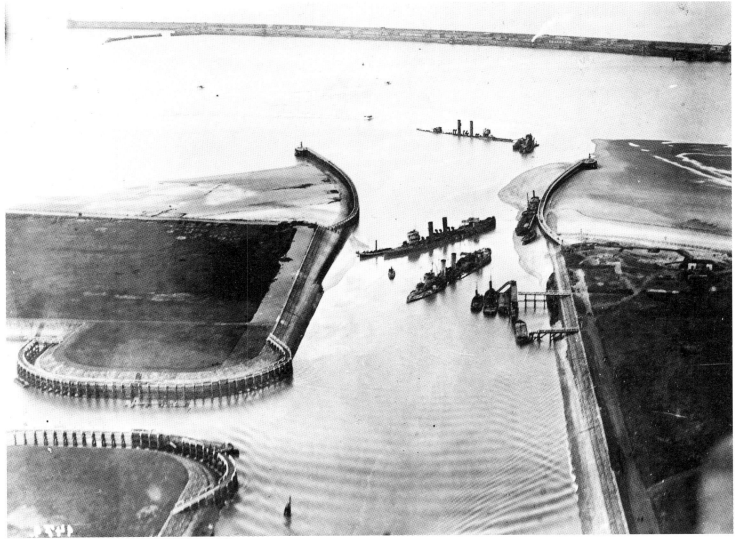

mole and opened fire on the German batteries at virtually point-blank range. At that moment gangplanks crashed from the ship onto the mole, disgorging heavily armed marines and bluejackets. Meanwhile, about 500 yards to the south, a small volunteer crew maneuvered the old submarine C-3 under a viaduct which connected the mole to the mainland. C-3's cargo was 30 tons of high explosive, and the crew set a timer to a detonator, climbed into a dinghy, and rowed seaward as fast as they could. The resultant explosion sent a sheet of flame about a mile high into the sky which, combined with the assaults of the marines and bluejackets, distracted the Germans from the real object of the raid. The old cruisers *Thetis*, *Intrepid*, and *Iphigenia* then steamed into the harbor, heading directly for the entrance of the Zeebrugge canal, down which lay the U-boat pens. *Thetis* was grounded while still in the harbor, but *Intrepid* and *Iphigenia* were swung across the entrance to the canal and then scuttled.

Within 48 hours, however, the Germans had managed to clear the entrance to the harbor. Thus, in a purely practical sense the results of the Zeebrugge raid were disappointing. The alarming casualty rate – 750 raiders killed or wounded – led some historians to dismiss it as a naval equivalent to the Charge of the Light Brigade. But despite this, the impact on British morale was immeasurable. Since 22 March 1918, each day had been punctuated with the increasingly gloomy news of fresh German gains. The Zeebrugge raid thus took place at the very time when British morale was at its lowest, and the news galvanized the nation. Eleven members of the raiding force received the Victoria Cross (most posthumously), and Keyes, now a national hero, became a firm advocate of assaults from the sea.

## RAIDERS FROM THE SKY
When the marines and bluejackets stormed ashore at Zeebrugge on 24 April 1918, it seemed to the Allies that Germany was about to triumph. Although the storm-trooper-led German offensives were close to petering out entirely by that summer, the Allied high command had as yet no indication that Germany was close to collapse. It was generally assumed that the front would stabilize, and that the war would continue until at least the summer of 1920. This was the context in

which the commander of the U.S. Army Air Corps in France, Major General William "Billy" Mitchell, devised a plan to use an airborne assault to break the deadlock once and for all.

Before the war, parachuting from balloons had been a well-established popular sport, and since 1914 most belligerents had issued parachutes to their aircrews. After much experimentation, by 1918 it was possible to jump, while relying on a static line to open the parachute, and then to control the direction of the fall by tugging the harness. In the meantime, the size and lift capacity of aircraft had increased enormously. The Germans had led the way with the production in late 1916 of the Staaken R VI, a four-engined bomber, 72 feet long, with a wingspan of 138 feet, capable of delivering two tons of bombs to, and on, London. British aircraft designers countered with the Handley Page V/1500, which first flew in May 1918. With a wingspan of 126 feet and a length of 62 feet, this aircraft was slightly smaller than the Staaken, but was propelled by four 500hp Galloway Atlantic engines (the most powerful in existence at the time), and could lift three-and-a-half tons of bombs, or (with a few modifications), about 40 fully equipped soldiers.

Mitchell proposed training the 1st U.S. Infantry Division to use parachutes, borrowing 200 or so Handley Page V/1500s from the new Royal Air Force, and dropping the bulk of the division's infantry behind German lines in the area of Menin-Roulers. Machine guns, light artillery, ammunition and other supplies would be dropped with the infantry, and the operation would be supported by every available Allied fighter and bomber aircraft. The commander of the American Expeditionary Force, General Pershing, however, had deep misgivings when the plan was presented to him in October 1918. In addition, a sufficiently large number of V/1500s would not be available until February 1919 at the earliest. In the event, the armistice on 11 November 1918 put paid to the scheme. Yet Mitchell was a gifted propagandist and had soon generated a flood of articles in American journals advocating the creation of similar forces of "parachutists." Although overlooked by the United States, Britain and France, Mitchell's ideas found a ready audience in Moscow and Berlin.

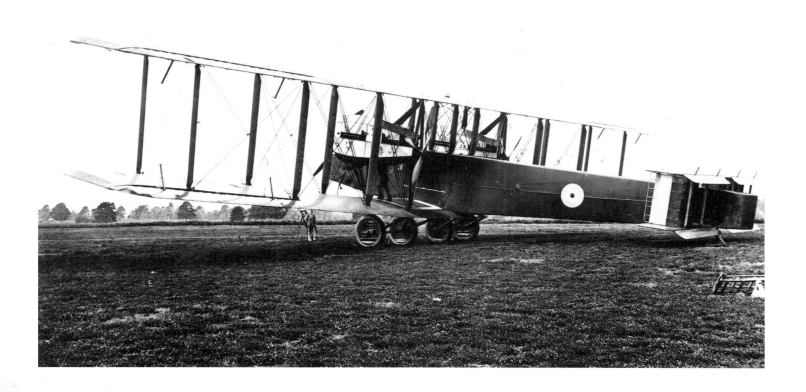

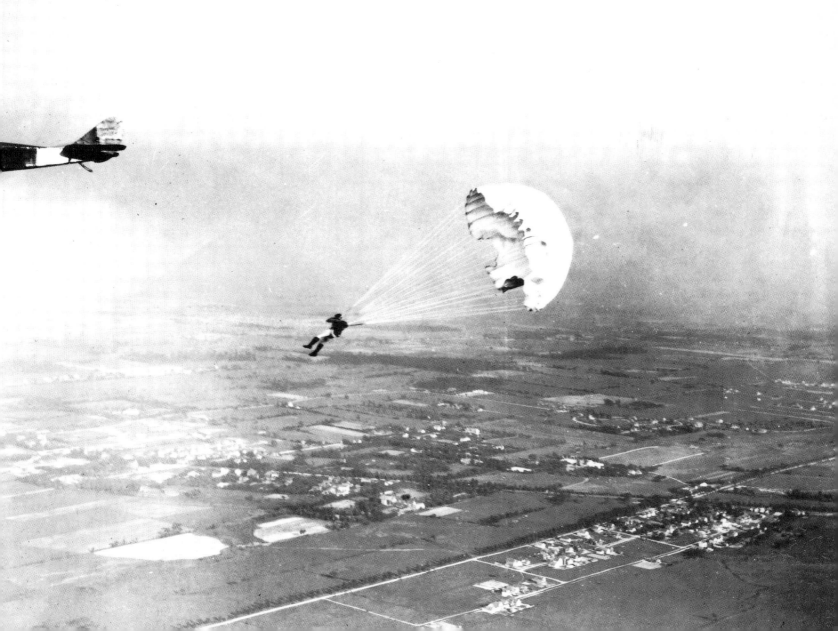

Thus by the time of the armistice, embryonic modern elites already existed. The storm trooper, the Royal Marine raider, the "parachutist" – all had evolved as a direct consequence of the demand for new forms of warfare created by the deadlock which had characterized the Western Front. In addition, both British and German guerrilla leaders, operating in theaters remote from western Europe, had shown it was possible to inflict great losses upon enemies with minimum casualties to one's own troops. The one aspect of the modern elite which had not yet emerged was its covert political role. However, the political turmoil which accompanied the end of the war would force that role into existence.

### THE GOVERNMENT'S "HIT-MEN": MILITARY ELITES AND POLITICIANS, 1918-34

World War I ended with nationalist revolts and revolutions which brought empires crashing down in chaos. As old regimes struggled to retain control, or fresh regimes attempted to build different systems on the ruins of the old ones, a new type of "political" soldier emerged. He resembled neither the "palace guard" nor the secret police of the nineteenth century and earlier, but combined elements of both. And many carried, in addition, the legacy of the guerrilla-raider elites of World War I. Early examples of this phenomenon included the Black and Tans and Auxiliaries in Ireland, and the Cheka in the U.S.S.R., which sustained the position of Lenin and his beleaguered Bolsheviks.

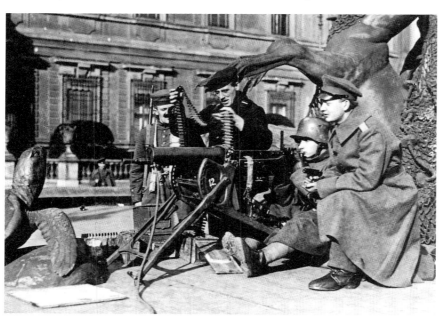

BELOW: A Freikorps machine-gun post in Berlin in December 1918. The Freikorps, composed largely of officers and N.C.O.s from the storm troopers, had little difficulty dealing with left-wing organizations like the Spartakists.

### NEW TASKS FOR THE STURMTRUPPEN: FROM FREIKORPS TO S.S. LEIBSTANDARTE

The Bolshevik regime was not alone in facing counterrevolution. In Germany during the winter of 1918-19 the combined forces of the political left – the Spartakist League and the newly formed German Communist Party – threatened to topple the government of the new German republic. Discipline collapsed throughout the Imperial Army and Navy as soldiers and sailors refused to obey orders; instead they formed councils with elected representatives – in effect, soviets after the Russian model. When these began to co-operate closely with similar organizations set up by workers in many German cities, it looked, for a while, as though a second Bolshevik revolution was imminent.

As the regime crumbled, Friedrich Ebert, the new German chancellor, desperately looked for help to Ludendorff's successor, the new Quartermaster General, Wilhelm Groener. Groener tried to deploy the front-line units returning to Germany to counter the Spartakists and strikers, but the troops refused to obey orders. On reaching Germany, many simply dropped their arms and set off for home, or alternatively joined the revolutionary elements.

The old Imperial Army was a broken reed. In late December 1918 Groener issued the demobilization order which finally disbanded it. Co-operating closely with Gustav Noske, the minister in charge of military affairs, he then authorized selected officers to raise a new special or "free" corps from among the least disaffected ex-soldiers. Like the Black and Tans and the Auxiliaries in Ireland, most were men who could not settle down to peace. They were largely young officers and N.C.O.s, the overwhelming majority of whom had served in elite storm-trooper units.

### The Landesjägerkorps and the Iron Division

One of the first and most famous of these new forces, the Freiwilligen Landesjägerkorps, was the work of Groener's old colleague, General Ludwig Märckers. On 14 January 1919 the Landesjägerkorps, along with a Freikorps raised from demobilized sailors (of the Kiel Naval Brigade), formed up at a military camp at Zossen to the south of

Berlin, and marched on the capital, taking the communists and Spartakists who controlled part of the city by surprise. For a brief period it looked as if order had been restored, but on 3 March the communists called for a general strike. It was the signal for an insurrection, and for the next two weeks the Freikorps and Spartakists battled for the administrative heart of Berlin. The Freikorps, comprising a rare concentration of military competence and aggression, utterly defeated their left-wing rivals.

The Freikorps tackled both the internal and external threats to government stability. While the Landesjägerkorps restored order in Berlin and a number of German cities, other Freikorps positioned on Germany's eastern frontiers staved off Polish nationalists and the Russian revolutionary army. In January 1919, Major Josef Bischoff, a former storm trooper, raised a force of 14,000 ex-officers and N.C.O.s – the Iron Division – for service in East Prussia and Lithuania. These men came to see themselves as latter-day Teutonic Knights, holding back the Slavic hordes, and rapidly adopted ancient Teutonic iconography for their signs and symbols. One particular device, painted on the sides of their black coal-scuttle-shaped helmets, would in time strike fear and loathing into the hearts of many: the ancient symbol for good fortune, the fylfot or crooked cross, better known under its Sanskrit name – the swastika.

In the spring of 1919 the Iron Division was the single most effective force operating in eastern Europe. It terrorized Polish nationalists, suppressed revolutionary activity in Lithuania, and on 22 May captured Riga from the Red Army. That summer the Berlin government ordered it to disband itself, along with most of the other Freikorps operating along the Baltic. But the Iron Division, which now had a life of its own, simply refused to do so. Bischoff and his men linked up with a White Russian force, and continued campaigning against the Bolsheviks in Russia until early 1920, by which time the Czarist cause was undoubtedly dead. The Iron Division then returned to Germany.

The Allies had at first seen the Freikorps as a useful means of containing and destroying revolutionary activity: at Versailles, meeting with representatives of the German republic, they had encouraged their formation. However, by early 1920, the immediate

danger was past, but Germany still retained a number of heavily armed, militarily proficient, independent corps. The Allies therefore imposed on Germany a deadline of 10 April 1920 for their disbandment. The now deeply worried republican government was only too willing to meet the deadline, but discovered, too late, that the genie refused to climb back into the bottle.

When it became known in Germany that their delegates had capitulated to Allied demands, the political right erupted in a storm of protest. Among the most bitter critics was the *Nationale Vereinigung*, a blanket organization formed by Erich von

ABOVE: Many members of the Freikorps went on to join the N.S.D.A.P.'s Sturmabteilung (S.A.). In November 1923 the S.A. set up roadblocks and machine-gun posts in Munich, in an attempt to take over the government of Bavaria.

Ludendorff and Wolfgang Kapp, the leader of the *Vaterlandspartei*, to unite the right wing. The imminent Allied deadline for disbandment acted as a flash point: in March 1920 Kapp, supported by many of the Baltic Freikorps, tried to seize power in Berlin. The republic tottered but did not fall. The right's activities were badly co-ordinated, and the "Kapp *Putsch*" had little active support outside the ranks of the Freikorps. Nearly a decade would pass before a populist right-wing organization had the power to draw enough people onto the streets to coerce governments effectively.

### The N.S.D.A.P. and the Sturmabteilung

Mass-membership of this kind was the aim of the newly formed National Socialist German Workers' Party (in German abbreviated to the N.S.D.A.P.). After 1920 its new leader was one of Ludendorff's more eccentric protégés – a badly gassed, highly decorated ex-corporal named Adolf Hitler. In November 1920 the N.S.D.A.P. formed a "sports" section, the "Turn- und Sportsabteilung." An emphasis on physical exercise was one of the N.S.D.A.P.'s genuine

ideological tenets, but its by-product – a superbly fit private army – had unmistakable advantages. The Sportsabteilung could be used both defensively and aggressively – to protect N.S.D.A.P. speakers from communist attacks at public meetings, and to disrupt opposition meetings. The promise of action and adventure lured many disillusioned Freikorps veterans, including the Landesjägerkorps and the Iron Division, into the Sportsabteilung.

In November 1921 the Sportsabteilung acquired a more familiar name: after it had quashed communist agitators in a bloody clash in Munich's *Hofbräuhaus*, Hitler rechristened it with the honorary title of Sturmabteilung, abbreviated to the S.A. Although it began as an elite (in November 1921 the S.A. had only 300 members), it expanded in the 1920s and 1930s into a large private army.

As the S.A. grew in numbers, Hitler selected from it an ultra-elite bodyguard, Stosstrupp Hitler – the Hitler assault squad. Deliberately limited to just 100 men, the exclusive Stosstrupp Hitler soon differentiated itself from the S.A. by sporting black-

BELOW: The elite within the S.A. – the Stosstrupp Hitler – proudly sporting their black-edged swastika armbands, photographed in Munich shortly before the attempted coup of 9 November 1923.

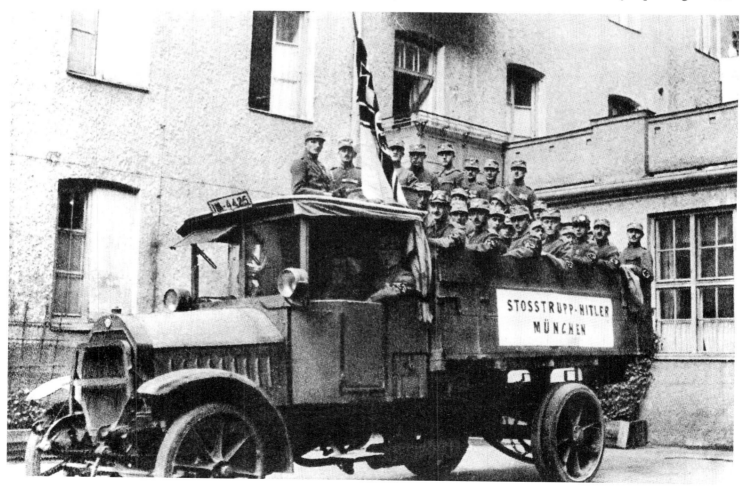

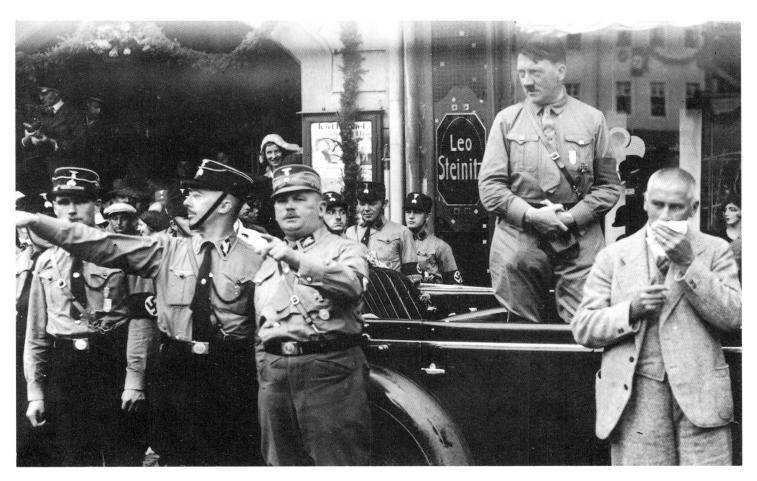

rimmed swastika armbands and black hats emblazoned with the skull and crossbones. On 9 November 1923 Hitler and Ludendorff led the Stosstrupp Hitler and the S.A. on a march through the streets of Munich, hoping that a show of force would bring down the Bavarian government. Police blocked the way, however, and, when the marchers refused to disperse, opened fire, killing five of Hitler's bodyguard. Hitler was arrested, jailed in Landsberg prison, and the Stosstrupp Hitler was disbanded.

### Birth of the Schutzstaffel

Hitler had narrowly escaped death in the *Putsch* attempt – the man immediately to his right had been killed, and the man to his left seriously wounded. As soon as he was released from Landsberg in November 1925, he wasted no time in forming another bodyguard from within the S.A.'s ranks. This new organization was called the "Schutzstaffel" [protection squad], although it soon became known merely by its initials – S.S. The S.S. was very different from the S.A.: Hitler intended to turn the S.A. into a mass movement but to maintain the S.S. as a personal, loyal elite. It was formed from a

hard core of highly experienced N.S.D.A.P. devotees; some had fought as guerrillas in Tanganyika, others as Sturmtruppen on the Western Front. Many of these men had then gone on to serve in the various Freikorps before gravitating toward the N.S.D.A.P. and joining first the Sportsabteilung, then the S.A., and finally the Stosstrupp Adolf Hitler. For them the S.S. was the end of a long road.

For new recruits, entrance requirements and discipline were strict. They attended, though could not participate in, all the discussion meetings of the party members. Only a small handful made the grade: in 1929 the S.S. numbered only 280 men when Heinrich Himmler (an N.S.D.A.P. founder member) was appointed their commander and given the impressive title *Reichsführer S.S.* Thereafter it expanded rapidly to 10,000 by 1931, although as late as 1939 it was still only about one-tenth the size of the mass-membership S.A.

### The Leibstandarte Adolf Hitler

When Hitler became chancellor in January 1933, he ordered the formation, from among the ranks of the S.S., of a 120-strong chan-

ABOVE: Adolf Hitler pictured about to address a rally in Gera in Thuringia, in September 1931. His closest henchmen stand to his right – Hess, Himmler and Röhm. To Hitler's left, coughing into his handkerchief, is Wilhelm Frick, the recently appointed minister of the interior for the state of Thuringia, the first National Socialist to hold a cabinet position in a provincial government.

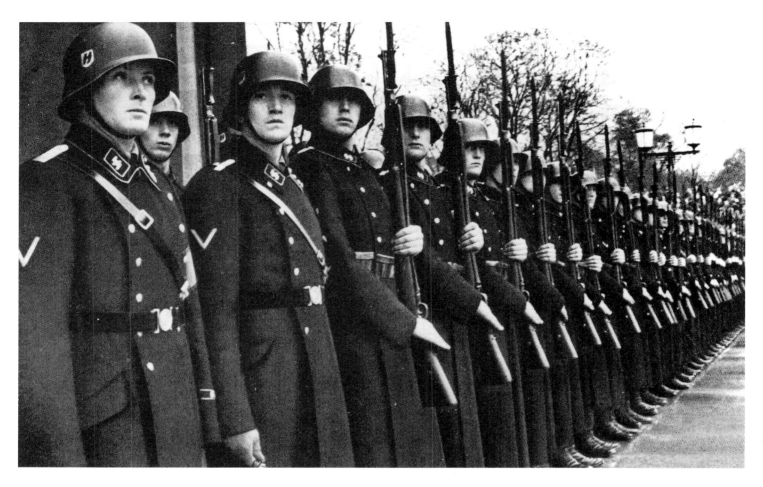

ABOVE: The first of the "modern elites" – the men of the Leibstandarte Adolf Hitler on parade in Munich in November 1933.

cellery Guard, to be placed under the direct command of Sepp Dietrich, another N.S.D.A.P. founder member. On 9 November 1933, the tenth anniversary of the failed Munich *Putsch*, Dietrich's Chancellery Guard was renamed Leibstandarte Adolf Hitler, and was increased in strength to 1000 men. This was the first S.S. unit to combine a political and military function: it was the foundation unit of the Waffen S.S.

Few elites have been more rigorously selected than the Leibstandarte Adolf Hitler. Not only did the volunteers have to be in superb physical condition, they also had to be able to prove from medical records that their families were free from genetic disorders: marriage and birth certificates were required as evidence of their "pure" Aryan stock. They also had to prove a high degree of ideological commitment to the National Socialist cause. Their physical training was demanding in the extreme, and half the volunteers failed to make the grade. For those who survived, the rewards were great: the Leibstandarte Adolf Hitler was housed in a magnificent barracks in central Berlin, with an indoor swimming pool, a lavishly equipped gymnasium, and an indoor riding

school. The regiment was being prepared as an embryonic ruling class for the new *Reich*, and ultimately for the new Europe.

### *"The Night of the Long Knives," 30 June 1934*

To an outsider's eye, the Leibstandarte Adolf Hitler seemed little different from the British Brigade of Guards. Tourists visiting Berlin photographed the tall, black-uniformed young men, resplendent in polished white-leather accouterments standing guard at the Chancellery, or goose-stepping with admirable precision in public parades. But in fact the Leibstandarte Adolf Hitler had more in common with the Cheka or the Black and Tans than with the guards outside Buckingham Palace. Ever since Hitler's accession to power, Ernst Röhm, leader of the half-million-strong S.A., had been demanding a thoroughgoing social and political revolution – a much more radical program than Hitler himself envisaged. By the early summer of 1934 it seemed clear that Röhm would very soon launch a direct challenge to Hitler's authority, and action needed to be taken to prevent this. On 29 June, therefore, two companies of the Leibstandarte Adolf Hitler left Berlin for Bad Wiessee, a

resort to the west of Munich where Röhm and some close S.A. associates were spending a holiday. On the following evening, 30 June, "The Night of the Long Knives" began. In Bavaria, troops of the Leibstandarte, personally commanded by Dietrich, murdered Röhm and six companions. Meanwhile, in Berlin, Leibstandarte squads directed by Göring and Heydrich raided and captured members of the remaining leadership, taking them back to the Leibstandarte's Lichterfeld barracks, where they were shot. The executions went on until 2 July, when Hitler ordered them halted.

"The Night of the Long Knives" cemented, as no other action could have done, the bonds between the men of the S.S. Leibstandarte Adolf Hitler: they had become a brotherhood of political assassins. Himmler expressly forbade them ever to speak of the events of 30 June to 2 July 1934 – a ban dictated less by shame than by political expediency. The Leibstandarte Adolf Hitler was well rewarded for its loyalty: Hitler pro-moted Sepp Dietrich to the rank of *Ober-gruppenführer*, the S.S. equivalent of lieutenant general, and 24 others also received promotion. In addition, in a solemn ceremony in Lichterfeld, Himmler presented those who had drawn blood on "The Night of the Long Knives" with ceremonial daggers. The veterans of 30 June 1934 were to wear them with pride.

The emergence of the Leibstandarte marks the end of the first stage in the evolution of modern elite forces. The Leibstandarte combined the twin legacies of World War I and its aftermath – the role of unconventional warrior (the trench-raider and the guerrilla) with that of the clandestine political warrior (the counterinsurgent and assassin). The Leibstandarte was no longer a temporary solution to a particular crisis, as were earlier "elite" forces like the Iron Division, but a permanent institution. And, unlike the Cheka, it was not allowed to expand beyond the size of a small regiment, until the demands of World War II set a dramatic increase in motion.

BELOW: The Leibstandarte parades through Berlin on the *Führer's* birthday, 20 April 1938. The Leibstandarte fulfilled the function of traditional elite regiments like the Grenadier Guards, but was equally capable of carrying out mass political murders, such as those committed on the "Night of the Long Knives" in 1934.

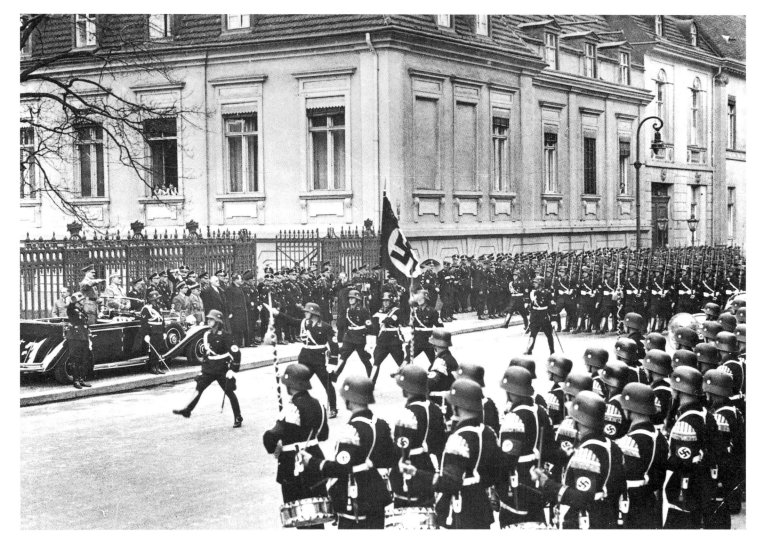

# CHAPTER II

# Hitler's Elite Forces, 1935-40

**THE KIEV MANEUVERS, 1935**

In August 1935 the Soviet foreign ministry invited hundreds of Western officers to observe its army maneuvers outside Kiev. Never had the U.S.S.R. put its army on display to so many observers from potentially hostile states. The exercise was designed not just to impress but to terrify, and it succeeded. British, French, Italian and German officers looked on in amazement as thousands of tanks and truckloads of infantry rumbled past through vast clouds of dust. These were the new Tank Armies, a byproduct of Stalin's first five-year plan and the brainchild of Marshal Mikhail Tukhachevsky, the father of the Soviet armored forces. Some German officers, including the Chief of Staff to the General Officer Commanding Panzer Troops, Brigadier Heinz Guderian, were so impressed that they concluded that war between the U.S.S.R. and Germany could only end in a Soviet victory.

Tukhachevsky, immensely proud of the 1935 maneuvers, was determined that the entire world should see the U.S.S.R.'s might, and ordered his film producers to create an hour-long documentary edited down from footage shot during the exercises. This piece of propaganda was then distributed free of charge to foreign embassies and press associations. By the fall of 1935, audiences in hundreds of cities as widespread as London, New York, Tokyo and Berlin sat riveted to their seats as they watched some of the most extraordinary military footage hitherto seen. Even today, an audience would still gasp at a sequence showing a mass drop of more than

2500 paratroopers. Only two years earlier, Hollywood had released the immensely popular movie *Flying Down to Rio*, featuring daredevil antics and breathtaking aerial ballet. Now audiences could watch a Soviet military version (this one for real), in which paratroopers clambered along the wings of giant, four-engined Tupolev TB-I heavy-bomber aircraft before hurling themselves into space.

The U.S.S.R. had stolen a march on the capitalist West. After 1922, communist youth organizations across most of the U.S.S.R.'s big towns and cities had started to establish their own parachute clubs. By the end of the decade, parachuting experience was fairly widespread, particularly among young apparatchiks and military officers. In 1929 Soviet forces operating against Muslim rebels in Central Asia formed ad hoc detachments of parachutists from among the young officers and N.C.O.s. These carried out the first operational drops in military history, acting as the "modern" communist state's answer to the horsemen of Turkestan. Reports of these operations soon reached the Soviet high command, which saw immense potential in such airborne forces. Since the beginning of recorded history, military operations in Russia had been dominated by problems of distance. At one stroke the use of paratroopers seemed to remove many of the difficulties.

During the winter of 1929-30, therefore, high-level discussions concentrated on drawing up a formula for a Soviet parachute force.

BELOW: Although it pioneered mass parachute drops, the U.S.S.R.'s lack of aerial superiority in the early phase of its "Great Patriotic War" made large-scale assaults suicidal. The best that could be achieved was dropping platoons like this one behind German lines, where they were expected to foment and co-ordinate guerrilla activity.

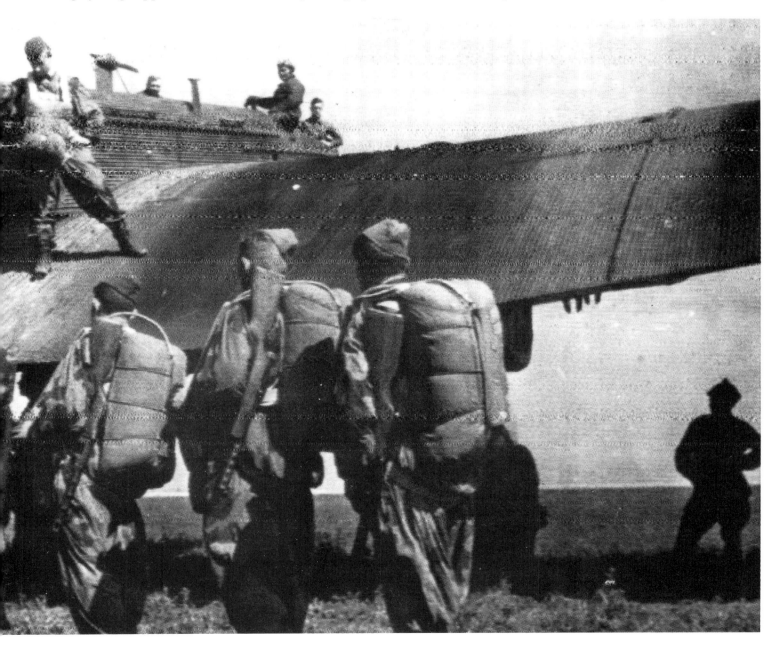

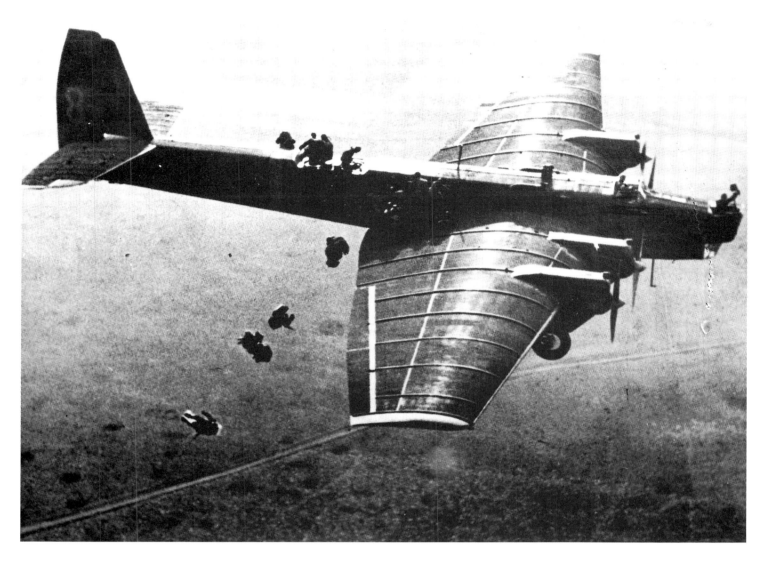

The N.K.V.D., the successor of the Cheka, argued for a relatively small, highly trained elite. Platoon-sized units could be dropped deep within the territory of the U.S.S.R.'s enemies – for example, Japanese-controlled territory adjacent to the Soviet Far East – in order to gather intelligence or carry out sabotage. The majority opinion, however, sided with Stalin, first secretary of the Communist Party, who viewed the notion of military elites with extreme suspicion: they scarcely conformed to his vision of a mass society. In the event, the first regular parachute regiment was formed in the Leningrad military district in 1931, and by 1933 it had expanded to an entire brigade. By 1935 the U.S.S.R. had three such brigades – in effect an airborne division – and planned to form airborne corps and armies.

As the sky over Kiev filled with parachutes on that August day in 1935, a handful of observers remained unimpressed. The officer leading the British delegation, Major

General Archibald Wavell, noted that the paratroopers had come down over a very wide area, and that one-and-a-half hours after the first troops had landed, small numbers of paratroopers were still being collected together. With magnificent British phlegm Wavell dismissed the landing of the parachutists as a gimmick: however impressive they might look, they would not prove suitable for any real military operations. But the leader of the German delegation thought otherwise: Colonel Kurt Student, the Luftwaffe's director of air technical training schools, immediately sent a glowing report on the proceedings to his commander in chief, *Reichsmarshall* Hermann Göring.

### THE FALLSCHIRMJÄGER
Student's report gave Göring a golden opportunity to establish a key role for himself in Hitler's military hierarchy. Göring had been appointed to command the Luftwaffe on 1 March 1935, and had watched the

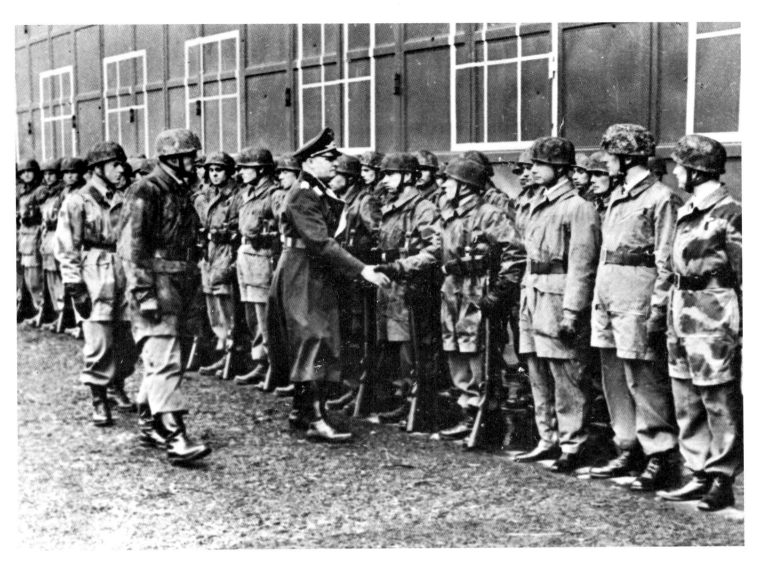

expansion of the S.S. empire controlled by his colleague and rival Heinrich Himmler with jealousy and alarm. He wanted to have an elite unit of his own to rival Himmler's much-envied control of the elite S.S. Leibstandarte. And indeed, in the fall of 1935, Göring secured the *Führer*'s permission to form a battalion of "Fallschirmjäger" [parachutists], to be known as the Hermann Göring Parachute Battalion.

Göring's Fallschirmjäger had to meet the same rigorous standards that Himmler imposed on the S.S. Leibstandarte. The battalion's operations were considered so dangerous that its members could be recruited only through voluntary enlistment, and the standards for entry were extremely high, both intellectually and physically. More than two-thirds of the first volunteers, mainly applicants from the Luftwaffe and the Prussian police, were rejected. This 3:1 ratio of applicants to acceptances continued well into World War II. A premium was placed on

qualities such as aggression, self-reliance and personal enterprise. Officers and men received exactly the same training, differing only insofar as officers had to meet more exacting standards. The inevitable deaths, which followed the first jumps when parachutes failed to open, did not destroy morale – in fact quite the reverse. The experience established an *esprit de corps*, which was captured in the lyrics of the stirring yet poignant song the Fallschirmjäger adopted as their anthem: *Rot scheint die Sonne* ["The dawn sun shines red"]. When they dropped on operations, sang the Fallschirmjäger, all their comrades, both the living and the dead, dropped with them.

Göring reinforced these elitist sentiments by approving, and in part designing, the Fallschirmjäger uniform. Here he displayed an element of genius, since the demands of parachute safety had to rank higher in the design than mere sartorial splendor. The rim of the coal-scuttle-shaped helmet was removed

ABOVE: Germany's response to the Kiev maneuvers was the creation of a Fallschirmjäger battalion, which was soon expanded into the 7th Air Division. The organizing genius in this process was Colonel (later General) Kurt Student, seen here inspecting members of the 7th Air Division.

to prevent it snagging parachute lines; the jackboots were abandoned and replaced with laced calf-length boots with thick rubber soles; and in place of the tailored pants and jacket of the traditional uniform, the men wore a pair of baggy pants tucked into the boots, and a long, loose-fitting smock which hung shapelessly around the shoulders. A few slight modifications – a collar and neck-tie worn under the open smock and a para-chute harness without the parachute to give shape to both smock and pants – made this workmanlike uniform the rival of the S.S. Leibstandarte's sinister, immaculately cut, theatrical affair. Göring knew that his Fall-schirmjäger could not cut more of a dash than Himmler's Leibstandarte and therefore cleverly chose a parade-ground uniform that asserted the dangerous nature of the Fall-schirmjäger's profession.

It proved easier to design a uniform for the Fallschirmjäger than to decide upon their role. Many senior Luftwaffe officers argued that paratroopers should be an extension of bombers. They anticipated that certain tar-gets, such as enemy airfields, would in time become so heavily defended that conven-tional bombing attacks would prove prohib-itively expensive. Instead, it might prove far more efficient to drop Fallschirmjäger some miles from the targets, possibly at night, and then have them carry out either sabotage actions or a full-scale ground attack. After-ward, they could withdraw to open country and prepare a landing strip for their escape, or select a suitable piece of road and be picked up by aircraft.

Senior army officers saw the future role of the Fallschirmjäger in a completely different light. Unhappy with the emergence of yet another elite force, controlled by yet another high-ranking N.S.D.A.P. officer, they valued the potential of airborne forces, but not operating in small units on what would soon come to be known as "special opera-tions." Instead, the Wehrmacht's high com-mand thought that the Fallschirmjäger could be used to break through the dense defensive lines which both the Czechoslovakians and the French had constructed along Ger-many's borders. They would, in effect, be airborne Sturmtruppen, with a mission very similar to that which Major General "Billy" Mitchell had conferred upon the U.S. 1st Infantry Division in 1918. This role would require the Fallschirmjäger to be employed

not in platoons or companies, but in batta-lions, brigades and even divisions.

The Fallschirmjäger might have been Göring's creation, but the Wehrmacht won the argument. On 1 July 1938 Kurt Student, now a major general and the Luftwaffe's In-spector of Air Training, was appointed to ex-pand the existing paratroop battalion into what was to be known as the 7th Air Divi-sion. Student was one of the few Luftwaffe officers to favor the expanded role of para-troopers, and his reward was the command of the new division. He later wrote:

I could not accept the saboteur-force con-cept. It was a daredevil idea, but I did not see minor operations of this kind as worth-while – they wasted individual soldiers and were not tasks for a properly con-stituted force . . . From the very begin-ning my ideas went much further. In my view airborne troops could become a battle-winning factor of prime import-ance. Airborne forces made third-dimensional warfare possible in land operations. An adversary could never be sure of a stable front because paratroopers could simply jump over it and attack from the rear where and when they decided . . . The element of surprise was an added con-sideration; the more paratroopers dropped the greater the surprise.

Student intended to turn the Hermann Gör-ing Battalion into a division without sacri-ficing its vital *esprit de corps*. He wrote: "The first thing to do is to instill regimental spirit – to make a man proud of belonging to the Parachute Corps. This pride must stem from a comradeship which is wider and deeper than that of any other regiment or corps."

Throughout the summer of 1938 the 7th Air Division trained hard to prepare for a drop on Czechoslovakia's Sudetenland defenses on 15 September – the date Hitler had set for the assault. But war was averted when Chamberlain and Daladier gave in to Hitler's demands at the Munich conference; on 1 October 1938, however, elements of the 7th Air Division landed peacefully in the Sudetenland. Six months later, battalions of Fallschirmjäger took part in yet another bloodless operation, the seizure of Prague airport, which heralded Hitler's occupation of the rump of Czechoslovakia. For the highly trained, highly motivated Fallschirm-jäger volunteers it had all proved something of an anticlimax.

## THE BIRTH OF THE BRANDENBURGERS

On 1 January 1935 Hitler appointed Admiral Wilhelm Canaris to the head of the German military intelligence, the "Abwehr." Canaris was the son of a wealthy industrialist; his social background had prevented him from joining the N.S.D.A.P., but during 1919-20 he had helped organize two Freikorps, had supported the Kapp *Putsch*, and had generally favored Hitler's policies. It was during his time with the Freikorps that Canaris had met Captain von Hippel, a veteran of von Lettow Vorbeck's Tanganyikan Schutztruppen. Canaris now appointed von Hippel to the Abwehr as an adviser on guerrilla operations. In a series of reports produced in the mid-1930s, von Hippel argued that the techniques employed by von Lettow Vorbeck in Africa could also be applied in a European conflict. He predicted that Germany would need guerrilla units: elite formations that were highly skilled, highly trained, and with specialist abilities. Such groups could infiltrate the enemy's lines well in advance of a declaration of war or the launch of an offensive: they would thus be in a position to seize vital targets as soon as operations began.

Like many others who had witnessed the slaughter of the European war, Canaris had been impressed with the cost-effectiveness of von Lettow Vorbeck's campaign. He was thus predisposed to experiment with a force of "professional guerrillas." Secret recruiting therefore began early in 1938. Like the Fallschirmjäger, the recruits had to be of above-average intelligence and physical fitness. In addition, they needed to be multilingual, adaptable, and sufficiently chameleon-like to pass themselves off in a variety of guises. Many of the first recruits were Germans who had been living in North and South America or in Africa. The recruits were trained to gather intelligence and to carry out acts of sabotage, after which they were infiltrated back into these areas of operation. In 1938 the highest priority for recruitment drives was Sudeten Germans who could speak Czech; after the resolution of the Sudetenland crisis the priority became Germans from Silesia and Eastern Pomerania who could speak Polish. Training was carried out at Brandenburg am Havel, and these units would become known throughout the German forces as Brandenburgers.

## SPEARHEADING *BLITZKRIEG*: GERMANY'S ELITES IN ACTION, 1939-40

By 1939 a combination of military and political pressures within the Third Reich had led to the creation of three distinct elite forces: the nascent Waffen S.S., the Fallschirmjäger, and the Brandenburgers. Of these three, it was the smallest and most recently formed force – the Brandenburgers – which particularly distinguished itself during the invasion of Poland.

On the night of 31 August-1 September 1939, a party of 80 Brandenburgers led by Lieutenant Gräbert, disguised as Polish railroad workers, were infiltrated across the Silesian-Polish border. By dawn on 1 September, Gräbert's men were mingling with Poles in the Katowice marshaling yards, the hub of all railroad communication in southwestern Poland. News that the Germans had attacked at dawn had already been received, and Polish engineers were busily laying demolition charges which, if detonated, would delay the advance of the Tenth Army. The marshaling yards were already in a state of excitement and confusion when around half of Gräbert's men ripped open their knapsacks and opened fire with submachine guns, also using grenades. Other Brandenburgers, still mixing with the Poles, shouted contradictary orders in Polish, while still others feigned panic by leaping onto a train and shunting rapidly out of the yard. Within seconds the alarm had spread, with scores of Polish railroad workers clambering aboard the train while others ran after it. That afternoon the Brandenburgers handed the marshaling yards over to the advance guard of the Tenth Army; the Poles had not carried out a single demolition.

Katowice set the pattern for the Brandenburgers' exercises in Poland. Many small but significant operations followed, of which the seizure of the road and rail bridge across the mile-wide Vistula at Demblin was the most important. During the first week of September the advance had been spectacular, but now German forces advancing from the west and southwest approached an obstacle which was bound to delay them – the river. On 8 September a platoon of Brandenburgers, dressed in the uniforms of Polish pioneers, infiltrated Polish lines and joined the columns of soldiers and civilians fleeing the German advance. They walked eastward for

two days and, on the morning of 10 September, reached the Demblin bridge. The Brandenburgers' commander, Sergeant Kodon, located the bridge commander and informed him that his pioneers had been tasked with the demolition of the bridge. The Polish officer tried to verify this by telephoning his superior officer. Unable to do so (Kodon's men had already cut the telephone lines), he gratefully accepted the Brandenburgers' story and joined the stream retreating eastward, after which the Brandenburgers quickly dismantled the Polish demolition charges. That evening the first German Panzers were able to drive across the Vistula.

## THE S.S. LEIBSTANDARTE AT WAR

Few regiments have ever gone to war with as much expected of them as the S.S. Leibstandarte. The eyes of the *Führer* were quite literally upon them, as Himmler told the S.S. men in his final address to the unit: Hitler intended to follow their progress across his operational map of Poland by using an extra-large marker flag, on which was written the name "Sepp." Himmler reinforced the message in his order of the day for 1 September: "S.S. men, I expect you to

do more than your duty." Unfortunately, the unglamorous task thereupon assigned to them gave them little opportunity to shine. The high command, the *Oberkommando der Wehrmacht* (O.K.W.), mindful of the regiment's relative lack of conventional training, assigned the S.S. Leibstandarte to the 17th Infantry Division, part of General Blaskowitz's Eighth Army, which had been tasked with protecting the flank of one of the spearheads, namely von Reichenau's Panzerheavy Tenth Army.

The men of the S.S. Leibstandarte did their best to make a mark, fighting with tremendous enthusiasm but relatively little skill. The commander of the 17th Division, Major General Lack, reported that during the first week the S.S. Leibstandarte's operations had been characterized by "wild shooting and the burning of villages from which the troops had supposedly received fire." Lack was also perturbed by the Leibstandarte's disregard for the accepted conventions of war, and ordered the arrest of a Leibstandarte officer for shooting Polish prisoners. Sepp Dietrich and his regiment chafed at any restrictions placed on their movements and, ignoring Blaskowitz's stop-

BELOW: On 7 September 1939 soldiers of the S.S. Leibstandarte advance through the burning town of Poljinice, to the southwest of Warsaw. They had already moved well ahead of the Wehrmacht.

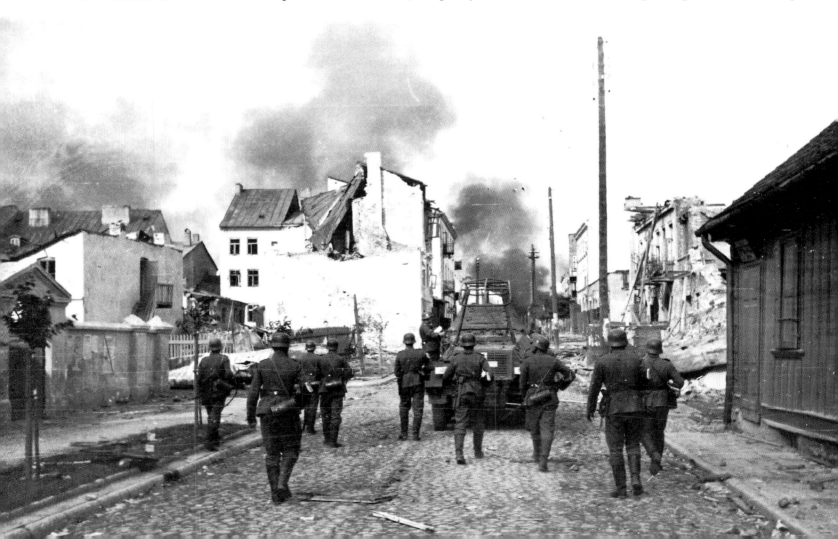

line, on 7 September moved several miles ahead of the rest of the Eighth Army in the area of Poljinice and soon found themselves surrounded by Polish forces. A furious Blaskowitz had to alter his plans and divert the 10th Infantry Division to rescue the Leibstandarte from the danger in which its excessive zeal had placed it.

Both Himmler and Hitler were alarmed by the Leibstandarte's relatively unprofessional performance. Both believed that the attachment of such a highly motivated unit to an army which had an unglamorous role was a crude attempt by the O.K.W. to keep the S.S. out of the limelight. On 8 September Hitler therefore intervened, and ordered the transfer of the Leibstandarte from the Eighth to the Tenth Army. Here it was attached to one of the spearhead units, the 4th Panzer Division. The Leibstandarte's aggression now paid dividends: the regiment spearheaded the Tenth Army's drive on Warsaw, and by 11 September was only 12 miles west of the Polish capital. The following night the Poles put on a furious attack, overran and annihilated part of the Leibstandarte's 2nd Battalion, and were only driven back after an equally furious counterattack. The Leibstandarte recovered during the day of the 13th; on 14 September it struck due north, spearheading an operation which resulted in the encirclement of an entire Polish corps around Bryzna, to the west of Warsaw. The Germans took 105,000 prisoners in the Bryzna pocket, of which the Leibstandarte

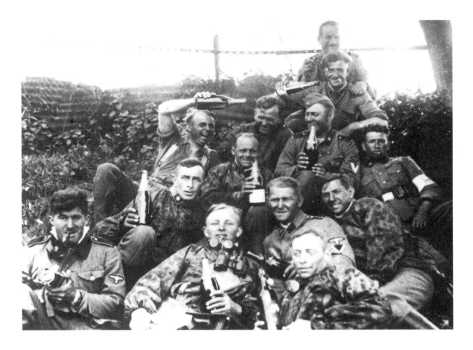

and the 4th Panzer Division claimed 20,000.

After a bad start, the Leibstandarte went on to finish the campaign covered in glory, thanks largely to Hitler's intervention. When the *Führer* visited the Tenth Army on 25 September, the honor guard was provided by the Leibstandarte, and the event featured prominently in German newsreels. A documentary film on the Leibstandarte's role in the Polish campaign was subsequently shown in all German movie theaters. It was now quite clear to Himmler that the Waffen S.S. could no longer exist as a small elite within the Wehrmacht: unlike the Fallschirmjäger or the Brandenburgers, its role

ABOVE: 17 September 1939; the S.S. Leibstandarte and the 4th Panzer Division celebrate the closing of the Bryzna pocket, with looted champagne and Polish vodka. The *Panzergrenadier* on the left is holding the ubiquitous Leica camera.

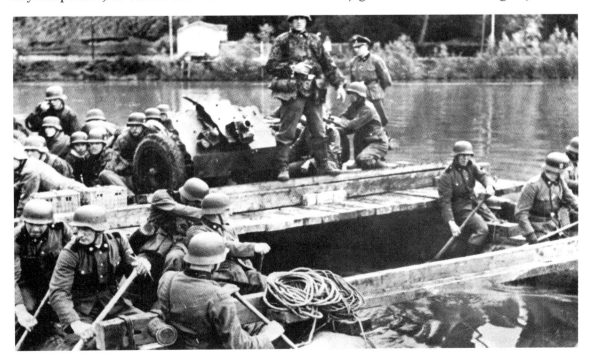

LEFT: 14 September 1939; under the direction of an officer wearing the new style of camouflage jacket, S.S. pioneers ferry a 37mm gun across the Bzura River, only 30 miles due west of Warsaw.

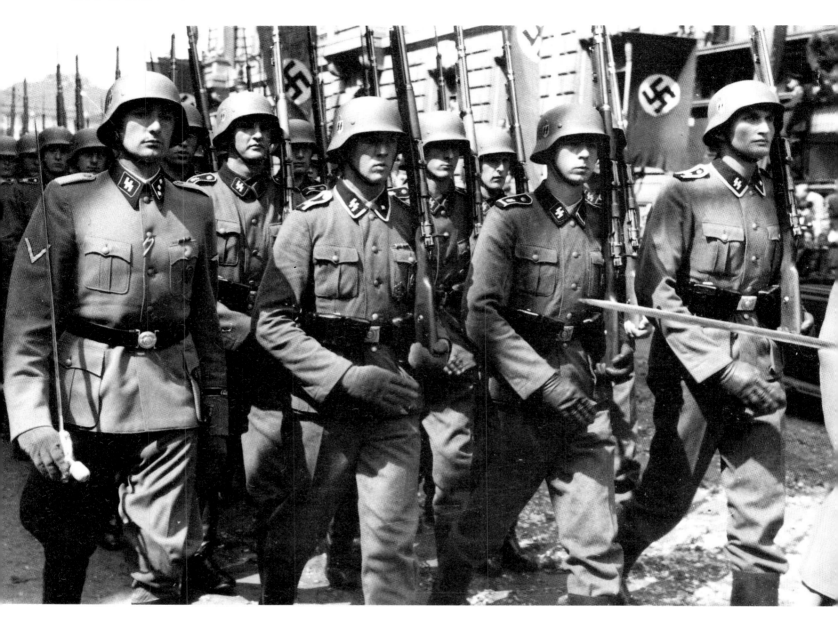

ABOVE: Wearing their Polish campaign ribbons on the left breast of their tunics, members of the Leibstandarte parade triumphantly through Berlin in October 1939.

did not *complement* the Wehrmacht but *competed* with it. There were simply too many hostile Wehrmacht generals; these would either assign Waffen S.S. units to humiliating protection duties, as Himmler suspected Blaskowitz had done to the Leibstandarte, or they would employ them in what amounted to suicide operations. The obvious solution was to expand the Waffen S.S. to a size which would allow it to operate independently of the army. In late September Himmler secured Hitler's approval to expand the Leibstandarte to divisional strength, and to raise two further Waffen S.S. divisions. During the winter of 1939-40 the Waffen S.S. ceased to be an "elite" and began an expansion which would eventually see more than 800,000 enter its ranks. The regiment was on its way to becoming a pan-European army.

## DENMARK AND NORWAY – APRIL 1940

September 1939 had been a frustrating month for the Fallschirmjäger of Student's 7th Air Division. They had waited patiently by the airfields strung out along the Berlin-Breslau *Autobahn* for the order to climb into the JU 52s, but the order never came. The German Army's rapid advance had rendered the roles previously assigned to them – securing bridges and blocking river crossings – redundant. Thus their morale was very low – so low, that some began applying for transfers to other units just so they could be sure of seeing *some* action before the war ended.

They were worrying unnecessarily. On 27 October Student was called to Berlin to see Hitler, who told him "the paratroopers are too valuable . . . I shall only employ them when I think the time is opportune. The

Wehrmacht managed very well on its own in Poland, and I do not want to disclose what amounts to a secret new weapon." Hitler already intended to use paratroopers to spearhead an attack into Belgium and the Netherlands, as part of a plan to outflank the French Maginot Line. But before this operation could be launched, plans revealing its details fell into Allied hands. Hitler and the high command subsequently decided on a radical new plan: a major armored thrust through the hilly, heavily wooded Ardennes region of southern Belgium, a region which the French and British believed to be impassable to tanks. The role of the paratroopers remained the same: they and the Brandenburgers would spearhead a drive into the Netherlands and Belgium, although this thrust was no longer designed to break through to northern France, but instead to draw the British and the French eastward toward Brussels.

While the planning and training for this operation, codenamed *Fall Gelb* [Plan Yellow] was in progress, a crisis developed in Scandinavia. Much of the high-grade iron ore required by Germany's war industries was mined in northern Sweden, transported by rail to the Norwegian port of Narvik, and then shipped down the Norwegian coast and through the Skagerrak into the Baltic. Early in spring 1940 German intelligence received information to suggest that Britain's Royal Navy was about to mine the Norwegian coastal waters, and that the British were preparing to occupy part of the Norwegian coast. Hitler decided on a pre-emptive strike, partly to protect Germany's supplies of iron ore, and partly to secure Germany's northern flank before launching *Fall Gelb*.

The Fallschirmjäger now came into their own. The assault on Norway would also entail the occupation of Denmark, and neither operation could be carried out purely by land forces. For the Danish operation, a company of paratroopers was assigned to seize the vital Vordingborg road bridge linking the islands of Falster and Zealand, across which the Germans would have to advance to reach Copenhagen. Meanwhile, another company was tasked with seizing the Danish air force's major base at Ålborg on the Skagerrak. The Fallschirmjäger accordingly took off from airfields in northern Germany before first light on 9 April, and by dawn were over Denmark. It was not a good morning – the weather was stormy and the winds were approaching gale force. As their JU 52s cruised at 500 feet to the west of Ålborg, the Fallschirmjäger jumped, letting the strong westerly winds carry them onto the airfield. Below, parked wing tip to wing tip, sat a squadron of Danish air-force fighter aircraft, Dutch-manufactured Fokker D.XXIs. The airfield looked deserted, and in fact most of the Danes were still asleep. From the time the first paratrooper landed, it took just 30 minutes to secure the airfield (not a shot was fired), and another 90 minutes for the first Luftwaffe aircraft to fly in. The seizure of the Vordingborg bridge proved equally straightforward. Fallschirmjäger, landing at opposite ends of the bridge, rushed the startled Danish defenders, who seemed too surprised to offer resistance.

On the same morning other companies of Fallschirmjäger were flying through thick cloud toward southern Norway. An important task, the seizure of Oslo airport, was abandoned when two JU 52s collided in the murk and exploded. Other paratroopers flew toward the major Norwegian air base at Sola near Stavanger, from which Norway's Italian-built twin-engined Caproni-Berbamasca Ca 310 bombers could threaten the movement of German convoys along the Norwegian coast. The cloud here was also low and thick but, after circling for some time, the transport aircraft found that conditions directly above the airfield had improved sufficiently to allow the paratroopers to jump. As they floated down, Norwegian troops opened up with rifles and machine guns, killing many paratroopers before they hit the ground. Me 109 escort fighters saved the day: sweeping down through the gap in the clouds, they strafed the airfield, thus allowing most of the paratroopers time to complete their drops, collect their weapons, and form themselves into assault units. Stavanger was the first-ever opposed parachute drop. The Fallschirmjäger had achieved their objective, but casualties were heavy.

The parachute operations of 9 April 1940 were relatively successful: a road bridge and two airfields secured. Eight days later, a reinforced Fallschirmjäger company was flown into central Norway and dropped in the Gudbrandsdalen Valley near Dombås, more than 100 mile north of the German front line, in order to prevent the British troops which

had landed at Narvik moving south to help the Norwegians. The drop was delayed by fog, and darkness was already approaching when the Fallschirmjäger jumped, unfortunately right over the top of a Norwegian concentration of armor. Intense ground fire blew apart a slow-moving JU 52, and many of the paratroopers were riddled with bullets well before they landed. The Fallschirmjägers' surviving officer, Lieutenant Herbert Schmidt, although badly wounded in the stomach, managed to rally 60 survivors and dig in on a hillside overlooking Norway's main north-south road. Schmidt and his dwindling command now fought an epic struggle – the prototype for many similar battles which paratroopers of all nations would experience from time to time over the next few years. Surrounded and outgunned, the Fallschirmjäger fought on for five days until, virtually out of ammunition, Schmidt and 33 survivors were forced to surrender.

### FALL GELB

Germany's strike west was scheduled for 10 May 1940. The advance of Army Group B into the Netherlands and Belgium was potentially a very difficult operation. Approach routes crossed many rivers and canals, and there was also the possibility that the Dutch and Belgians might open the

sluice gates to their sea defenses (as the Belgians had done in 1914) and flood the country. Unlike during the assault on Poland, this time the Brandenburgers and Fallschirmjäger would work in close cooperation. For the advance to take place on schedule, two key points on the Meuse had to be secured: a railroad bridge at Gennep which carried the main line from the Ruhr to Rotterdam; and the Dutch bridges which spanned both the Meuse and the Albert Canal, carrying the main roads and rail lines from Cologne and Aachen to Antwerp and Brussels. The latter bridges were crucial to east-west communications in northwestern Europe, and were covered by the guns of Eben Emael, a Belgian fortress just to the southwest of Maastricht, which was reputed to have the strongest defenses in Europe. The German high command knew that surprise was essential if the Gennep bridge was to be captured intact and Eben Emael neutralized and therefore assigned the Brandenburgers to the former and the Fallschirmjäger to the latter.

### The Gennep Bridge

Half-an-hour before midnight on the night of 9 May, a small party of Brandenburgers slipped across the frontier near Gennep. Unlike during their clandestine operations in

BELOW: One of the very few pictures of the Brandenburgers in action. Still dressed in the uniforms of Dutch military police, the Brandenburgers are photographed just after the seizure of the road bridge across the Meuse at Venlo. Though not as important as the simultaneous Gennep operation some 30 miles to the north, the seizure of the Venlo bridge allowed the Germans to advance rapidly through the southern Netherlands.

Poland, they all wore German uniform, except for two who were disguised as Dutch military policemen. Making their way to the eastern approach to the bridge, they hid out until shortly after dawn, then the "Germans," holding their hands on their heads, were marched at gunpoint through the river mist by the "Dutch," until they reached the Dutch control point. Within seconds the Brandenburgers silently overpowered the guards at the eastern end of the bridge, those on the western side remaining unaware of this sudden turn of events. One of the Brandenburgers who could speak fluent Dutch telephoned the commander of the western end of the bridge, informing him that two Dutch military policemen and a party of prisoners were about to cross the bridge. As the Brandenburgers reached the western side of the bridge, a German armored train approached from the east. Before the Dutch could detonate any demolition charges, the Brandenburgers were upon them. The Gennep bridge fell into German hands intact; by

mid-morning German troops were pouring across it into the central Netherlands.

### Eben Emael

Deception worked well at Gennep, but could not have been used to secure Eben Emael. The fortress housed four battalions in deep underground bunkers connected by subterranean passages. The armament was formidable: 10 heavy guns, protected by machine guns firing on interlocking arcs from pillboxes of reinforced concrete. When studying how to neutralize Eben Emael, German engineers had advised against aerial or artillery bombardment, because the reinforced concrete was simply too thick to be penetrated by any bomb or shell then available. A surprise assault from the air seemed the only possibility, but the fortress measured only 1000 by 900 yards – too small an area for a concentrated parachute drop to be carried out with any hope of success. It was decided that the solution was to transport the Fallschirmjäger in gliders which would land

ABOVE: The *Führer* awards the Knight's Cross to the embodiment of the modern military elite, Lieutenant Witzig (center) after the capture of Eben Emael.

on the roof of the fortress, their fuselages wrapped in barbed wire to create the friction needed to slow them over such a short space.

In the early hours of 10 May, 11 gliders carrying a company of 85 Fallschirmjäger engineers were towed to a height of 7000 feet and then, while still on the German side of the border, released to begin a noiseless descent onto the fortress. Two towropes broke during the ascent; both of these gliders landed in Germany, but one of them unluckily carried the assault force's commander, First Lieutenant Witzig. The other nine gliders swooped down on Eben Emael, taking the Belgians by complete surprise, as intended. The Fallschirmjägers' training was good: every man knew exactly what he had to do and, in Witzig's absence, the senior N.C.O., Master Sergeant Wengel, took command. The engineers ran from casement to casement, placing 25-pound hollow charges against the concrete which, when detonated, devastated the upper compartments of the fortress. A few of the defenders who managed to get to the pillboxes and open fire with machine guns were incinerated by Fallschirmjäger flamethrower teams. Some paratroopers even dropped through the holes which their charges had created, fighting hand-to-hand with the surviving Belgians in the upper corridors.

Meanwhile, Belgian forces outside Eben Emael, recovering from their astonishment, swept the roof of the fortress with machine-gun and field-artillery fire, forcing the Fallschirmjäger to huddle behind casements. Belgian infantrymen emerged from nearby woods and cautiously began to advance on the fortress, until their leading elements were themselves pinned down by fire from the Fallschirmjägers' MG-34s. In the middle of the battle a glider spiralled onto the roof of Eben Emael and screeched to a halt. Out jumped Witzig and his men: having come down near Cologne, they had immediately commandeered another glider and a JU 52 transport as a tow. Witzig arrived at the critical moment: his radio was still functioning and he was soon in contact with the Luftwaffe. At 0930 hours squadrons of Stukas screamed down on the Belgian positions around Eben Emael, forcing some Belgians to retreat hurriedly. But the battle was by no means over. Throughout the rest of the day and the long night which followed, the paratroopers clung on to Eben Emael, those on the roof pinned down by artillery fire, while those within the fortress were fighting from corridor to corridor with pistols and knives. At dawn on 11 May German engineers reached the bank of the Albert Canal immediately opposite the fortress, and by midmorning the first German Panzers were across, tearing westward toward Brussels. Shortly thereafter the surviving defenders emerged waving a white flag.

The capture of Eben Emael was a daring and brilliant operation – the German equivalent of Keyes's Zeebrugge raid of 1918. The Fallschirmjäger had also been assigned key roles in spearheading the advance into the Netherlands. Here there were two main aims: to stop the Dutch from demolishing bridges, and to seize the airfields and command-and-control centers in the heart of the Netherlands – the area between Rotterdam, The Hague and Amsterdam. Once across the Gennep bridge, the main obstacle which the Germans would encounter before reaching Rotterdam was the Waal. The Dutch had rigged up demolition charges on the main road and rail bridge crossing this river, just south of Rotterdam, and the Germans knew that as soon as the paratroopers dropped from JU 52s, or their gliders came in to land, the Dutch would detonate the explosives. The officers of the Fallschirmjäger therefore came up with a novel solution: 12 Dornier flying boats, the same models as used by the Dutch Naval Air Force, put down on the

BELOW: Fallschirmjäger of the 7th Air Division descend on the outskirts of Rotterdam on 11 May 1940. For those who survived the Dutch ground fire it was the beginning of four days of hard fighting.

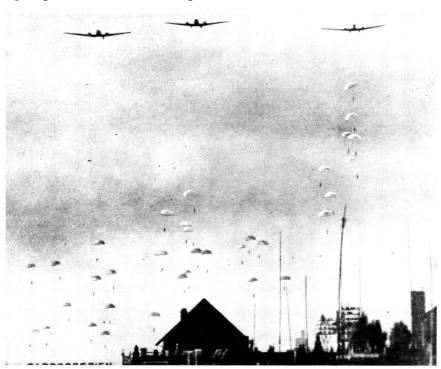

Waal and taxied under the bridge. While the Dutch were still uncertain as to the identity of the aircraft, Fallschirmjäger ran out along the wings and onto the superstructure of the bridge, ripping out the detonator wires with their bayonets. By the time the Dutch were able to respond, the Fallschirmjäger were in control of the bridge, which they then held in the face of determined Dutch attacks until the Panzers arrived on 12 May.

However, the Fallschirmjägers' operations in the Netherlands were not a total success story. A new paratroop unit, the 22nd Airborne Division, attempted a knockout blow against the Dutch. The plan was to seize airfields around The Hague, land troops in JU 52s, and then capture the centers of government, and also the royal family. The Dutch, however, forewarned by the German use of paratroopers in the Scandinavian campaign, had held substantial forces back around their capital. As the JU 52s lumbered over the airfields around The Hague on the morning of 10 May, the Dutch put up a dense screen of antiaircraft fire, which brought scores of German transports crashing earthward in flames. The 22nd Airborne Division tried to push home its attack. A handful of JU 52s actually put down on the main runway of The Hague's airport, only to somersault to destruction when their undercarriages collided with the logs that the Dutch had laid across the runway. Throughout the area between The Hague and Amsterdam the story was much the same: the survivors of the 22nd Airborne Division ended up scattered over the countryside, pinned down by the Dutch. Lieutenant General Student had jumped, together with elements of his 7th Air Division, near Rotterdam on 10 May, and survived four days of close-quarter fighting with the Dutch. On 14 May, as he stood by the window of his command post looking south for the Panzers which he knew were not far off by now, he was shot and severely wounded by the advance guard of the ever-aggressive S.S. Leibstandarte. Ironically, the Dutch had just surrendered.

The campaigns of September 1939 and April/May 1940 established Germany's elite forces as an essential element of "*Blitzkrieg*," a term which now took on a new meaning from the original German "short campaign relying on surprise and shock action." Sensation-seeking Western journalists and panic-stricken British and French com-

manders saw *Blitzkrieg* as a revolutionary new technique, although at the operational level the campaigns in Poland, the Low Countries and France were actually only the motorization and mechanization of the traditional German concept of the "*Kesselschlacht*" – the battle of encirclement. However, at the tactical level, *Blitzkrieg* was indeed revolutionary. While deception had been used from the dawn of recorded military history, it had never before been employed on such a systematic basis by specialist "dirty-tricks" units.

And nothing like the Fallschirmjäger had ever been seen before. It is hard for us to comprehend today the imaginative power which the brilliant seizure in one single day of Eben Emael, the strongest fortress in Europe, displayed for those who had lived through the blood baths of Verdun and the Somme. Goebbels's propaganda ministry played up the revolutionary aspects of the campaign in the documentary film *Blitzkrieg im Westen*. Supplied to embassies in Berlin late in the summer of 1940, it was soon given English-, Spanish-, and French-language sound tracks and sent out on general release to more than 30 neutral nations. Audiences throughout the world thrilled to realistic re-enactments of the assault on Eben Emael, and to actual footage of mass Fallschirmjäger drops. And nowhere was the impact of Germany's elite units greater than in the country of the Reich's one surviving enemy, the now-beleaguered British Isles.

ABOVE: A still from *Blitzkrieg im Westen*. The image of Fallschirmjäger rounding up surrendering Dutch soldiers suggested the almost effortless victory of a modern elite over a conscript infantry whose uniforms dated from World War I. In reality, the Dutch had inflicted very heavy casualties on the Fallschirmjäger.

# CHAPTER III

# The British and American Response: Northwestern Europe, 1940-42

## CHURCHILL AND THE COMMANDOS

As the Battle of Britain got under way, Britain's new prime minister, Winston Churchill, was under no illusions about the cause of the defeat in France. He wrote to the Foreign Secretary, Anthony Eden:

I feel that the Germans have been right, both in the last war and in this, in the use they have made of storm troops . . . The defeat of France was accomplished by an incredibly small number of highly equipped elite, while the dull mass of the German Army came on behind, made good the conquest, and occupied it.

Britain in the 1930s had differed greatly from Germany. In Germany, the National Socialist victory had led to a political revolution, and these circumstances did much to foster the development of modern military elites. But the long-established British military hierarchy, suspicious of innovation, remained firmly wedded to more orthodox formations. The disastrous experiment with the Black and Tans had put paid to any "dirty tricks" unit; the Royal Marines had been positively discouraged from developing their skills as amphibious raiders, and the Royal Air Force had decisively crushed any suggestion that the army might develop a force of parachutists.

Throughout the summer of 1940 Churchill issued a flood of memoranda to the Chiefs of Staff. He demanded that they throw all their efforts into creating forces which he described variously as "storm troopers," "leopards," and "hunters." Whitehall officials finally settled on the term "Special Service Battalions." All official correspondence until late 1944 referred to them as "S.S. troops," though the general public, Churchill, and the troops themselves quickly adopted the name suggested by the South African-born officer who organized the first units – "commandos." Like the Afrikaner kommandos of 1900, the British commandos' original function was to organize and lead guerrilla resistance against an enemy occupation. Indeed, His Majesty's Stationery Office was busy printing and preparing mass-distribution pamphlets with titles such as *The Art of Guerrilla Warfare, Partisan Leaders' Handbook,* and *How To Use High Explosives.* But Churchill had no intention of waiting until any Germans arrived on Britain's shores before unleashing his commandos. On 3 June he thundered out a minute to the Chiefs of Staff:

The completely defensive habit of mind which has ruined the French must not be allowed to ruin all our initiatives . . . we should immediately set to work to organize raiding forces on those coasts where the population are friends.

Two days later he demanded "a vigorous, enterprising and ceaseless offensive against the whole German occupied coastline."

By the late summer of 1940 12 commando units, each about the size of an infantry battalion, had been formed from volunteers

LEFT: 10 November 1940; six months into his premiership Churchill's face is etched with strain and anxiety. By this time his only consolation was that he knew his commandos would not have to conduct a guerrilla war against an invading German army on the soil of mainland Britain – at least not until the following spring.

from throughout the British Army. Royal Marines, then being expanded to divisional strength, were not allowed to volunteer, partly because Churchill meant to maintain them as a strategic reserve for any last-ditch defense of central London. All army commanding officers acted on the instructions that only the very best volunteers were to be selected: men who were young, fit, intelligent, and able to drive motor vehicles. They came from every unit in the army, kept their own headdress with regimental distinctions, and lived in billets rather than in barracks. A commando training school would have been the next logical step, but at first the emphasis was on decentralization. Until early 1942 the officers of each commando unit were separately responsible for training programs;

standards of efficiency could, and did, vary widely.

The activities of these would-be amphibious raiders required co-ordination. On 17 July Churchill appointed his old friend, Admiral Sir Roger Keyes, hero of the 1918 Zeebrugge raid, to the new post of Director Combined Operations. Things did not go as well as Churchill had hoped. Amphibious raiding required months of training and the construction of special landing ships. Even with the support of Britain's military establishment, it would have taken many months to have established a program of regular commando raids, and unfortunately Keyes did not have the support of the military hierarchy. General Alan Brooke, the Commander in Chief Home Forces (soon to

become Chief of the Imperial General Staff)
and his Chief of Staff, Lieutenant General
Bernard Paget, were both convinced that the
creation of commando forces separate from
the regular army was a mistake. Keyes
clashed bitterly with both men: the equip-
ment he demanded never came, and all the
raids he proposed were canceled. One
notable exception was the first large-scale
raid, to destroy fish-oil factories on the
Lofoten Islands in Norway on 4 March 1941,
which met very light resistance and was
really little more than a realistic major train-
ing exercise. If it had any value, it was in the
vital practice which it gave the men and the
chance it presented for publicity. The news-
reel movie made of the operation did much to
improve civilian morale; however, the
period of inactivity which followed the
Lofoten raid led to a rapid decline in com-
mando spirit. Keyes started to quarrel with
Alan Brooke once more, and then took on
the Admiralty for good measure. Finally,
even Churchill became tired of the infight-
ing, and on 27 October 1941 removed Keyes
from office.

## CHURCHILL AND THE PARATROOPS

In the summer of 1940 Churchill also
demanded that some of the commandos be
trained as parachutists. This dubious honor
fell upon 2 Commando, which was now de-
signated 2 Special Air Service Battalion.
Training, provided by Royal Air Force in-
structors, began in July at Manchester's
Ringway airport. Ringway was thought to be
far enough north and west to be safe from the
constant attacks which the Luftwaffe was
then making on airfields in southern and
eastern England. The R.A.F. hierarchy,
determined that any parachute forces should
be under its control, did its best to stifle their
development. For example, the only aircraft
allocated to paratroop training were five
Whitley bombers; these were completely un-
suitable, since the only way to jump from the
aircraft was through a hole in the floor and,
as the paratrooper did so, he stood a good
chance of having his legs dragged back by the
aircraft's slipstream, so that his head
smashed against the rim of the hole. Of the
initial intake of 342 men accepted for para-

chute training, 30 refused to jump, two were killed, and 20 seriously injured – a 15 percent wastage rate which severely affected morale.

The paratroopers needed to gain a sense of purpose, it was felt. A "practice" raid, like the commandos' assault on the Lofoten Islands, was therefore planned. In February 1941 Whitley bombers attempted to drop 38 paratroopers near the Tragino Aqueduct in southern Italy, a massive structure which supplied water to Bari, Taranto and other naval bases. One group managed to land very close to the aqueduct, but they carried only 800 pounds of explosives, which proved just about enough to destroy one single span, which the Italians soon repaired. Another group, carrying the bulk of the explosives, landed in a neighboring valley. On hearing the distant detonation they decided to make for the coast and rendezvous with a Royal Navy submarine. In the event, neither group covered more than a few miles before they were surrounded by hordes of curious Italian peasants: men, women and children. Rather than attempting to shoot their way out and thus almost certainly precipitating a massacre, they surrendered.

Unlike the Lofoten raid, the assault on the Tragino Aqueduct could not be justified as a training exercise. After all, none of the paratroopers returned to impart their experience. Churchill tried to restore morale by making a personal visit to Ringway in April 1941 to witness a parachuting demonstration. While he was in the radio tower, he overheard an altercation between ground control and an officer in a Whitley, who had suddenly discovered that five of his men were refusing to jump. This was the low point in the development of the parachute forces, and the R.A.F. now redoubled its efforts to secure the disbandment of the Ringway operation, claiming that it was diverting urgently needed resources into an organization which could never be used operationally. The success of the Fallschirmjäger the year before, as the argument presented in R.A.F. staff papers in late April 1941 went, had been the product of surprise; such operations would never be attempted again, because ground forces now had their measure. By this stage, even Churchill was inclined to agree.

On 20 May 1941, however, thousands of Fallschirmjäger floated down over Crete. Ten days later, the last remnants of the British, Australian and New Zealand garrison were evacuated from fishing villages on the south side of the island. Yet only days earlier R.A.F. staff papers had said that such an event was impossible. German casualties were horrific: indeed, so heavy were they that Hitler forbade all further large-scale paratroop operations. But when the news of the invasion reached London, neither the high German casualty level or Hitler's reaction were known; all that was seen was a German triumph. Churchill, furious with the R.A.F., ordered the Chiefs of Staff to expand the training of paratroops immediately, and to have 5000 ready for service by May 1942, along with another 5000, who would be carried by glider.

## New Commanders

In their early stages, the commandos and paratroops therefore developed in similar ways. Both at first raised wildly optimistic expectations, which were then dashed by long periods of inactivity. Both were held back by the hostility of the army, navy and air force. But, during the fall of 1941, as the pace of war quickened, both organizations soon began to develop into the units of popular legend. Churchill gave them commanders who were young, dynamic, socially well-connected, and politically influential. The naval hero Lord Louis Mountbatten, one of the king's cousins, took over from Keyes as Director Combined Operations. Meanwhile, Major General Frederick Browning, an officer in the Grenadier Guards and the husband of novelist Daphne Du Maurier, took command of the paratroops. Both men possessed considerable personal charm, had contacts which they could use to cut through bureaucratic logjams, and had managed to get substantial increases in their forces. By the end of 1942, Browning was in command of two brigades, while Mountbatten was able to overcome Alan Brooke's objections to recruiting more commandos from the army by converting much of the Royal Marine Division into what was now called the Royal Marine Commandos.

## New Training

These appointments also ushered in a new era of far more professional training. The dangers of parachuting were greatly reduced by the use of tethered balloons, rather than a hole in the floor of a Whitley, to make training jumps. In November 1941 the newly

formed 2 and 3 Parachute Battalions (2 and 3 Para) made 1773 descents, with only two refusals, 12 injuries and no fatalities. Parachuting might have become less glamorous, but it was also much less dangerous.   Two months later, the training of the commandos was centralized at Achnacarry, the castle of Cameron of Lochiel, 14 miles from Fort William in Scotland. The training program devised for the men was designed to test not just physical strength, stamina, and skill at arms, but also intelligence and resourcefulness. Exercises included "speed-marching" 15 miles in full kit over hilly country in three hours, abseiling 40 feet down the castle wall, mock amphibious assaults across the loch under live fire, and the construction of bridges across raging mountain torrents using only toggle ropes. These punishing activities were designed to sort out the men from the boys and, indeed, they distinguished future commandos from those who would be returned to their units.

### New Uniforms

Intensive training for both paratroopers and commandos was like a rite of passage, a bonding exercise which greatly enhanced unit cohesion. Browning reinforced the paratroopers' distinctive sense of identity by

establishing a standard headdress. He chose a maroon (his racing color) beret, on which was pinned a new badge depicting the Greek hero Bellerophon riding the winged horse, Pegasus. Some months later, officers of 1 Commando, then stationed in Ayrshire, also decided to standardize their headdress, and had a local tam-o'-shanter-maker run them up berets from the only military-style cloth he had available. It was green. Within weeks other commandos were following 1 Commando's example.

### EARLY OPERATIONS

The earliest operations of both the commandos and the paratroopers had been disappointing – pinprick raids which sometimes resulted in fiascos, like the descent on the Tragino Aqueduct. Although disasters still occurred, they were now the result of bad luck, not bad training. The first large-scale British-based commando raid took place on 27 December 1941. The goal was the Norwegian town of Vaagso, a defended port. 3 Commando, supported by naval gunfire and Hampden bombers, fought their way street by street through the town; the Germans resisted fiercely, but proved no match for the commandos. By the end of the day the commandos, at a cost of 71 casualties, had

BELOW: Landing craft pull away from the transport *Prince Charles* and head for Vaagso at dawn on 27 December 1941.

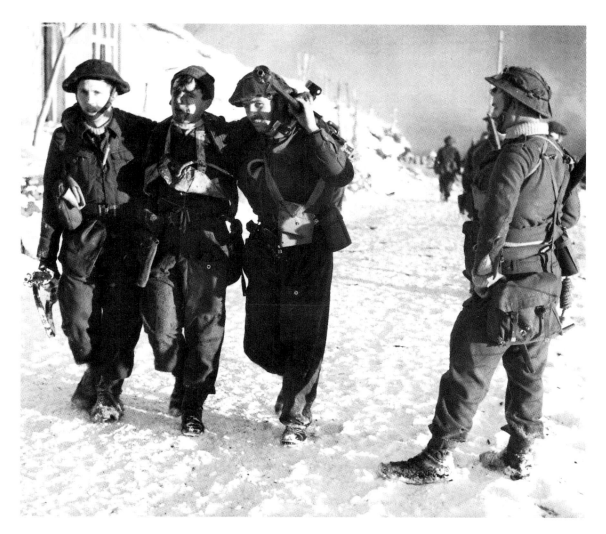

LEFT: Wounded in the hand during the fierce house-to-house fighting in Vaagso, Second Lieutenant Denis Flaherty is helped to the landing craft by his men. He was later awarded the D.S.O.

BELOW: An aerial photograph of the German radar station at Bruneval, clearly observable in a shallow pit halfway between the cliffs and the isolated house. 2 Para's seizure of parts of this station on the night of 28 February 1942 saved British scientists months of hard work.

killed, wounded or captured 209 enemy troops and had sunk 16,000 tons of coastal shipping.

Vaagso opened a new chapter for Britain's elite raiders. It was closely followed by two operations which rivaled, and in some ways surpassed, Witzig's assault on Eben Emael. On the night of 28 February 1942, "C" Company of 2 Para (nicknamed "Jock Company" because it was composed entirely of Scottish volunteers) parachuted onto the French coastal village of Bruneval, the site of a new German radar installation. Led by their newly appointed commander, Major John Frost, the paras quickly overcame the surprised Germans, dismantled as much of the electronic components as they could carry, and photographed what they had to leave behind. They then "speed-marched" to the coast and were picked up by waiting landing craft. The only casualties were two signalers who got lost on the way to the rendezvous and were captured. Mountbatten was delighted, describing Bruneval enthusiastically (but ungrammatically) as "the most

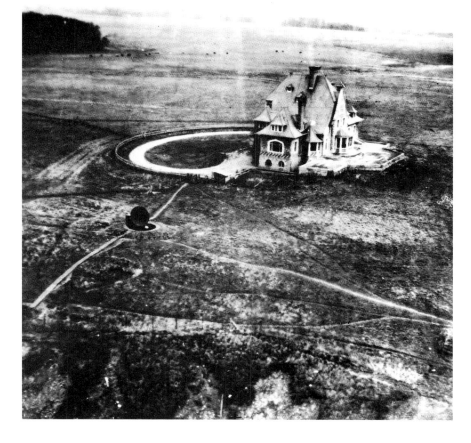

RIGHT: Shortly after dawn on 28 March 1942, an exhausted and apparently defeated commando who had donned the uniform of the Black Watch (his parent regiment) just before the assault, sits in a street in St. Nazaire. German photographers had intended to use this photograph as propaganda, but within a few hours *Campbeltown* had exploded, transforming what seemed to be a British defeat into a victory.

100 percent perfect of any raid I know."

Just one month later it was the turn of the commandos. On the night of 27 March 1942 the old destroyer *Campbeltown*, her silhouette modified to match that of a German Möwe-class destroyer, led a small flotilla of motorboats up the estuary of the Loire to the great dry dock at St. Nazaire. This dock was the only facility on the French Atlantic coast equipped to take the German battleship *Tirpitz*. *Campbeltown*'s disguise worked brilliantly: she was only 2000 yards from the dock when the Germans realized their mistake and opened fire. At this point she hoisted the white ensign, surged up the river at 20 knots, and smashed into the dock gates. The crash of steel grinding on concrete was still reverberating through St. Nazaire when commando demolition parties leapt ashore from the *Campbeltown* to set charges on hydraulic and pumping machinery. German fire was now intense. By this stage the motorboats – the commandos' only means of escape – had been virtually destroyed. The remaining commandos tried to fight their way through the streets of St. Nazaire, but casualties were very heavy: 369 of the 611 who set out failed to return, and subsequently five commandos were awarded the

Victoria Cross – the largest number awarded for any single action, with the exception of the defense of Rorke's Drift in 1879. On the morning of 28 March the Germans were still puzzling over the purpose of the raid. *Campbeltown* was wedged firmly onto the gates, but the gates themselves, each of which weighed several hundred tons, were scarcely damaged. However, at 1030 hours, as some 300 German engineers and sailors swarmed over the old destroyer, four-and-a-half tons of depth charges, set in concrete in a steel box below the foredeck, exploded. The number of German casualties was horrific, and the dock was so badly damaged that it could not be repaired until the mid-1950s.

The daring operations at Bruneval and St. Nazaire had an enormous public impact since they took place, virtually simultaneously, at a low point in the war: Singapore had surrendered to the Japanese on 15 February 1942, and Rangoon had fallen on 9 March. These successful operations therefore captured the imagination of both the British public and the Allied nations. British popular writers, such as W. E. Johns and C. S. Forester based their own adventure stories on these extraordinary real-life exploits, making them even more colorful.

Over the summer of 1942, Hollywood used Forester's fictionalized version of the Vaagso raid as the basis for an immensely successful movie, *The Commandos Strike at Dawn*. The paratroopers had to wait until 1953 for their own piece of Hollywood immortality, when Alan Ladd, playing a Canadian volunteer, relived their exploits in *The Red Beret*.

## ENTER THE AMERICANS

Britain might have started from a low point in the summer of 1940, but exactly two years later she could boast an array of elite special forces which not only matched but even surpassed those of Germany. The events of the summer of 1940 also galvanized military opinion on the other side of the Atlantic. The United States (which remained neutral until 1941) had mirrored Britain in the rate at which its special forces progressed – not fast, and after years of delay. But on 25 June 1940, just 72 hours after the surrender of France, the U.S. War Department directed the 29th Infantry Regiment at Fort Benning, Georgia, to form a parachute test unit. A little over two months later the first "mass jump" (it involved less than a company) was made from DC3 transport aircraft. Senior officers were so impressed by this event that there was virtually immediate authorization for the creation of an entire battalion, designated the 501st Parachute Infantry Battalion.

After the initial panic caused by the fall of France, the U.S. development of parachute forces slowed down until the next big shock – the successful German parachute assault on Crete. As in Britain, the sky was suddenly (and quite literally) the limit. By December 1941 the U.S. had four parachute battalions in training – the 501st, 502nd, 503rd, and 504th – and was in the process of forming airlanding units.

Like their German and British counterparts, the U.S. paratroopers fast developed an *esprit de corps*. A young officer of the 501st, Lieutenant William P. Yarborough, designed a distinctive cap badge: a parachute encircled by eagle's wings; while the uniform he designed resembled a smartened-up version of the Fallschirmjägers' jump suits. The paratroopers were also given permission to wear their jump boots on formal parades, with their pants tucked in the tops. By that time, too, the paratroops had adopted a distinctive war cry. During one of the first drops in the summer of 1940, a few

ABOVE: The reality of Crete; wrecked JU 52 transport aircraft litter Máleme airfield. The Fallschirmjäger suffered such heavy casualties in Crete that they were never again employed in divisional strength.

RIGHT: The image that the Nazi propaganda ministry presented of the German airborne assault on Crete in May 1941: heroic Fallschirmjäger advance through the smoke to victory. It was an image accepted in both Britain and the U.S.A., and led both countries to expand their airborne forces dramatically.

BELOW: A major problem for paratroopers was that once they were on the ground they were no more mobile than other infantrymen. The transport glider, large enough to carry a jeep, was an attempt to solve this problem.

would-be paratroopers had screamed in terror as they jumped from the aircraft. A young officer decided to turn his inevitable scream of fear into something more aggressive, by yelling out the word "Geronimo," the name of the famous Apache chief, as he jumped from the plane. Soon "Geronimo" had become the war cry of the American airborne forces. It was an excellent way of controlling fear.

Propelled into the war on 7 December 1941, American developments followed those of Germany and Britain – battalions became brigades, and brigades became divisions. By the summer of 1942, the U.S. had formed two divisions: the 82nd "All American," commanded by Major General Matthew B. Ridgway, and the 101st "Screaming Eagles," under Major General William C. Lee. By this time the first paratroop unit had already left for war: the 509th Parachute Infantry Battalion, commanded by Lieutenant Colonel Edson D. Raff, had arrived in England in June 1942 and was based in Chilton Foliat in Wiltshire. Here it trained with the British 1st Parachute Brigade.

## THE U.S. RANGERS

Even before America entered the war, Roosevelt had sent U.S. forces across the Atlantic. On 7 July 1941 the 6th Regiment U.S. Marine Corps (U.S.M.C.) had arrived in Reykjavik to replace the British forces. Because the U.S.M.C. had become involved in fighting in the Pacific after 7 December 1941, the U.S. War Department decided to send all available marines as reinforcements, including those in Iceland, who were replaced by U.S. Army forces in March 1942.

After January 1942, the number of American troops in England grew steadily. Their initial excitement about living in a country at war rapidly gave way to boredom. The papers, including the American magazines *Time* and *Life*, were filled with the exciting exploits of Britain's maritime raiders, and *The Commandos Strike at Dawn* seemed to be playing in every movie theater. America might have been *at* war, but was not yet *in* the war. The one notable exception was a long way off – MacArthur's gallant stand on Bataan and Corregidor in the distant Philippines. America's own excellent

BELOW: "Somewhere in England" on 4 July 1942. The newly promoted Brigadier General Lucian K. Truscott (center) accompanies Major William O. Darby on an inspection of volunteers for the U.S. Army's new ranger battalions.

ABOVE: William O. Darby, the rangers' namesake.

ABOVE: William O.
Darby, the rangers'
namesake.

OPPOSITE PAGE: Two of
Darby's Rangers,
photographed in the
summer of 1943,
demonstrate the sort of
equipment now carried
by "elite raiders."
Their packs are light
and hold a large
amount of ammunition.
They are armed with
the Thompson
submachine gun (right)
and the Browning
automatic rifle (left).

amphibious forces were all positioned in the Pacific, and pressure now grew to create a new force designed to carry out raids alongside the commandos. This was the recommendation which Colonel Lucian K. Truscott carried back to U.S. Chief of Staff, General Marshall, after a fact-finding tour in May 1942.

On 1 June Marshall ordered the formation of an "American Commando" unit, to be raised from volunteers from U.S. forces serving in Great Britain. Major General Dwight D. Eisenhower, recently appointed Chief of the Operations Division of the General Staff, suggested a more distinctively American name. Truscott, who had just seen the film *Northwest Passage*, in which Spencer Tracy played Captain Robert Rogers, the commander of a force of frontiersmen raiding French communications along the Hudson Valley during the Seven Years' War,

suggested the name that the real Rogers had used for his unit nearly 200 years earlier – "Rangers." This settled, over 2000 American soldiers serving in Great Britain volunteered, and by late June the 1st Ranger Battalion under Major William O. Darby was training alongside the commandos at Achnacarry.

**OPERATION JUBILEE**

In the euphoria following the St. Nazaire raid, Mountbatten's Combined Operations headquarters began planning Operation Rutter, a large-scale raid against Dieppe. This was to involve all the existing special forces: the commandos, the new American rangers, British and American paratroops, and the equivalent of a brigade of the 2nd Canadian Division. Deteriorating weather conditions forced the cancellation of Rutter, but the plan was soon revived as Operation

ABOVE: Dieppe beach,
photographed by the
Germans on the
morning of 20 August
1942, the day after the
disastrous raid.

OPPOSITE PAGE, TOP:
Commandos return to
Newhaven from
Dieppe, their faces still
blackened.

OPPOSITE PAGE,
BOTTOM: Escorted by
German soldiers,
Canadian prisoners
are marched through
the streets of Dieppe in
the aftermath of the
raid.

Jubilee: essentially the same as Operation Rutter, but without the airborne forces, who were annoyed at being left out.

Before dawn on 19 August five squadrons of landing craft, escorted by destroyers, approached the French coast. At about 0400 hours the landing force blundered into a German convoy, and a confused, close-quarter naval battle ensued, in which the British sank two German escorts. The surprise factor so essential to Operation Jubilee had now been lost. At 0500 hours the largest of the landing craft, carrying the Royal Regiment of Canada, ground onto the shingle beach leading up to Dieppe's main esplanade. But the Germans were waiting for them, and over the next few hours virtually annihilated the Canadians. The smaller squadrons carried commandos and rangers to the eastern and western flanks: their task was to destroy the coastal batteries covering the main landings.

This part was generally successful: a party from 3 Commando, under Major Peter Young, a veteran of Lofoten and Vaagso, kept a battery to the east of Dieppe at Petit Berneval occupied for much of the morning, while 4 Commando, under Lieutenant Colonel Lord Lovat, seized and destroyed a battery to the west of the town.

Dieppe was a disaster. Of the 6100 landing forces, 1027 were killed and 2340 captured, though the comandos and rangers escaped relatively lightly, with only 257 casualties out of the 1173 engaged. In the bitter aftermath, experienced commandos voiced their criticisms: Jubilee had been too large for a raid and too small for an invasion. However, it had shown that, for future large-scale invasions, the commandos and rangers would be best employed operating in the flanks of the main landing beaches, destroying strong points and batteries.

## HITLER'S COMMANDO ORDER

In the months after Dieppe, Combined Operations reverted to small-scale raids. On one of these, Operation Basalt, a landing on Sark in the Channel Islands on the night of 3 October 1942, the commandos captured and tied up four Germans, who were subsequently killed during a fire fight as the raiders withdrew. The Germans declared this an atrocity, and made the most of the incident for propaganda purposes. Indeed, Hitler responded by issuing his infamous Commando Order of 18 October 1942, writing:

> For a long time now our opponents have been employing in their conduct of the war methods which contravene the International Convention of Geneva. The members of the so-called commandos behave in a particularly brutal and underhand manner. . . I order, therefore, from now on all men operating against German troops in so-called commando raids in Europe and Africa, are to be annihiliated to the last man.

This was an eloquent testimony to the effect which Britain's maritime raiders were having by the fall of 1942.

# CHAPTER IV

# From the Nile to the Rhine: Elite Operations in the Mediterranean Theater, 1940-45, and in Northwestern Europe, 1944-45

**PRIVATE ARMIES OF THE MIDDLE EAST: LAYFORCE, THE L.R.D.G. AND THE S.A.S.**

Public attention was focused on raiding across the English Channel from Britain. But commandos had also been raised from among British forces in the Middle East since the summer of 1940. These would have a considerable influence on the development of future elite units, not just in Britain, but in virtually every other country which aspired to raise such forces.

It all started very unpromisingly. In June 1940, Middle East Command, acting on instructions from Whitehall, established a commando training center at Kabrit on the Great Bitter Lake in Egypt. The raw material was good, but the commandos' training was patchy and their equipment poor. During the winter of 1940-41 they were involved in disastrous operations behind Italian lines in Abyssinia and in the Italian-occupied Dodecanese Islands, which ended with commandos actually surrendering to an Italian landing force. An incredulous Churchill demanded a board of inquiry into the operation, the findings of which were suppressed until after the war.

### Layforce

Raiding in the Mediterranean had to be revitalized. This meant sending three commando battalions under Colonel Robert Laycock (the raiders were hence known as "Layforce") to the Middle East. They traveled via the Cape and arrived at Suez in March 1941. Laycock incorporated the best of the existing commandos into his own force, disbanded the rest, and set out to restore the reputation of amphibious raiders. It was a vain hope.

Between April and June 1941 Layforce was virtually annihilated in three operations. The first was a raid which took place on 17 April on Bardia in Libya, now far behind Axis lines. Layforce landed, located and set fire to a stockpile of Italian tires, but on the way back to the rendezvous several parties lost their way: in all 67 were left behind. The second operation was the landing of two Layforce battalions on the north coast of Crete on 21 May, who were tasked with recapturing Máleme airfield from the Fallschirmjäger. By the time they were ashore the situation was beyond redemption; the Layforce battalions therefore acted as the rear guard during the retreat to the south side of the island, allowing the bulk of the garrison to escape, but only 179 members of Layforce eventually reached Egypt. The third operation was the landing on 8 June of Layforce's last surviving battalion on the coast of Vichy French Lebanon, its task being to assist the advance of British and Commonwealth forces from Palestine. The fighting was very heavy, and the battalion lost a quarter of its strength – 123 casualties.

This final disaster proved the end of Layforce. On 15 June 1941 General Archibald Wavell, the Commander in Chief of the British forces in the Middle East, ordered it disbanded.

### The Long-Range Desert Group

For a naval power like Great Britain, the Mediterranean was an obvious corridor through which attacks could be launched against targets spread along the North African coast. To some British officers who had served in Egypt in the 1930s, it seemed equally obvious that the Western and Libyan deserts, stretching westward 2000 miles to merge with the Sahara, were "seas of sand" through which raiding forces could move to attack targets on the coast.

Major Ralph Bagnold, an officer in the Royal Signals, had devoted himself during the 1930s to exploring and mapping the Egyptian and Libyan deserts. With Wavell's approval, in June 1940 Bagnold set up a reconnaissance and raiding force, called the Long-Range Desert Group (L.R.D.G.). Improvisation was the order of the day: for example, the British Army did not have enough suitable trucks, so Bagnold bought 14 30-cwt trucks from the Chevrolet Company in Cairo, and begged and borrowed another 19 from the Egyptian Army. Since the

British Army did not encourage men to volunteer from regular units, Bagnold turned to New Zealand and Rhodesian units, although eventually patrols were established from the British Guards and Yeomanry (home reserve) regiments.

The first raid was spectacular. Between 26 December 1940 and 8 January 1941 a L.R.D.G. patrol traveled 1000 miles southwest of Cairo. After negotiating largely unexplored country, such as the formidable dunes of the Great Sand Sea, it reached the Italian-garrisoned oases of the Fezzan region of southeastern Libya. There it linked up with a Free French force which had advanced simultaneously northeast from Chad. The combined Anglo-French columns then swept out of the desert and into the Italian-held oasis of Murzuk, to the utter astonishment of the enemy garrison. Casualties were light, but included the commander of the Free French column, Colonel d'Ornano. He was replaced by his second-in-command, Colonel le Vicomte de Hautecloque, alias Jacques Leclerc, the unassum-

ABOVE: The 30-cwt Chevrolet truck with a Vickers .303-inch machine gun mounted on the back, the vehicle which made the success of the Long-Range Desert Group possible.

ing name which he had adopted to protect his family in France.

The Murzuk raid showed what might be achieved. New operations were planned, but in late March 1941 the newly arrived Afrika Korps under Lieutenant General Erwin Rommel launched an offensive which drove the British back into Egypt. A cautious high command therefore ordered the L.R.D.G. to garrison the oasis of Siwa on the Egypt-Libya border, well inland from Rommel's forces, where it would spend most of the summer of 1941.

### The Special Air Service

Meanwhile, in Cairo, events were unfolding which led to a dramatic development with regard to Britain's elite forces. In June 1941 the Deputy Chief of the General Staff, General Ritchie, was working in his office when a lieutenant 6 feet 6 inches tall hobbled in uninvited with a scheme to destroy the Axis air force. His name was David Stirling, a member of the by-now defunct Layforce, who had been injured while learning to parachute. Stirling's scheme was bold, imaginative and so crazy, that the new C-in-C Middle East, Auchinleck, thought it might work.

Stirling proposed to raise a force of 65 men from the remains of Layforce. Using obsolete Bombay transports, they would parachute down near Axis airfields, plant delayed-action explosives on the enemy aircraft, and then walk to prearranged rendezvous points to be picked up by patrols of the L.R.D.G. Stirling's new force, called the Special Air Service (to confuse German intelligence), was soon in training.

### OPERATION CRUSADER, TOBRUK AND COMBINED OPERATIONS

By the fall of 1941 Britain had three major special elite units in the Middle East: the commandos, the L.R.D.G., and the S.A.S. The first of these, the commandos, ultimately played only a marginal role in the fight against Rommel. Churchill had ordered them to be reconstituted, and they were again placed under the command of the by-now Brigadier Laycock (Churchill, however, persisted in referring to him as "General" Laycock).

In November 1941 Auchinleck launched Operation Crusader, a major counter-offensive, in which all special forces were involved deep in the enemy's rear areas. This

BELOW: During 1942 the Long-Range Desert Group (L.R.D.G.) and the S.A.S. were re-equipped with American jeeps. These vehicles were smaller than the Chevrolets, but were more rugged, mobile, and had a greater range. In addition, the twin machine guns gave them formidable fire power.

proved, in the end, disastrous, with consequences similar to those of Dieppe. On 15 November submarines carrying Laycock and his commandos landed on the coast of Cyrenaica, where he secured a base area near the beach. Meanwhile, a party under Lieutenant Colonel Geoffrey Keyes, Sir Roger Keyes's son, pushed inland, heading for the villa which British intelligence had assured them was Rommel's headquarters. They stormed the villa, and, in the vicious hand-to-hand fighting which followed, Keyes (as well as many German soldiers) was killed. The tragic irony lay in the fact that intelligence had been wrong: it was not Rommel's headquarters after all. Both the weather conditions and the German reaction subsequently and simultaneously turned nasty. Huge storms and mountainous seas left the commandos without sea transport and landlocked. The only alternative, as Laycock saw it, was to walk back to British lines, several hundred miles to the east. On Christmas Day two men staggered into a British position – Laycock himself, and one of his men. All the others had been killed or captured. The only glory to emerge was the posthumous Victoria Cross awarded to Keyes.

Similar failure met 55 S.A.S. saboteurs who tried to parachute onto airfields in the area of Gazala the night after Laycock's landing. The same winds which had prevented the evacuation of the commandos scattered the S.A.S. wide across the desert. Not a single aircraft was destroyed and only 21 of the S.A.S. managed to reach rendezvous points with the L.R.D.G.

Operation Crusader, without much help from the commandos, had driven Rommel out of Cyrenaica by December 1941. However, Rommel counterattacked early the next year and by the summer was well entrenched. He had driven the British troops back to El Alamein, had established supply lines stretching hundreds of miles back to Tobruk, and was in striking distance of Alexandria. But when the commandos and the L.R.D.G. combined to attack Tobruk, the port's heavy defenses shelled them out of existence. The navy lost two destroyers and the commandos 300 out of the 382 men who took part.

The Tobruk disaster, like that of the very recent Dieppe, enforced the learning of some bitter lessons. New, less wasteful techniques were needed. One had already been successfully tried out at a raid nine months earlier on an airfield at Tamat, near Benghazi. Here the S.A.S. and the L.R.D.G. worked together closely, each playing a distinctive role. The L.R.D.G. waited in camouflaged trucks near the airfield while Stirling and his small band of saboteurs placed thermite bombs on 24 aircraft and destroyed each one.

Such combined operations became more frequent over the summer and fall of 1942. A radically new approach, adopted in June, produced spectacular results. During a raid

ABOVE: A L.R.D.G. patrol moves out from the desert base of Siwa Oasis on the Egypt-Libya frontier in the summer of 1941. The long stay at Siwa allowed the L.R.D.G. to become "desert-wise," and laid the groundwork for some spectacular operations in 1942.

on Bagush airfield, Paddy Mayne had become furious when the bombs which his squadron had placed on the aircraft failed to detonate. In a rage, he and Stirling drove their vehicles onto the airfield, firing their machine guns and in the process destroying seven German warplanes. In July the S.A.S. managed to secure scores of the newly arrived American jeeps, in which they mounted two twin Vickers or .5-inch Browning machine guns. With all guns firing simultaneously, a single jeep could produce a devastating 5000 rounds per minute.

Thus began the glory days for the S.A.S. and the L.R.D.G. Infiltrating across the Qattâra Depression again and again, their patrols swept onto Axis airfields, sometimes 18 jeeps abreast, their guns producing a hurricane of 80,000 rounds per minute. By the time he began his retreat to the Mareth Line on the Tunisia-Libya frontier, Rommel had lost 400 aircraft in these raids, and with them all hope of challenging British aerial superiority.

## OPERATION TORCH

Rommel began his retreat to Tunisia on 4 November 1942. On 8 November the Allies launched Operation Torch – amphibious landings on the coast of Vichy French North Africa designed to crush the retreating Ger-

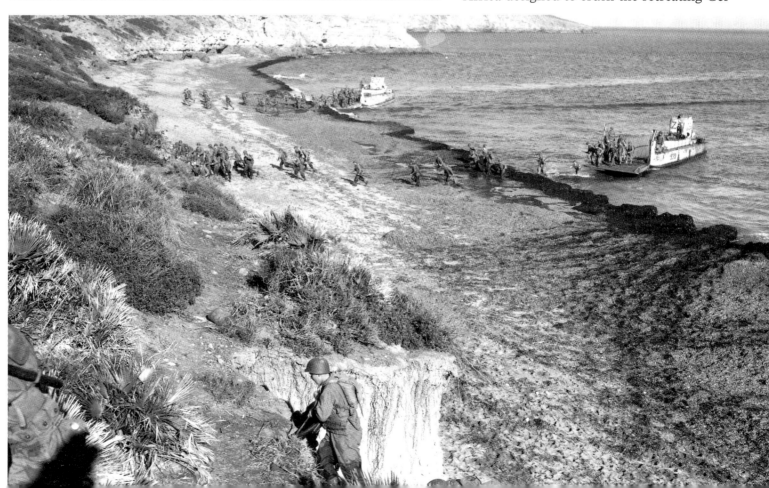

mans in a vise. The commandos and rangers were assigned roles very similar to those which they had carried out at Dieppe 10 weeks earlier, but now had far greater success. The 1st Ranger Battalion stormed a battery which was covering a landing beach at Arzew in western Algeria, while 1 and 6 Commando sailed directly into the Bay of Algiers and disabled the coastal fortifications.

Unlike the ferocious resistance experienced at Dieppe, French resistance in North Africa was patchy. The paratroopers were assigned vital tasks in taking French air bases, communication centers, and in moving the Allied forces eastward into Tunisia as rapidly as possible. Thirty-nine C-47s carried the American 509th Parachute Battalion from England across Spain to the air base at La Senia near Oran. There was an early moment of catastrophe. The commanding officer, Lieutenant Colonel Raff, who had been told by Allied intelligence that French resistance was nonexistent, decided to land on the runway. As in the case of Rommel's villa in Operation Crusader, intelligence proved disastrously wrong. The French opened up on them with everything they had, and Raff ordered his force to land on a nearby salt lake and let the ground forces have the honor of taking La Senia.

Thereafter things improved. On 8 November 3 Para descended on Bône, only 150 miles west of Tunis, and three days later the 509th (now recovered from the shock of their welcome) came down on Tébessa airfield, 120 miles due south of Bône on the Tunisia-Libya border. Here they were hailed as liberators. 1 Para received a far less welcoming reception when it dropped on Souk el Arba, only 70 miles west of Tunis on 16 November. Fortunately British officers managed to avert conflict by bluffing the 3000-strong French garrison into believing that Allied armored divisions were only a few hours distant.

By now the Germans were pouring troops into Tunis, but on 29 November 2 Para, commanded by John Frost (the battalion's lieutenant colonel since Bruneval) landed near Oudna air base, only 10 miles from the city. The air base was deserted, but from a nearby ridge the paratroopers could see not only Tunis, but also a countryside literally crawling with the motorized and armored units of the Axis. As 2 Para began its withdrawal on 30 November, the Germans and

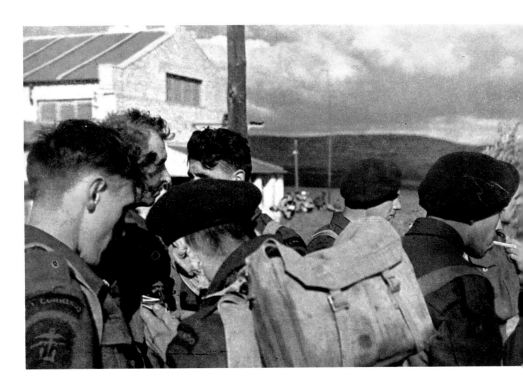

Italians closed in. The British retreat should have resembled a wounded springbok being hounded by a pride of lions, but it became more like a wounded lion being stalked by a pack of hyenas. When 2 Para reached the Allied forces on 3 December it had lost 266 men. But its line of retreat was marked by burnt-out Axis tanks and hundreds of dead Germans and Italians. For the first time, but by no means the last, 2 Para had defied the logic of war.

## THE "*ROTE TEUFEL*"
From early December 1942 it was clear that, despite the best efforts of the paratroopers, the Allies had missed their chance of taking Tunis, and that the war in Africa would drag on into 1943. Axis forces were now compressed into an area totaling some 200 miles from north to south, and the opportunities for raiding were very much reduced. British commandos and paratroopers were now placed in the line to fight as conventional (if very high-quality) infantry. The same thing happened many times over the next two years. On 7 March 1943 the first clash occurred between a battalion of Fallschirmjäger, under the legendary Witzig, and 1 Para, during which the Germans almost overran the paras, but the British counterattacked and drove the Germans back. The commandos and paras were pulled out of the line in April, the paras alone having suffered 1700 casualties. Their enemies had noted the

ABOVE: After landing at Algiers on 8 November 1942, British commandos moved east, linking up with the paratroopers who had dropped on outlying airfields.

OPPOSITE PAGE, TOP: A raiding party of the S.A.S. drives through the Western Desert for the Qattâra Depression late in the summer of 1942. Raiding forces like these destroyed 400 Axis aircraft in the weeks before El Alamein, thus conferring aerial superiority on the British Desert Air Force.

OPPOSITE PAGE, BOTTOM: A reinforcement company of the 1st Ranger Battalion lands at Arzew in western Algeria on 8 November 1942. Earlier in the day an assault company had overrun a French coastal battery.

terrifying violence and bravery with which the men in the red berets fought, and had christened them the "*Rote Teufel*" [the "Red Devils"]. It was a name which the paras bore with pride.

While the commandos and paras were in the line, American paratroopers were being used for reconnaissance and raiding – highly dangerous operations, given the relatively small area, the terrain, the density of Axis forces, and the hostility of the Tunisian Arabs. On 21 December a platoon of the 509th dropped near El Djem in southern Tunisia to blow up a railroad bridge. Although it successfully carried out the demolition, its withdrawal – a forced march across 110 miles of mountains and desert to American lines – turned into a nightmare. It was a small-scale version of 2 Para's epic retreat earlier in the month, and of the 33 men who took part in the raid only eight survived.

Even the experienced desert raiders attached to the Eighth Army advancing from the southeast now experienced difficulties. David Stirling's S.A.S. patrol scouting through the Gabès Gap in southern Tunisia was discovered and captured by the Germans. Stirling escaped but was recaptured 36 hours later. Patrols of the L.R.D.G. had better luck: one patrol – New Zealanders

commanded by Captain Nick Wilder – discovered a gap in the hills west of the Mareth Line, which would soon bear Wilder's name. On 20 March 1943 Wilder led 27,000 troops and 200 tanks (the great majority belonging to the 2nd New Zealand Division) through the gap and in a great hook around the western flank of the Mareth Line. It heralded the beginning of the end for the Axis forces in Tunisia.

## OPERATION HUSKY

By 1943 the special forces had come to play a role quite different from that of the guerrilla raiders of 1940. They were now being used in paving the way for large-scale conventional offensives requiring the deployment of commando brigades and airborne divisions. These new-style assault operations were every bit as hazardous as raids, but casualties were on a very much greater scale: indeed, the figures were so large that at times they seemed totally disproportionate to any advantage gained.

The Allies returned to the European theater with Operation Husky, the amphibious assault on Sicily. It involved commandos, rangers, the Special Raiding Force (an S.A.S. battalion retrained for amphibious operations), and the British 1st Air-

BELOW: Fallschirmjäger on patrol in the rugged hills around Tunis. On 7 March 1943 a Fallschirmjäger unit commanded by Witzig clashed bloodily with 1 Para. The result was a drawn fight, a case of "Greek meeting Greek."

ABOVE: Operation Husky, the invasion of Sicily in July 1943, was the first time that the Allies had used massed paratrooper and glider forces. This picture, taken during a training exercise a month earlier at Oujda base in Morocco, made such operations seem very easy. The reality was very different.

LEFT: The real thing this time: U.S. para-troopers en route to Sicily on the night of 9/10 July 1943. The tension before the drop is palpable; the reality was beyond their worst imaginings.

borne and American 82nd Airborne divisions, both of which had earlier flown to North Africa. The amphibious part of the operation went well. The U.S. rangers, now expanded to three battalions, landed at Géla and Licata on the south coast of Sicily a few hours before the main landings, and seized the Italian-manned coastal batteries. On the eastern coast 40 and 41 Royal Marine Commando landed on the left flank of the beaches destined for the 1st Canadian Divison and cleared a number of machine-gun nests, while 3 Commando overran coastal batteries farther south at Avola. The night's most spectacular success, however, belonged to the Special Raiding Force of the S.A.S., led by Paddy Mayne, which came ashore at Cape Murro Di Porco. The S.A.S. may have been only 250 strong, but they knocked out a formidable section of the Axis defenses, capturing 700 men, 14 heavy coastal guns, and scores of machine guns and mortars, all for the loss of just three men.

Unfortunately, however, during the airborne assault virtually everything that could go wrong did. Husky was the first Anglo-American operation to use parachutes and gliders to deliver an entire division to the battlefield. A combination of bad weather and inexperience ended in disaster. In the first stage, 144 gliders were supposed to put the British 1st Air-Landing Brigade down at Ponte Grande to the south of Syracuse. High winds interfered with navigation, the gliders were released early, and 78 came down in the Mediterranean, drowning 252 paratroops. Most of those gliders that did make it safely past the sea then crashed while trying to put down on the rocky, boulder-strewn hillsides. Of 288 glider pilots, 101 were killed or seriously injured. Only 12 gliders landed in the area intended, by which time the brigade had already sustained 500 casualties, the majority of which were fatalities.

Meanwhile, squadrons of C-47s carrying Colonel James A. Gavin's 505th Regiment to the hinterland of Géla and Licata ran into heavy antiaircraft fire. The panicking pilots, with no previous experience of action, swerved and dived all over the sky. Soon any semblance of an ordered formation had vanished; Gavin's men descended over an area of about 1000 square miles, some even landing in Syracuse in the British sector, about 100 miles due east of their intended drop zone. The 82nd Airborne's com-

mander, Major General Ridgway, quickly realized that the 505th might as well be on the surface of the moon for all the use they could be now. He immediately ordered his reserve regiment, the 504th, to fly to Sicily but, as the C-47s carrying it flew over the Allied invasion fleet, British warships, mistaking the American transports for Italian torpedo-bombers, sent up a devastating barrage. A dozen C-47s plunged into the sea and another 37, many badly damaged, abandoned the mission and limped back to North Africa. In all, 318 of the 504th were killed by Allied fire.

The second attempt to fly in the paratroops – this time by the British – ended almost as badly. When, on 13 July, 115 British transports tried to carry the 1st Parachute Brigade to the island, the Allied fleet opened up again, either shooting down or badly damaging 58 aircraft. German and Italian antiaircraft batteries joined in, completing the devastation. Of the 1900 men who had flown from North Africa, only 250 landed close to the objective: the Primasole bridge on the main road from Syracuse to Messina. But those 250 paras fought with the strength of at least double their number. Having just endured a terrifying flight and a descent under heavy fire, the remnants of 1 and 3 Para picked themselves up, dusted themselves down, and charged on to the bridge, overwhelming the German defenders and cutting their demolition charges. They then held the bridge throughout the next day, in the face of furious counterattacks by Fallschirmjäger battalions. Finally, reduced to platoon size and almost out of ammunition, they were forced to withdraw.

## THE ITALIAN CAMPAIGN
Operation Husky taught the Allies the same hard lessons about large-scale airborne operations which the Germans had learned more than two years earlier on Crete. Airborne operations were more prone to accidents than any other form of warfare. Against a determined enemy, casualties would always be very high. After Husky, Allied planners worked on the assumption that only 10 percent of any parachute or glider force would reach an objective in any condition to fight. Airborne forces were therefore used very sparingly from then on. Furthermore, the mountainous terrain of the

OPPOSITE PAGE, TOP: From the fall of 1943 until the spring of 1945 S.A.S. units were landed along the Italian coast behind German lines to support and help organize Italian partisan resistance. In some places, as in this village in Umbria, the S.A.S. could operate more or less openly. Here they carry out maintenance on a .5-inch Browning heavy machine gun.

OPPOSITE PAGE, BOTTOM: Italian partisans were enthusiastic but not very well trained. S.A.S. heavy weapons teams, like this mortar crew dropped near Florence, gave the partisans valuable fire support.

Italian Peninsula made it unsuitable for a large-scale air assault. The Allies made only two parachute drops: on 14 September 1943 the American 504th and 505th battalions descended onto the Salerno beachhead to reinforce the Allied landing which had been made five days earlier.

Southern and central Italy make a long, narrow peninsula: thus a front line stabilized very quickly. After the first few weeks, raids from heavily armed jeeps of the kind common in North Africa became impossible. Amphibious operations now became the norm, since Allied fleets and air forces dominated both the eastern and western coasts of Italy. On 9 September 1943 the 1st, 3rd, and 4th Rangers, 2 Commando and 41 Royal Marine Commando had little difficulty in seizing strongpoints along the western side of the Gulf of Salerno. But they soon became heavily involved in driving back German

ABOVE: Fallschirmjäger units in the town of Cassino in January 1944 prepare to launch a counterattack. Cassino was the key point in the Gustav Line, which German paratroopers held against successive Allied assaults from 15 November 1943 until 18 May 1944.

RIGHT: The aftermath of the 2nd New Zealand Division's assault on Cassino on 18 February 1944. The "Kiwis" failed to take Cassino, but did overrun some German positions, taking several hundred Fallschirmjäger prisoner.

counterattacks, with serious losses. In the first nine days of the fighting, the British commandos, who took the brunt of the assaults, suffered 50 percent casualties and were withdrawn to Sicily.

In mid-September the Germans slowly withdrew northward to the formidable Gustav Line, which ran across the peninsula about halfway between Naples and Rome. The Allies attacked in vain in October, November and December and, despairing of a breakthrough, finally decided to use their amphibious power to go around it. On 22 January 1944 all three ranger battalions and the 509th Parachute Battalion (acting in an amphibious role) landed at the port of Anzio, 100 miles north of the Gustav Line, and just 50 miles south of Rome. The Germans were caught by surprise. Had the Allies moved rapidly inland they could have fallen on the rear of the German defenses; instead, they were delayed by the logistical difficulties inevitable in any major amphibious operation.

By 29 January 1944, when the rangers attempted to filter out of the beachhead, German forces were already becoming more numerous. Fourth Rangers ran into strong

opposition and went to ground just beyond the perimeter; the 1st and 3rd were more successful, but by dawn were surrounded by Panzer formations. An attack by the U.S. 3rd Infantry Division, which was to have followed the rangers' infiltration, soon bogged down. By mid-morning the encircled rangers' perimeter had shrunk to 300 yards, and by nightfall the battle was over. Out of the 767 men who had attempted the infiltration, only six made it back to Allied lines. It was the end of Darby's Rangers in the Mediterranean. A few weeks later, a ceremony held in Washington officially declared all three battalions inactive.

Thus it was that the use of airborne and amphibious elite forces in the assaults on Vichy French North Africa, Sicily and Italy had produced very mixed results. Airborne operations in North Africa, faced with only light opposition, had been successful. But the catastrophe which followed the attempted landing of two airborne divisions in Sicily put paid to any idea of using airborne forces in Italy. Amphibious operations had in general been far more successful, even though commando casualties at Salerno had been very high, and at Anzio the rangers had been annihilated. Already the elites were becoming associated with glorious but ultimately futile endeavor: for example, 2 Para in Tunisia, and 1 and 3 Para at the Primasole bridge. This was the legacy that the successor to the Director Combined Operations, the Chief of Staff Supreme Allied Commander, had to contemplate in spring 1944 as he planned Operation Overlord, the invasion of northwestern Europe.

## OPERATION OVERLORD

Operation Overlord, the largest air and amphibious assault ever undertaken, began on the night of 5/6 June 1944. Paratroops and gliderborne infantry of the 6th Airborne Division began landing on the eastern flank of the Normandy beachhead just after midnight. Things still went wrong (inevitably in airborne operations they always will), but, compared with Sicily, this was a model of military precision.

Imitating the Fallschirmjäger at Eben Emael, three gliders of the British 6th Airborne Divison landed within 200 yards of bridges over the River Orne at Ranville and Bénouville, just to the north of Caen. Screaming like banshees, the glider troops,

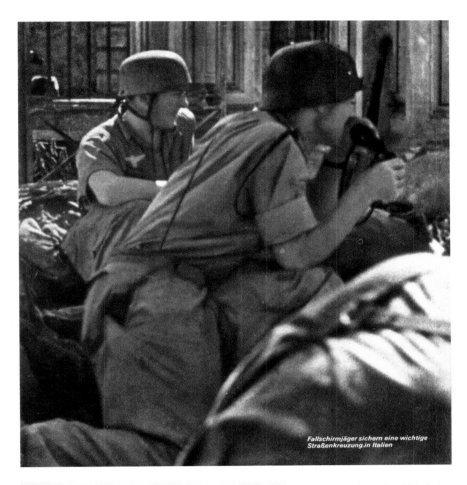

*Fallschirmjäger sichern eine wichtige Straßenkreuzung.in Italien*

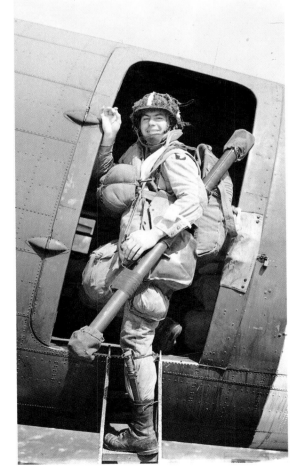

ABOVE: Perched high in mountaintop villages, as well as in towns, Fallschirmjäger observation posts could detect even the smallest movement of the Allied forces, and bring murderous concentrations of fire down upon them. Here Fallschirmjäger secure an important crossroad in Italy.

LEFT: Smiling and confident, a paratrooper of the 101st Airborne Division climbs into a C-47 in May 1944, for a pre-D-Day publicity shot. Even without the "bazooka," he is carrying close on 200 pounds, a weight which caused American paratroopers difficulties if they fell into water.

RIGHT: Gliders like this one, being towed into the air on the morning of 6 June 1944, carried British airborne forces to Normandy for D-Day.

BELOW: Major John Howard's glider at Pegasus bridge on the morning of 6 June. The British airborne forces' feat almost equaled that of Witzig's, more than four years earlier. The pilots landed their gliders in a small field only a few yards from the bridge, which allowed the airborne troops to capture their objective literally minutes after putting down.

led by their commander, Major John Howard, rushed the bridges, causing the startled German defenders either to flee or to surrender. To the northeast, 9 Para, under Lieutenant Colonel Terence Otway, had descended near a massive coastal battery at Merville, the guns of which dominated the British invasion beaches. Reinforced by glider troops, Otway overran and annihilated the Germans in a bloody frontal assault, in which he lost 70 of his 150 men.

Meanwhile, in the largest airborne operation yet carried out, 18,000 paratroopers of the 82nd and 101st divisions were dropped over the Cotentin Peninsula. It went less well than the 6th Airborne's assault: as in Sicily, heavy antiaircraft fire broke up the formations, and the Americans came down over an area of almost 100 square miles. The Germans had flooded large areas of the eastern coast of the Cotentin, and many Americans plunged into the newly formed swamps; weighed down with heavy equipment and

ABOVE: Major General Ridgway (left) with a lieutenant of the 82nd "All American" Airborne Division. Ridgway dropped with his men on 6 June, on landing making contact with only 11 of his men. As a consequence he spent the day fighting as a platoon commander.

LEFT: The Supreme Commander, General Eisenhower, visits the 101st "Screaming Eagles" on the evening of 5 June. Eisenhower was profoundly moved by the experience, for he knew that within hours many of the young men he had talked to would be dead.

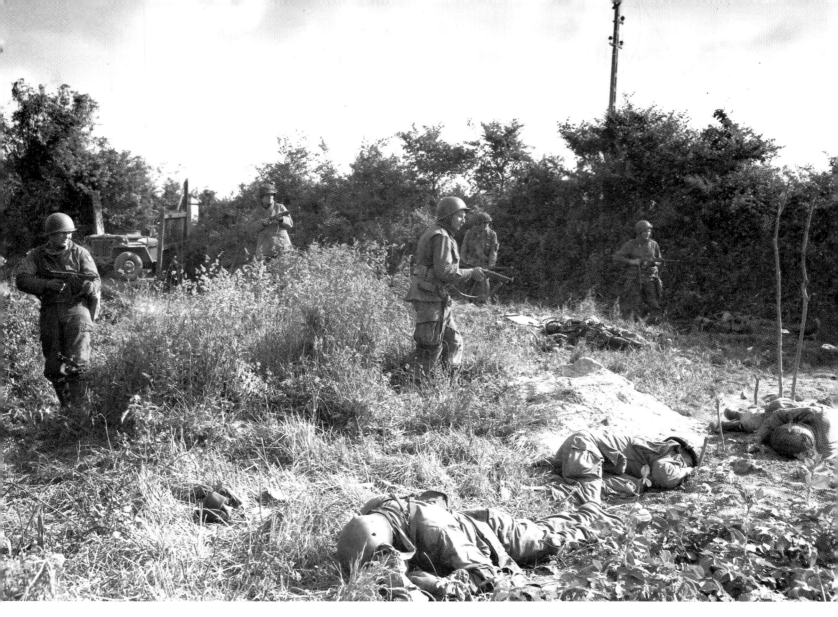

ABOVE: The 82nd and 101st divisions saw very bitter fighting in the first week after D-Day. A paratrooper patrol is photographed coming upon the aftermath of a skirmish that the Americans had lost – the dead soldiers of the 82nd Airborne.

RIGHT: American paratroopers advance cautiously through the village of St. Marcouf, just to the west of Utah Beach, on the afternoon of 6 June.

entangled in lines, hundreds drowned. The divisions soon ceased to exist as coherent formations – the 82nd's commander, Major General Ridgway, found on landing that he was in command of just 11 men – but, even so, the situation was by no means as disastrous as it seemed. So scattered were the paratroopers that the Germans were confused as to where the main landing had taken place, and could make only piecemeal counterattacks. Chaos soon spread throughout the German rear areas, which, after all, was precisely what the paratroopers had intended to achieve.

Commando and ranger formations spearheaded the amphibious assault. The American 2nd Ranger Battalion, which had been formed and kept in England while the rest of Darby's force fought in the Mediterranean, faced a particularly dangerous task: the scaling of sheer cliffs to attack the batteries on Pointe du Hoc, a position which dominated the American landing beaches. Landing at the foot of the cliffs, the rangers fired up rockets with grapnels and ropes attached

ABOVE: Men of the 2nd Ranger Battalion aboard a landing craft en route to the cliffs and gun positions of Pointe du Hoc.

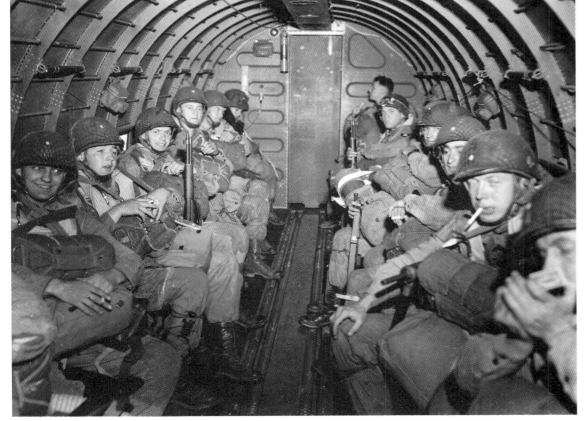

LEFT: Inside a C-47 approaching Normandy, on the night of 5/6 June. The flash of the camera has picked up a variety of emotions and responses, from forced smiles to tight-lipped resignation.

BELOW, TOP: Even an elite force can experience some funny moments in the middle of battle. Here a commando loses his footing coming off an assault craft on Sword Beach.

BELOW, BOTTOM: On 6 June these British commandos moved quickly off Gold Beach and headed west in an attempt to link up with the Canadians.

to them, and then started to climb; the operation resembled nothing more than an assault on a medieval fortress. While the Germans dropped grenades from the cliff tops, the rangers, swinging from the ropes, fired back with submachine guns. The rangers eventually took Pointe du Hoc, but at a heavy cost: of the 225 who landed, 135 were either killed or wounded.

The 1st and 4th Commando brigades led the British landings, their role being to secure the flanks of the main beaches and to link up with the paratroopers. While the Free French commandos, under Commandant Kieffer, fought their way into Ouistreham, on the extreme left flank of the British beaches, the bulk of the 1st Commando Brigade, under Lord Lovat, advanced inland toward the 6th Airborne Division, which

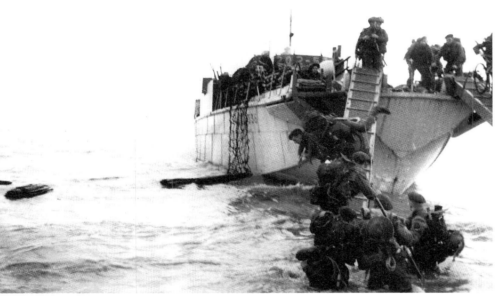

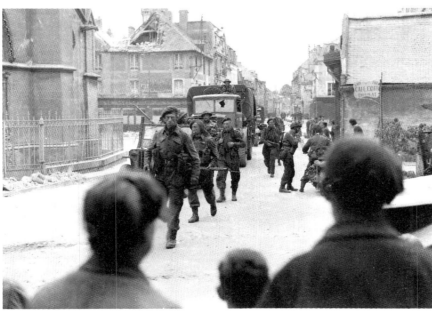

had been heavily engaged with the 21st Panzer Division since dawn. Lovat's men reached the paras just after 1300 hours; the left flank, upon which the powerful German formations were already closing, was now secure.

Unlike the situation in Sicily, or at first in Italy, here in France a powerful guerrilla force (the French Forces of the Interior, FFI) was preparing to wrest large areas of northern France from the Germans. This was the perfect environment in which to deploy the S.A.S., which had been raised to brigade strength in the spring of 1944. Unfortunately, during the planning for D-Day, a serious dispute had broken out between the new commander, Brigadier William Stirling (David Stirling's brother) and the amphibious planners. The planners wanted to drop the S.A.S. immediately inland of the landing beaches, thereby interposing the S.A.S. between the enemy's front and his reserves. Stirling argued that this would be tantamount to throwing away a highly trained elite for no good purpose, and resigned. His resignation shocked the planners back to their senses, and, although Stirling was not reinstated, the planners now accepted his concept of operations: that the S.A.S. should be dropped deep within France to establish bases and launch a co-ordinated attack with the F.F.I. on German communications.

The S.A.S. brigade – the 1st and 2nd S.A.S. regiments, with two French S.A.S. battalions and a Belgian S.A.S. squadron – was now 2500-strong. On 21 June 1944 the first complete squadron – A Squadron, 1st Regiment – was dropped into France. By August the S.A.S. was operating from 43 scattered bases from Brittany to Belgium. During its time in France it suffered 200 casualties (just a fraction of the number which the 1st Airborne Brigade had lost in Sicily on a single day) and inflicted on the enemy thousands of casualties and immense dislocation. This was proving an extremely cost-effective way for an elite to wage war.

It was a war of hit hard and run, but was not without its heroic episodes. To take but one example: on 15 August, as S.S. troops prepared to machine-gun a group of terrified French civilians in the main square of Les Ames, a squadron of S.A.S. jeeps roared into the village, their twin .5-inch machine guns scything down the Germans. Of such incidents are legends made.

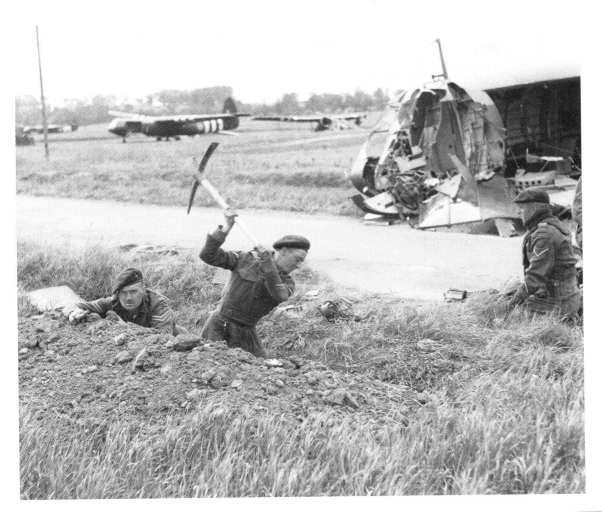

LEFT: During the morning of 6 June British airborne forces dug in on the eastern side of the Orne River. They spent several desperate hours under attack from the 21st Panzer Division, until relieved by commandos advancing south from Sword Beach.

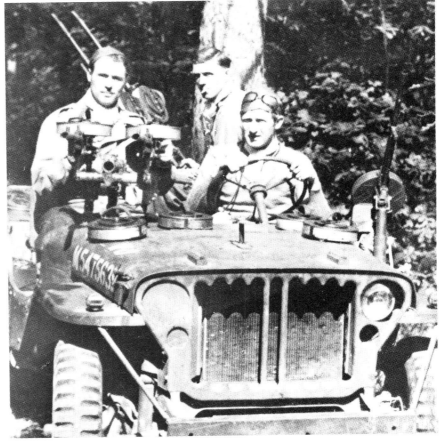

BELOW: The S.A.S. in France in July 1944. The three-man crew of these jeeps have five machine guns (two twin-mounted), which could generate an immense storm of fire.

## OPERATION MARKET GARDEN

While the S.A.S. returned to its original North African raiding style, the commandos and paratroopers were employed as line infantry. The 1st Airborne Division, being held in reserve in England, was particularly disappointed as the Germans began to retreat eastward. By mid-September 1944, the 1st Airborne had been warned of imminent action on 16 different occasions, but each had been canceled due either to bad weather or because the Allied forces had already advanced over the intended drop zones. Then, on 17 September, there at last came an operation which would go ahead. The Allied planners believed that the collapse of the German front in Normandy and the rapid retreat of the remnants of the German Army through northern France were indications that the war was almost over. The situation bore many similarities to the period after the Hindenburg Line had been broken in August 1918. It looked as if the Germans might surrender within weeks if the pressure on them could be maintained.

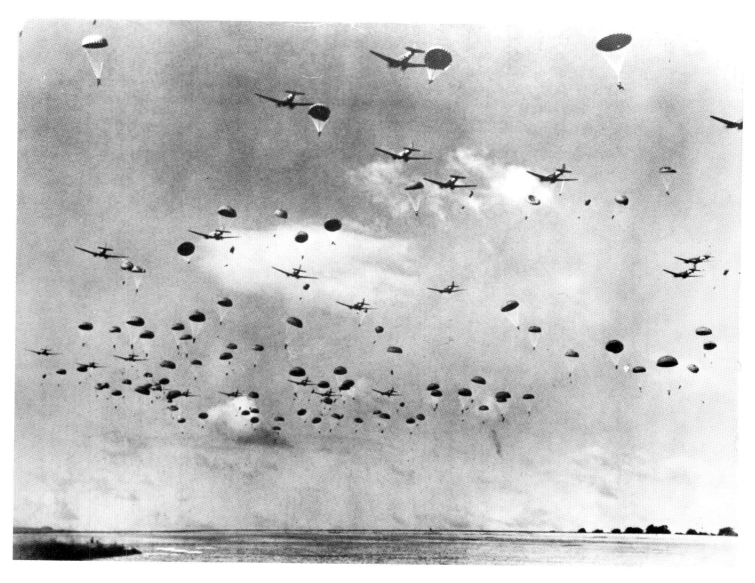

ABOVE: Operation
Market Garden, 17
September 1944. The
82nd Airborne Division
drops from C-47s near
Nijmegen.

This thinking lay behind Operation Market Garden, the landing of the U.S. 101st and 82nd and British 1st Airborne divisions along a 50-mile corridor through eastern Holland to seize bridges across the Meuse, the Waal, and finally – at Arnhem – the Rhine. The British Second Army would then advance along the corridor and, after crossing the Rhine, would swing south to capture the Ruhr, which was sure to bring about Germany's final collapse. The American landings north of Eindhoven and at Nijmegen generally went well, and the advancing British ground forces soon reached them, but at Arnhem, the British 1st Airborne Division landed near two S.S. Panzer divisions.

The Germans of September 1944 were not like their predecessors of September 1918: they were very far from collapse. Fighting raged in and around Arnhem for four days, the paras being heavily outnumbered and outgunned. A badly wounded Lieutenant Colonel John Frost and 2 Para (veterans of Bruneval and the retreat from Oudna and Sicily) held grimly on to the northern approach of the bridge, by now blocked with the smoking wreckage of German armored vehicles. Pried out of their positions by constant German attacks, on the morning of 21 September 2 Para, now down to 120 men, counterattacked. They had no chance of success, but their exploits secured their immortality. Of the 11,000 para and glider forces that had landed around Arnhem, only 2000 were able to regain British lines. It was a disaster, but it was magnificent.

## CROSSING THE RHINE

The failure of Market Garden meant that the war would certainly last another winter, thus producing more operations for the 6th Airborne Division and the commandos, now refitting after the Normandy campaign. In an

assault on Walcheren Island in the Netherlands in November 1944, commandos secured the lower Rhine and allowed the British to begin using the port of Antwerp, which solved many supply problems. Four months later the commandos and 6th Airborne Division spearheaded the crossing of the Rhine at Wesel.

These were large-scale operations against an opposition which was becoming patchy, although the Allied gliderborne forces themselves suffered such heavy casualties that they were never used again. Only the S.A.S. maintained the raiding role: squadrons were dropped into northern Italy early in 1945 to co-operate with antifascist partisans, while other squadrons infiltrated the northeastern Netherlands to locate and attack V-2 rocket launch sites. It was a role which, nearly half a century on, their grandsons would carry out against a direct descendant of the V-2, the Scud missiles of Saddam Hussein's Iraq.

ABOVE: C-47s carry the 1st British Airborne Division over ruined houses in Eindhoven toward their drop zone to the west of Arnhem, the rest area of the 10th S.S. Panzer Division.

LEFT: Arnhem, 20 September 1944. Men of 1 Para defend an ever-decreasing perimeter against intense German pressure.

RIGHT: A German photograph of the bridge at Arnhem on the afternoon of 21 September 1944. After four days of continuous fighting, 2 Para had virtually ceased to exist. Wrecked German vehicles offer mute testimony to the intensity of the fighting.

BELOW: The last large-scale paratroop operation of World War II. On 24 March 1944 on the east bank of the Rhine, men of the 6th Airborne Division advance on a village they suspect has been defended by the Germans.

LEFT: A five-gun jeep of the 1st S.A.S. Regiment in the eastern Netherlands in November 1944. These jeep patrols infiltrated behind German lines, located V-2 launch sites, and directed R.A.F. bombing strikes against them.

BELOW: Major Otto Skorzeny (left), pictured after rescuing Italy's deposed *Il Duce*, Benito Mussolini, (right) from the mountaintop hotel at Gran Sasso on 12 September 1943.

## THE GERMAN RESPONSE

Having developed the world's first modern elite special forces, the Germans, during their years of success, had largely ignored them. The Fallschirmjäger and Brandenburgers were expanded into divisions and employed in ways which were indistinguishable from any other formation. As the Reich began to crumble, the Germans responded to the imminence of defeat very much as the British had in the summer of 1940.

The last 18 months of the war saw the reemergence of German elite raiding forces, whose operations were conducted with considerable flair and brilliance. The turning point came on 12 September 1943, when an ad hoc force of Fallschirmjäger and S.S., commanded by a young S.S. major, Otto Skorzeny, crash-landed in eight gliders onto the small front lawn of the Hotel Alberto Rifugio, perched on the top of Gran Sasso, a peak in the Abruzzo Mountains accessible only by funicular railway.

Skorzeny and his men stormed into the hotel and quickly located their objective, the *Führer*'s old friend and former *Il Duce*,

ABOVE: S.S. Fallschirmjäger and Mussolini's former jailers, some of whom now give fascist salutes, watch as the pilot guns the engine and flies over the edge of the precipice. He managed to glide out of the dive when literally just a few feet from the valley floor.

RIGHT: One of the eight gliders of Skorzeny's rescue force, which came to rest perilously close to the edge of the Gran Sasso precipice.

Benito Mussolini, who was being held prisoner by the new Italian government. Skorzeny, taking Mussolini with him, departed in an equally dramatic manner. A light Fieseler Fi 156 Storch landed on the lawn, Skorzeny and Mussolini crammed themselves into the cockpit beside the pilot, and the now heavily laden Storch taxied to the edge of the cliff and plunged over, the pilot at the last minute managing to turn the precipitous descent into a gentle glide.

Skorzeny's daring exploit received wide publicity: he appeared on the front page of *Signal* and in other mass-circulation magazines. Hitler, too, was impressed, and empowered Skorzeny to raise new special service battalions from volunteers from among the Fallschirmjäger and the S.S. On 25 May 1944 one of these new units, S.S. Parachute Battalion 500, descended on the Bosnian town of Drvar, the headquarters of Marshal Tito and the Allied military mission to Yugoslavia. Casualties were heavy, but Tito was forced to abandon his headquarters and flee to the British-held Adriatic island of Vis.

Five months later another battalion, this time commanded by Skorzeny himself, descended into central Budapest and kidnapped members of Admiral Horthy's government who were attempting to negotiate a surrender to the U.S.S.R. Skorzeny himself had by now achieved near-legendary status, being widely referred to as "the most dangerous man in Europe."

## THE GREIF KOMMANDO

The most spectacular German operation was also the last. On the night of 15-16 December 1944, 400 Germans, some of whom could speak idiomatic American English, and all of whom were dressed in American uniforms, infiltrated through the American lines in the hilly, heavily forested Ardennes region of southern Belgium. Once in American rear areas, they began changing road signs, setting up roadblocks, and misdirecting traffic. This unit, known as the "Greif Kommando" [the Griffin Commando], had been formed by Skorzeny only eight weeks earlier, and was tasked with preparing the way for a mas-

ABOVE: Wrapped in a long overcoat (even in summer the wind on Gran Sasso is chill), Mussolini prepares to enter the Storch, followed by Skorzeny. The combined weight of the pilot, Mussolini, and Skorzeny, was more than the Storch should have carried for such a short takeoff.

RIGHT: The way already prepared by Skorzeny's Greif Kommando, Hitler's "last *Blitzkrieg*" surges through the Ardennes. A German armored personnel carrier drives past a ditched American half-track just to the east of the Belgium village of Stavelot.

BELOW: The Germans launched a series of furious assaults against Bastogne between 20 December 1944 and 3 January 1945, all of which were fought off by the 101st Airborne. The paratroopers christened themselves "The Battling Bastards of Bastogne" and the siege has since become legendary.

sive offensive which Hitler believed would allow Germany to avert defeat. Just before dawn 2000 German guns opened up, and 11 battlegroups, the spearheads of eight Panzer divisions, rolled through the shattered American front. The final *Blitzkrieg* of the war was under way.

Skorzeny's commandos might not have directly influenced the conduct of the offensive, but their indirect effect was immense. The Americans soon realized that Germans were among them, and the ensuing roadblocks and endless questioning for evidence of knowledge of the minutiae of American football and baseball slowed down movement when a speedy response was vital. The rumor mill ran amuck. One widespread story was that Skorzeny himself was on his way to Paris in an American jeep, his target the Supreme Allied Commander, General Eisenhower. For a man who had rescued Mussolini and had kidnapped the Hungarian government, anything seemed possible; for several days Eisenhower was virtually incarcerated in his headquarters, which made communication very difficult. Armies func-

tion like clockwork mechanisms, and Skorzeny's commandos acted like a handful of sand in the works.

However, 1944 was not 1940. Instead of surrendering in droves, the Americans fought back. The hub of communications in the Ardennes was the town of Bastogne, and in Bastogne was an American elite formation – the 101st Airborne Division. Cut off, attacked from all sides, and under constant shellfire, the 101st's acting commander, Brigadier General Anthony C. McAuliffe, responded to a German demand to surrender with a single word: "Nuts!" The 101st's defense of Bastogne slowed the German offensive down, and by 26 December plunging temperatures had cleared the sky of the low cloud and fogs of the fall. American air power was now unleashed onto the Germans, and the British, closing in from the north, infiltrated the S.A.S. into the eastern Ardennes and the Eifel hills, where its machine-gun-equipped, four-wheel-drive jeeps raised hob with German communications. The game of the elite, special-force raider was now one at which two could play.

BELOW: Two young S.S. soldiers captured by the Americans in the fighting around Bastogne. The burly American M.P.s are about half as large again as these boys, underlining the fact that by this stage Germany was fast running out of Witzigs and Skorzenys.

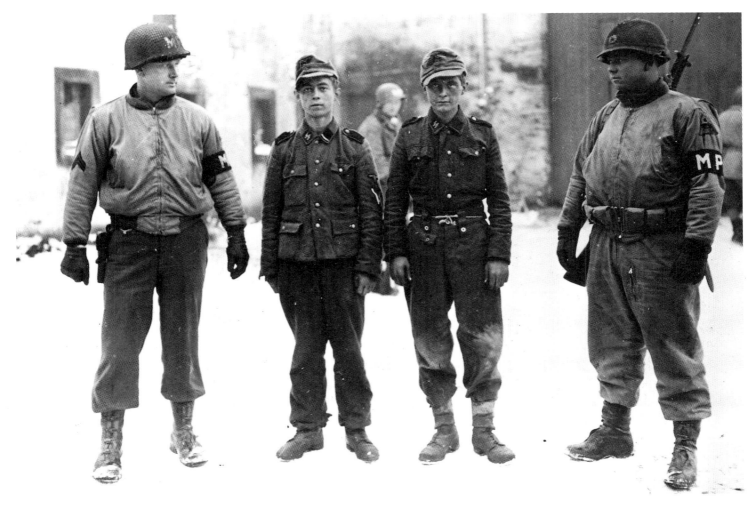

# CHAPTER V

# Elite Operations in the Pacific and Burma, 1942-1945

## TULAGI AND MAKIN

By early 1942 Japan dominated a huge area of the Far East and the Pacific, throughout which there were many weak points against which hit-and-run raids could be conducted. In the spring of 1942, in response to a suggestion by President Roosevelt, the U.S.M.C. raised two raider battalions – "elites within an elite" – the 1st commanded by a former marine pilot, Lieutenant Colonel Merret A. Edson, and the 2nd by Lieutenant Colonel Evans F. Carlson, who had served as an observer with Mao Tse-tung's Eighth Route Army guerrillas in China in the late 1930s.

The raider battalions' first operations were prepared and carried out almost simultaneously, but on targets 1600 miles apart. In early August 1942 two companies of the 2nd Raider Battalion commanded by Carlson, who chose Major James Roosevelt as his executive officer, left Pearl Harbor aboard the U.S. submarines *Argonaut* and *Nautilus* for Makin Island, an atoll 2400 miles to the southwest in the Japanese-controlled Gilbert Islands. Although important, their role would also distract the Japanese from Guadalcanal. At the same time, the 1st Raider Battalion under Edson sailed northwest from Fiji as part of a much larger convoy, tasked with spearheading the landing of the 1st U.S. Marine Division in the southeastern Solomon Islands.

At dawn on 7 August, while Carlson's raiders were still at sea, Edson's raiders stormed ashore on Tulagi, a small island in the Sealark Channel between Guadalcanal and Florida Island in the Solomon Islands, thus becoming the first American troops to land on enemy territory in World War II. Strategically important Tulagi had been the center of the British administration of the islands before the war and was now occupied by about three companies of Japanese. A few hours later the bulk of the 1st U.S. Marine Division began landing on the opposite side of the Sealark Channel on the northern coast of Guadalcanal. Their objective was an airfield which Japanese

construction workers had almost completed. Although the Tulagi garrison was small, the Japanese put up ferocious resistance of the kind which would become their hallmark over the next three years. It took the raiders, with the support of a regular marine battalion, nearly two days and cost 36 dead to kill 200 Japanese defenders.

Edson and his raiders remained on Tulagi until 7 September 1942. Meanwhile, Carlson and his raiders had become famous. *Nautilus* and *Argonaut* arrived off Makin Island on 16 August, and throughout the day Carlson studied the island through the *Nautilus*'s periscope. Just before first light the following morning, the submarines moved to within 500 yards of the shore and surfaced. Then the raiders clambered into 19 rubber boats, each equipped with an outboard motor, for the run to the beach. Unfortunately, few of the motors worked, and there was a heavy swell: the raiders, drenched to the skin, finally paddled ashore along a mile-and-a-half of beach. While Carlson was running along the beach trying to gather his men into their companies, one raider accidently discharged a round. The gunshot reverberated through the early morning air and alerted the Japanese garrison – two platoons of reservists, still asleep on the far side of the island and blissfully unaware of the Americans' arrival. They immediately sprang into action, running and cycling

OPPOSITE PAGE: The legendary Lieutenant Colonel Evans F. Carlson, second from right, with top brass including Admiral Raymond A. Spruance, first left, and Secretary of the Navy, James V. Forrestal, third left. It was a tribute to Carlson's reputation that he was included in such a group.

BELOW: 7 August 1942; Edson's raiders land on Tulagi, the first enemy-held territory to be retaken by the U.S. marines in World War II.

ABOVE: On the same
day as Edson's raiders,
7 August 1942, men of
the 1st Marine Division
made an unopposed
landing on the north
coast of Guadalcanal.
After the beachhead
had been secured, a
small landing party
made a dramatic
assault for the benefit
of the newsreel
cameras.

toward the sound of the shot. In the predawn half-light filtering through the coconut plantations, the raiders and Japanese clashed in hand-to-hand combat. Some of the Japanese climbed up into the palms, whence they sniped at the Americans. It was an unequal struggle: the Americans outnumbered the Japanese. But the Japanese, who had radioed for help, had no intention of surrendering. About mid-morning a 1500-ton corvette and a 3500-ton transport carrying about 60 Japanese troops sailed into Makin's lagoon, diverted from their routine patrol by the radio signal. The U.S. submarines, which by this time had moved to the seaward side of the island, opened up on them with their single 6-inch guns, sending a total of 23 shells smashing into the Japanese ships. Within 20 minutes both ships were blazing wrecks and sinking fast. Watching from the shore, one of Carlson's companies opened up on the hapless survivors with medium machine guns. None of the Japanese made it to the beach and safety.

At about 1300 hours the Japanese tried again. Twelve warplanes, including four Zero fighters, bombed and strafed what they

thought were the raiders' positions, but only managed to kill many of their own garrison. During the attacks two large, four-engined Mavis flying boats, carrying roughly a platoon of Japanese infantry, put down in the lagoon. The raiders at once opened up with antitank rifles, destroying both aircraft, and then opened up on those soldiers and airmen who had made it into the water. Once again, not a single Japanese reached the shore.

During the day the raiders had had the advantage, but that night, in the darkness and confusion surrounding their evacuation, nine raiders were left behind. When the Japanese arrived in force on Makin two days later, they took out their anger and humiliation on the stranded Americans, beheading them one by one. Sadly, no one in the U.S. knew of their fate. On Saturday 22 August 1942 the American press ran banner headlines proclaiming a victory: "Jimmy Roosevelt in Thick of Fight at Pacific Base" screamed the front page of the normally sober New York *Journal American*. Other papers, even those which normally supported the Republicans, voiced the same triumphalism.

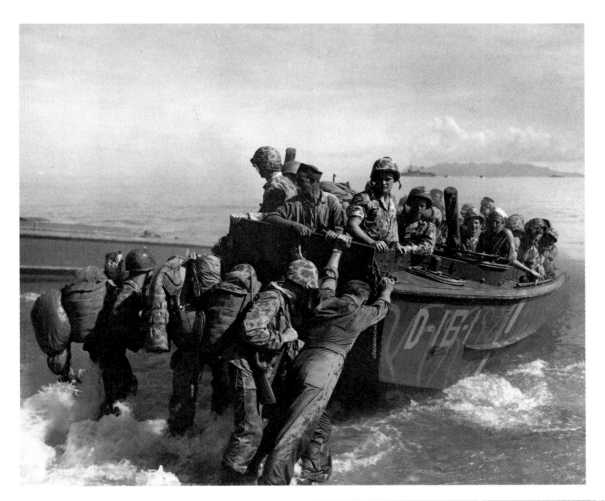

LEFT: Packed into a Higgins boat, Edson's raiders leave Tulagi for Guadalcanal on 7 September 1942.

BELOW: Between 7 September and the massive Japanese assault on 12 September, there was sporadic skirmishing around the marines' perimeter. Shortly after arriving from Tulagi, a raider takes a shot at a Japanese sniper.

Two weeks later it was the turn of Edson's battalion to seize the American public imagination. By this time the 1st Marine Division had captured the airstrip on the northern coast of Guadalcanal, named it Henderson Field (after a marine pilot killed during the Battle of Midway), and dug in around it. The Japanese had rushed in troops in response, and by early September they were closing in on the marines' perimeter. Warned by intelligence that a Japanese attack was imminent, Major General Vandegrift, the commander of the 1st Marine Division, decided to send the raiders out in force on a reconnaissance mission. They left Tulagi on 7 September aboard the destroyer transports *Manley* and *McKean*, at 0500 hours landing on the north coast of Guadalcanal, west of the marines' positions around Henderson Field. Edson's men discovered and destroyed a large Japanese depot, but there was still no sign of the Japanese. On 10 September they therefore returned to the main position, Vandegrift positioning them on a ridge about a mile south of the airfield and his own headquarters.

The warning signs came mid-morning the

next day, 11 September. As the raiders dug their foxholes and laid barbed wire, twin-engined Betty bombers attacked the ridge. The remainder of that day and most of the next were quiet – ominously quiet. At 2100 hours on 12 September a Japanese aircraft flew over and dropped flares, while a Japanese cruiser and three destroyers cruising off the beachhead simultaneously opened fire on the ridge. For about half an hour, 4- and 6-inch shells crashed down onto the raiders' positions. Suddenly the barrage lifted. For a second there was silence and then, with screams of "*banzai!*" hundreds of Japanese broke from the jungle edge and charged up the ridge. Confused hand-to-hand fighting raged throughout the night. Positions were lost, recaptured, and lost again, but at dawn Edson led his men in an all-out counterattack which drove the Japanese back into the jungle.

Violent as this onslaught had been, Edson knew that there was worse to come. Under constant air attack, his raiders worked frantically throughout 13 September. But that night the Imperial Navy again opened up on them, and this time there was no mistake. When the barrage lifted, the ghostly flicker

of the American parachute flares revealed more than 2000 Japanese coming straight for them. Through sheer numbers the Japanese were able to overwhelm some raider positions. Edson was in the front line, moving from bunker to bunker, encouraging his troops. As positions were overrun he called in artillery fire directly onto them. The Japanese attack faltered, they withdrew and regrouped, and then attacked again. Three Japanese even got as far as Vandegrift's command post, but were immediately shot down by marines as they tried to storm in; this was the high-water mark of the Japanese assault. By this stage Japanese casualties were very heavy: it became clear that they did not have enough men left to carry on. As the sun rose, more than 700 Japanese lay dead on what was now called "Bloody Ridge." The 1st Raiders had suffered 263 casualties – about 40 percent of their strength – but they had saved the marines' beachhead.

The battle for Guadalcanal settled down into an attritional slogging match, with the Americans gradually gaining the upper hand. At the beginning of November a U.S.N. construction battalion landed at Aola on the northern coast of Guadalcanal,

BELOW: Intense fire from the U.S. Marine Corps' artillery broke up the Japanese assaults on 13 and 14 September. The Japanese came so close to breaking through that, at times, Edson and his officers had to call fire down onto their own positions.

30 miles east of the beachhead, to start work on another airfield. The navy asked the marines to provide some protection, and Vandegrift sent them Carlson's raiders, who had been shipped to the New Hebrides after the raid on Makin. This choice proved very lucky. On 1 November a Japanese battle group, led by one Colonel Shoji, landed at Tetere, about halfway between Henderson and Aola. Unaware that Carlson's raiders were to his rear, Colonel Shoji advanced west, attacked and was repulsed by the marines defending Henderson, and then withdrew eastward. Carlson's raiders closed in, cut off Shoji and his men from the sea, and then followed them into the jungle-clad mountains of the island's interior. This was a very different operation from Edson's defense of Bloody Ridge. Throughout November, Carlson and his raiders stalked the Japanese, in the process wearing them down and killing most of them in innumerable small actions. Finally, on 4 December, the raiders returned to Aola, leaving the battered remnants of Shoji's task force to the mercy of the Solomon Islanders.

The battle for Guadalcanal was a turning point of the Pacific War. Despite the Japanese pouring men, ships and aircraft into the southeastern Solomons, they were still defeated. They withdrew the remnants (13,000 men) of their forces during the first week in February 1943, but left behind 24,000 dead. The Americans might have had more ships and aircraft, but, just as significantly, for the first time the Japanese faced enemy soldiers every bit as tough, brave and ruthless as themselves. Elite tore at elite, often resulting in a blood bath; however, most of the blood that stained Guadalcanal was Japanese. Nevertheless, the raiders and marines of Vandegrift's 1st Marine Division – volunteers commanded by long-serving professional officers and N.C.O.s – were exceptional in every respect. In early 1943 most American troops were young conscripts commanded by inexperienced officers. By 1945 they were very good, but their expertise was the result of "on-the-job' training, which had cost thousands of casualties and a number of avoidable disasters.

### Marine Raiders on New Georgia

One such disaster took place on the island of New Georgia, 150 miles northeast of Guadalcanal – the next objective for the American

BELOW: During November 1942 Carlson's raiders pursued a Japanese landing force through swamps and near-impenetrable jungle, into the center of Guadalcanal.

ABOVE: Advancing through the dense jungles of New Georgia's north coast in July 1943, men of the 1st Raider Regiment used dogs to give advance warning of any Japanese ambushes.

advance through the Solomons. On 3 July 1943 the newly formed 43rd Infantry Division landed at Zanana Beach, six miles east of the Japanese base at Munda on New Georgia's south coast. Over the next three days they dug in, undisturbed by the 2500-strong Japanese garrison. Then, on the night of 6 July, the Japanese finally struck. The American perimeter collapsed, and entire units fled in panic, some soldiers from one regiment – the 169th – even throwing away their equipment and trying to wade out to sea to escape. The American commander in the Solomons, Admiral "Bull" Halsey, rushed in the 23rd and 37th divisions – effectively a whole corps – to hold the beachhead against the equivalent of six battalions. Three weeks after landing, the Americans' front line was still exactly where it had been on the first day.

However, things were very different on New Georgia's north coast. On 4 July 2200 men of the newly formed 1st Raider Regiment (the 1st and 2nd battalions had been joined by a 3rd and 4th battalion) had landed at Rice Harbor, about 30 miles from Zanana Beach on the opposite side of the island. Despite atrocious conditions (the area was covered in tangled jungle, interspersed with swamps, while torrential rain turned the

ground everywhere to knee-deep mud), the raiders pushed on. They hacked and clawed their way toward the Japanese-held Enogai Inlet, some 10 miles down the coast and only 20 miles from Zanana Beach. The march was a test of human endurance: for five days the raiders' columns had to battle against the terrain and vegetation as well as handling vicious attacks from small Japanese ambush parties. Finally, on 9 July, the raiders attacked and captured Enogai.

Now deeply alarmed, the Japanese commander, General Noburu Sasaki, ordered about 1200 of his men to the north coast to deal with the raiders. The raiders' commander, Colonel "Harry the Horse" Liversedge, was also a worried man. Fighting and illness had reduced his regiment to only about 1000 effectives. He nevertheless pressed on down the coast; and on 20 July attacked Bairoko, now firmly held by the Japanese. By evening the raiders had suffered another 200 casualties and Liversedge broke off the attack and pulled back to Enogai, drawing the Japanese behind him. Four days later the American divisions at Zanana, supported by tanks, artillery and aircraft, attacked toward Munda. It took them 10 days to cover six miles – hard enough, but it would have been harder still without the diversion provided by the 1st Raider Regiment. The remnants of the raiders, now only a few hundred strong, made contact with the troops from Zanana on 9 August. In little over a month of fighting on New Georgia, battle casualties and tropical disease had reduced the regiment to a shadow of itself.

## THE COASTWATCHERS

The raiders' bloody fate was all too common for those regimental-sized elite special forces tasked with objectives more suitable for a conventional infantry division. The Solomons campaign also witnessed the employment of a different type of special force: one designed purely for reconnaissance.

Back in 1919 the Royal Australian Navy had set up a secret organization in the southwest Pacific: the Coastwatching Service, which was expanded in 1941. The Coastwatchers were not, strictly speaking, an "elite," being planters, government officials and traders. Some of the latter were no different from beachcombers: they could have stepped straight out of a Somerset Maugham

novel. These men knew the area inside out and had volunteered to stay behind in hiding if the Japanese came, to report their movements by radio. The Americans soon came to value their activities. On Guadalcanal, one British Colonial Office official, Martin Clemens, would on occasions emerge from the jungle to warn the Americans of imminent Japanese attacks, and then disappear back into the jungle just as suddenly.

Two Coastwatchers on Bougainville, a large island 200 miles to the northwest of Guadalcanal, radioed Vandegrift on 7 August with news of a major Japanese raid, giving the Americans two hours' warning to prepare a hot reception for the raiders. The most famous operation of all, however, occurred off the west coast of New Georgia on 6 August 1943, when Australian Coastwatcher Reginald Evans rescued Lieutenant John F. Kennedy and the crew of PT-109 which had been cut in half by a Japanese destroyer six nights earlier.

There were never more than 50 Coastwatchers at work at any one time, and they paid a heavy price. The Japanese tracked down and killed 36, but the information they supplied meant that their deaths were not in vain.

## THE ALAMO SCOUTS

In time the Americans began to advance beyond the Solomons and the area covered by the Coastwatchers. Lieutenant General Walter Krueger, the commander of MacArthur's Sixth Army, decided that the U.S. forces should raise a similar unit – a reconnaissance force which could pave the way for the advance back to the Philippines. In November 1943 a training camp was accordingly established on Fergusson Island, Papua New Guinea, and by the end of the year the first volunteers had graduated. Krueger, who although German by birth had made his home in San Antonio in Texas, named the unit the Alamo Scouts. Never more than 70 strong, the scouts carried out more than 80 missions in the southwest Pacific without losing a single man.

## THE CHINDITS

The Solomon Islands lay at the southeastern extremity of Japan's new empire. Four thousand miles to the northwest, the Japanese had succeeded in driving the British forces from Burma. Thus it was that in early 1943 an utterly demoralized British Eastern Army

sat in eastern India, brooding on the humiliating defeat in which its attempt at a counteroffensive in the Arakan had ended. Future successful offensive operations seemed impossible. Yet the new Viceroy of India, Field Marshal Lord Wavell, the former British commander in the Middle East, refused to be put off by these setbacks; he was absolutely determined to take the war to the Japanese.

During his time in the Middle East Wavell had encountered an eccentric, fiery British officer – Captain (now Brigadier) Orde Wingate – a fanatical fundamentalist Christian, who was also an ardent Zionist supporter. Wingate, stationed in Palestine in the 1930s, had helped Jewish settlers to set up a self-defense force. He was convinced that until the Jewish people had rebuilt the Temple of David he could not hope to see Christ's second coming: they therefore needed all the help from him that they could get. When Italy declared war in 1940 Wingate went on to lead a company of Ethiopian guerrillas – Gideon Force – behind Italian lines in Abyssinia. Wavell wondered whether a similar kind of guerilla operation could take place behind Japanese lines in Burma, and asked Wingate to report back. Wingate concluded that Burmese hostility to the British would

ABOVE: Bearded, dirty, and emaciated, a Chindit column returns from Burma in the spring of 1943. Casualties in the first Chindit operation were heavy, but were justified on the grounds that the Chindits had beaten the Japanese at their own game in the jungle, and had been responsible for raising the morale of the British Eastern Army.

make it impossible. However, he did put forward an alternative proposal: the creation of a long-range penetration force, to operate rather like a Southeast Asian version of the Long-Range Desert Group and the Special Air Service.

By New Year 1943, 3000 "Chindits" were in training. Wingate named his force after a mythical beast, the Chinthe Lion, which (appropriately enough) guarded the tombs of Burma. The men were a mixed bunch: Gurkhas, some Kachin, Karen and Shan hillmen from Burma, and the British, who mainly belonged to the King's (Liverpool) Regiment. Many had reached their mid-30s and were certainly not young by S.A.S. or commando standards. Wingate argued that any lack of youthful vigor would be more than offset by greater maturity, coolness under fire, and stamina. Furthermore, even if they were not in tiptop physical condition when they joined the Chindits, his rigorous physical-training program meant that they soon would be. In the first weeks, trainees found Wingate's enforced long route-marches on low rations so punitive that in some units almost 70 percent were hospitalized. It was a horrendous training program, but necessary preparation for the conditions

which faced them. They would soon have to conduct a campaign in one of the unfriendliest areas of the world – Burma's disease-harboring jungles, wide rivers, and steep mountains – against an even more formidable enemy: the Japanese infantryman.

Wingate divided the Chindits into two battlegroups, placing one under the command of Lieutenant Colonel Leigh Alexander. He commanded the other himself. On the night of 24 February 1943 the Chindits crossed the Chindwin River and made slow progress toward their objective, the Mandalay-Myitkyina railroad, along which all Japanese logistical supplies in north Burma had to pass. By 1 March Wingate's force was in Pinbon, about halfway between the Chindwin and the railroad. Here he split the Chindits into columns, which pressed on toward the railroad. Five days later two of the columns, one under Major Bernard Fergusson, the other under Major Michael Calvert, blew up the railroad in four places. The Chindits had achieved their objective and had stirred up a hornet's nest; however, Wingate would not now withdraw from Burma. Like Joshua before Jericho, he decreed that his columns should advance ever-deeper into enemy territory. Marching

southeast on 19 March, they crossed the mile-wide Irrawaddy, but found open savanna country on the opposite bank: they would stand little chance if spotted by Japanese aerial reconnaissance. Wingate was all for pressing on, but his immediate superior, IV Corps' commander, Lieutenant General Geoffrey Scoones, radioed an order for the Chindits to return.

The Japanese, however, now fully alert, had moved large forces between the Chindwin and the Irrawaddy to prevent the Chindits' withdrawal. Wingate responded by breaking his columns into ever-smaller units, too numerous for the Japanese to be able to intercept more than a few. Small, bloody actions, widely separated, marked the 200-mile withdrawal of Wingate's forces to the Chindwin; some groups were totally annihilated. One column, deciding it would be unable to pass through the Japanese to reach the Chindwin, turned north and escaped its enemies by marching hundreds of miles into China. Of the 3000 men who had crossed the Chindwin in mid-February, only 2200 – many ill and emaciated – re-

turned. Only a few hundred of these were ever fit enough again to see active service.

In one sense the Chindit operation was a failure; yet it did prove a turning point for the demoralized British in Southeast Asia. The Chindits had proved beyond doubt that it *was* possible for ordinary men in their early middle years to survive for weeks on end in the Burmese jungles and even beat the Japanese at their own game. After this, the morale of the British Eastern Army – soon to be redesignated the Fourteenth Army by its new commander, Lieutenant General William Slim – began to improve.

Churchill was delighted with the success of the Chindit operation and secured Wingate's promotion to major general. He took Wingate with him to the Quadrant Conference in Quebec, from 14 to 24 August 1943, and showed him off to the Americans as a British officer who had defeated the Japanese. The Americans were eager to accept Wingate's proposals for a Chindit operation in northern Burma, since it would serve to support their own plans. They already intended to send Lieutenant General

ABOVE: Chindits (British and West African) wait to board the gliders which will take them deep into Burma on the Chindits' second operation on 5 March 1944.

"Vinegar Joe" Stilwell's Chinese and American forces in Yunnan due south to clear the Japanese from the Burma Road and free it as a major supply route to the Chinese city of Chungking. Wingate wanted – and was promised – two brigades (later raised to the equivalent of six brigades), which he proposed to deposit amid the Japanese lines of communication in northern Burma.

### Colonel Philip Cochrane and the Air Commando

The commander of the United States Army Air Force, General Henry "Hap" Arnold, was an ardent supporter of Wingate's concept of war. He could see that it might help him win his long struggle with the U.S. Army and Navy for them to accept an independent air force. Wingate's force would need transport and support and Arnold authorized the creation of 1 Air Commando, consisting of 25 transport planes, 12 medium bombers, 30 fighter-bombers, 100 light aircraft, 225 gliders, and eight experimental helicopters. The Air Commando, placed under the command of Colonel Philip C. Cochrane, quickly captured the public im-

agination. Indeed, the United States conferred comic-strip immortality on Cochrane and the Air Commando members in the widely syndicated cartoon exploits of "Colonel Flip Corkin" and his men. Twenty years after the end of World War II, 1 Air Commando was reborn as the 1st Air Cavalry, this time destined to fight in the jungles of South Vietnam.

### Merrill's Marauders

To assist Wingate's operations, the conference at Quebec decided to form an American long-range penetration group based on the Chindits. Roosevelt's signature stood at the bottom of the request circulated throughout military bases in the Pacific "for volunteers from experienced jungle troops for a dangerous and hazardous operation – somewhere." By November 1943, 3000 American troops (codenamed Galahad Force) were training in central India with the Chindits. But, to Wingate's fury, on 27 January 1944 they were ordered to Ledo on the China-Burma border to spearhead Stilwell's offensive. The U.S. Army designated Galahad Force the "5307th Composite Unit (Provisional)" – a cumbersome title. American newspapermen coined something snappier: they named the unit after its commander, Brigadier General Frank Merrill, a man who had been in Burma when the Japanese invaded in 1942, and had taken part in the retreat with Stilwell. Indeed, Merrill had actually walked through much of the country in which his unit was now going to operate. Thus "Merrill's Raiders" were born – soon to be known by the more memorable name of "Merrill's Marauders."

### THE CHINDITS RETURN TO BURMA

On 5 March 1944 scores of 1 Air Commando gliders landed two Chindit brigades – the 77th under Michael Calvert (now a brigadier) and the 111th under Brigadier Joe Lentaigne – on two preselected jungle clearings, codenamed "Broadway" and "Chowringhee." While columns spread out to create confusion, the main body headed for Mawlu on the Mandalay-Myitkyina railroad, and dug in athwart the main Japanese supply line. Resupplied by air, the area around Mawlu was soon so knee-deep in parachutes that the Chindits christened their position "White City."

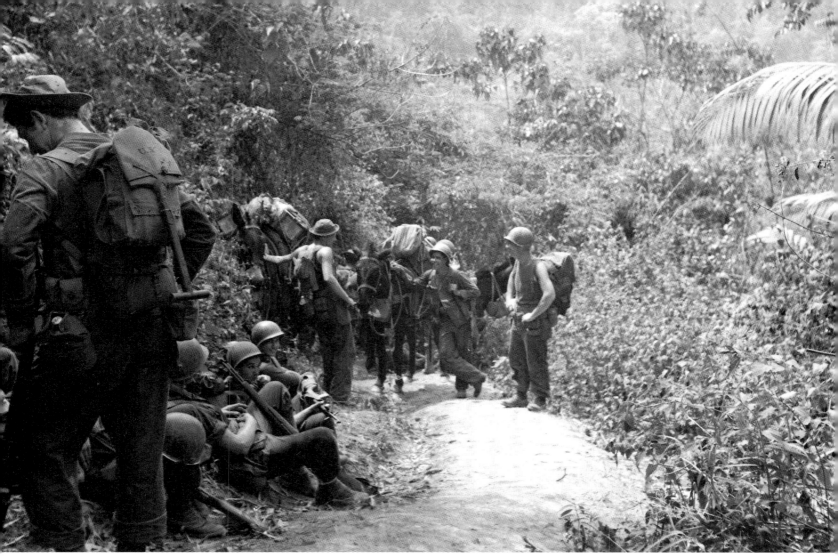

The Chindit landing coincided with a major Japanese offensive across the Chindwin farther south. When the Burma-area Japanese commander General Kawabe received reports of glider landings north of Mandalay, he at first thought they were merely raids, and withdrew only a few battalions from front-line units to deal with them. In sporadic fighting during March the Chindits brushed these Japanese forces aside, so in early April Kawabe dispatched 10 front-line battalions to eradicate this threat to his communications for good. For the next month fighting raged around White City as the Chindits steadily repulsed every Japanese thrust, and then counterattacked, virtually annihilating the enemy. It was a great victory: 8000 Japanese casualties (most of whom were dead) for 1100 Chindit casualties, many of whom were evacuated by air. Sadly, Wingate did not live to see it. On 25 March 1944 the aircraft in which he was flying crashed into a cloud-covered mountain.

## THE MARAUDERS MARCH ON MYITKYINA

During February 1944, Stilwell's forces had begun to advance south from Ledo: a

RIGHT: To slow the marauders' advance down the Hukawng Valley, the retreating Japanese left behind numerous delaying detachments in carefully sited bunkers. Marauder flamethrower teams like this one became skilled at dealing with these rearguards.

BELOW: In the Pacific theater equipment was scaled down to the bare essentials required for surviving and fighting. The paratrooper's weaponry was light but formidable: a Thompson submachine gun, an automatic pistol, three hand grenades, a machete, and a vicious-looking knife-brass-knuckles combination.

detached brigade of Chindits under Brigadier Fergusson on the right flank; a Chinese division in the center, and Merrill's Marauders on the left. The three elements soon diverged. Fergusson's Chindits advanced due south toward White City, while the Chinese and the marauders moved southeast along the Hukawng Valley toward Myitkyina, the lightly equipped marauders pulling ahead and attempting to encircle the Japanese units. This phase of the advance lasted two months.

The marauders unfortunately lost Merrill, who was evacuated after a heart attack on 31 March. He was replaced by his executive officer, Lieutenant Colonel Hunter. By the end of April the marauders had suffered 1500 casualties, and many of the survivors had low fevers. After 60 days of more or less continuous campaigning they longed to be relieved; but now Stilwell ordered them to march another 90 miles across the rugged Kumon Range to take Myitkyina. In the event, the advance over the Kumon Range took 19 days and became an epic. Some marauders, overrunning a small Japanese

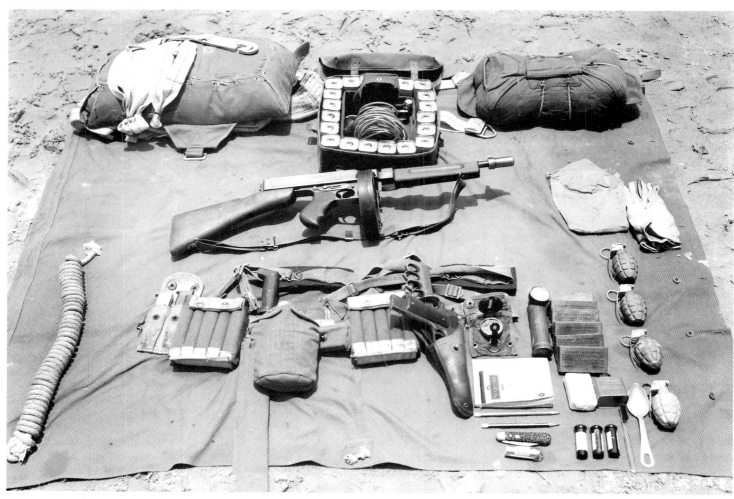

garrison, contracted miteborne typhus from the enemy corpses; 149 were evacuated, of whom many died. On the morning of 17 May the surviving marauders reached the airfield outside Myitkyina; discovering it to be only lightly held, they quickly captured it.

The operation now went badly wrong. Reinforcements and supplies were not landed quickly enough to prevent the Japanese from strengthening their garrison in the town. The marauders were forced to launch frontal attacks without the support of tanks and artillery, and suffered extremely heavy casualties. On 25 May, when Stilwell flew into Myitkyina, Hunter handed him a note in which he claimed the marauders had been abused and neglected. Since they were now down to 200 effectives, the letter recommended that they be disbanded. Indeed, the marauders hated Stilwell. One of them later said of this visit: "I had him [Stilwell] in my rifle sights, I could have squeezed one off and no one would have known it wasn't a Jap that got the sonofabitch."

By this time the Chindits were in no better condition. Lentaigne had taken over as commander after Wingate's sudden death, but he was still very much Stilwell's subordinate. Indeed, only Wingate, always in direct contact with Churchill, could have stopped Stilwell from exploiting the Chindits. On 6 May 1944, in the face of renewed Japanese attacks against White City, Lentaigne decided to abandon the base, moving north to a position closer to Myitkyina, which he codenamed Blackpool. The 111th Brigade, now under Colonel John Masters, had scarcely begun to dig into their new position when they were struck by the Japanese 52nd Division; they held out for five days but, on 25 May, when they were almost out of food and ammunition, Masters ordered them to withdraw to the mountains in the west. Calvert's brigade took 1000 casualties in an attack on Mogaung, the last large railroad town before Myitkyina.

Stilwell kept the Chindits in action until August, even though medical officers protested that the entire force was now sick. In the end Stilwell relented, but only under direct pressure from the Supreme Allied Commander in the Southeast Asia Command, Lord Louis Mountbatten; by 27 August the evacuation of the Chindits was complete. On 3 August Myitkyina had fallen and the Japanese had suffered 3000 casual-

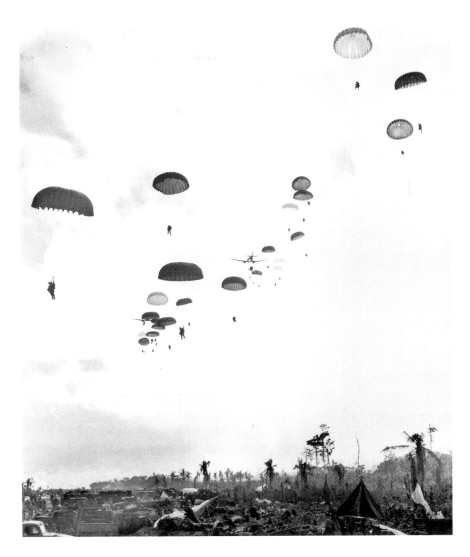

ties. But Allied losses had also been very severe: the Chindits, once 23,000-strong, had suffered 5000 battle casualties; while the marauders, 3000-strong, had suffered nearly 1300. By this stage virtually all the British and Americans were ill, many seriously. The six months of campaigning in northern Burma had destroyed both the Chindits and the marauders.

## RETURN TO THE PHILIPPINES
By the fall of 1944, Japan was on the defensive on all fronts. While the remnants of the Burma Army prepared for what they knew would be a major British offensive in the spring, Japan's forces in the Philippines had suffered a catastrophe. On 20 October 1944 MacArthur's forces had landed on Leyte Island in the central Philippines. Japan's Combined Fleet, attempting a massive counterattack, had lost four aircraft carriers, three battleships, 10 cruisers and 11 destroyers: the Combined Fleet had effectively ceased to exist.

ABOVE: Although the Americans launched no opposed parachute landings in the Pacific campaign until they reached the Philippines, paratroopers were often dropped as a way of rapidly reinforcing areas already captured. This descent on Numfoor Island, off the north coast of western New Guinea, on 4 July 1943 looked spectacular, but many men sprained or broke their ankles when landing on Numfoor's runway of iron-hard crushed coral, and had to be evacuated as casualties.

### Operation Wa

Yet despite this naval disaster, Japan's supreme commander in Southeast Asia, Field Marshal Terauchi, and his commander in the Philippines, General Yamashita, had not given up hope of driving the Americans into the sea. They believed that the key to the Americans' success had been their control of the air; if this could be wrested from them, Japan's redoubtable infantry would have a fighting chance. The problem was how to do it. Although the Japanese had managed to transfer 1000 new aircraft from other parts of their empire to the Philippines, the Americans had moved five times that number to airfields on Leyte and yet more were arriving every day. Japan would clearly never be able to wear down the American air forces in attritional air-to-air combat. The Japanese therefore arrived at the solution which the British had themselves reached in 1941 in the Middle East when faced with a similar situation: to form raiding forces to strike directly at the enemy's airfields.

Operation *Wa* was a complex series of airborne, amphibious and land assaults designed to destroy the three main American air bases east and northeast of Burauen, a town near the center of Leyte's east coast. On the night of 26 November 1944 four Japanese transports tried to crash-land on two of the airfields: one was shot down, and the others landed miles from their objectives. On 5 December the Japanese tried again: 26 transport aircraft attempted to drop 350 paratroops onto Buri airfield a few miles north of Burauen. Most missed their objective and landed instead on nearby San Pablo airfield – in many ways actually a better target. San Pablo was held by American rear-echelon troops who panicked badly when the Japanese paratroopers descended among them. Throughout the night the Japanese created havoc, setting fire to aircraft and ammunition dumps. At dawn, realizing that they were on the wrong airfield, they set off on foot for their original objective and ran into American artillery

BELOW: The situation on Numfoor's runway on 4 July 1943. It would have been more sensible, but much less spectacular, if the C-47 transports had simply landed on the runway.

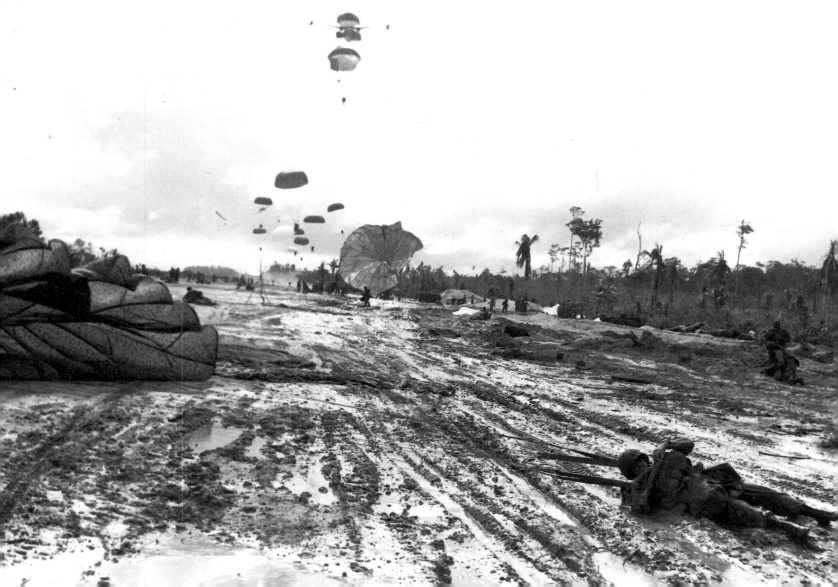

barrages and tanks. Three days later the remnants of the paratroopers, in an epic not unlike 2 Para's withdrawal in Tunisia, regained Japanese lines in the west of the island.

### The Pangatian Rescue

Organized Japanese resistance on Leyte collapsed on 25 December 1944. Two weeks later four American divisions landed on the shores of the Lingayen Gulf on the west coast of Luzon and advanced south rapidly toward Manila. Alamo Scouts operating beyond the American spearheads were able to make contact with Filipino guerrillas and by mid-January they could report to the Sixth Army commander, General Walter Krueger, that the Japanese were holding several hundred American prisoners in a camp at Pangatian, a few miles from the town of Cabanatuan, on the route of the American advance.

The fear was that the Japanese might massacre their prisoners as Krueger's Sixth Army came closer. Over the next few days Sixth Army staff put together a rescue mission. It would involve the Alamo Scouts and Filipino guerrillas, but the main force would be the 6th Ranger Infantry Battalion, formed at Krueger's insistence from Sixth Army volunteers only four months earlier. This would be their first taste of active service.

By the last week in January the Alamo Scouts had the Pangatian camp under surveillance, while a company of rangers slipped through Japanese lines and marched 30 miles to link up with the scouts. At dusk on 30 January the rangers struck. They stormed into the camp killing virtually all the 220 Japanese guards for the loss of only 12 of their own number, and freed 513 amazed American prisoners. Filipino guerrillas covered the withdrawal. Japanese units, believing that they could overtake many of the sick and emaciated prisoners, followed the Americans at great speed but with little caution. The guerrillas ambushed and killed almost a whole Japanese battalion before they too withdrew.

### The Return to Corregidor

On 3 February 1945 American forces reached Manila and began a month-long battle to recapture the city. The best harbor in the Philippines – indeed, one of the best harbors in the world – was Manila Bay. However, it could not be used while the Japanese held the fortress island of Corregidor, which dominated the bay's entrance. By February 1945 MacArthur no longer had the time for lengthy siege operations. The recapture of Manila was vital, since troops would have to pass through here to reach Luzon, which he intended to function as the major training and staging area for the invasion of Japan. His planners decided that without a massive preliminary bombardment an amphibious landing would probably be wiped out. They therefore decided to take the island in the same way that the German Witzig had taken Eben Emael nearly five years earlier: by landing airborne forces directly on top of it.

Up to this point the war in the Pacific theater had been a sequence of amphibious operations. The Americans did have airborne forces available (for example, the 503rd Parachute Infantry Regiment which had arrived in Australia in the summer of 1942), and these had already been dropped by parachute. But they had not, as yet, carried out a descent on an active enemy. While airborne forces had fought the

BELOW: The faces of these paratroopers of the 503rd Regiment indicate that this time it is the real thing: the descent on 16 February 1945 onto Topside on the island of Corregidor.

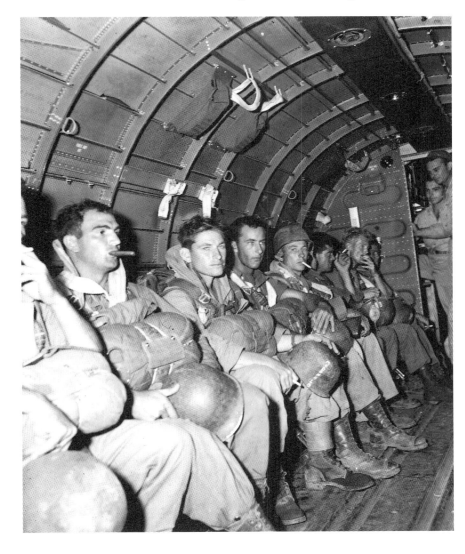

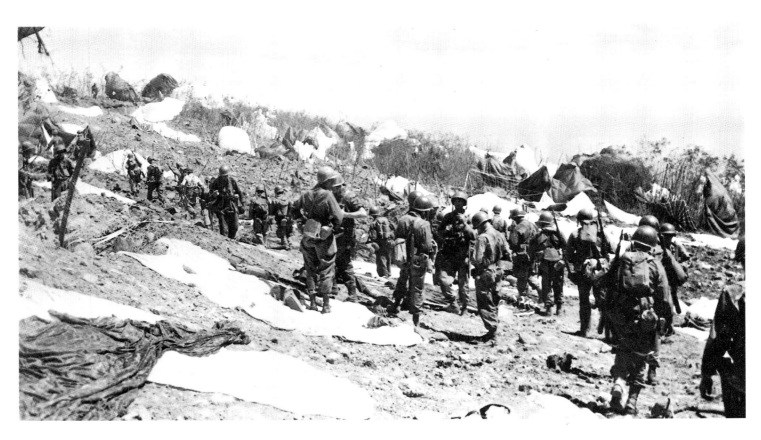

ABOVE: The parachutes of the 503rd litter the ground around Topside on Corregidor. A parachute descent was the one contingency for which the Japanese had not prepared, and this was why it was an outstanding success.

Japanese, it had always been as line infantry. However, the paratroopers were now going to end their war in the Pacific with one of the most dangerous and spectacular drops of all time. At 1000 hours on 16 February 1945 the paratroops of Colonel George M. Jones's 503rd Regiment began their descent from C-47s above the island. MacArthur's intelligence chief had estimated the strength of the Japanese garrison at about 800; in fact, it was closer to 4500.

The commander of Corregidor's garrison, Captain Akira Itagaka, had dug his men in to cover the more obvious landing beaches. When the C-47s flew overhead the Japanese mistook them for bombers and took cover; even when the first parachutes opened, only a handful of the Japanese could employ their weapons. The 503rds' drop zone was the highest point of the island, a flat-topped hill known as Topside, which rose precipitously from a narrow coastal ledge; the Japanese had left it virtually undefended. Of the 2320 Americans who jumped over Corregidor, only 270 were killed or wounded in the descent; about two dozen paratroopers missed Topside and floated down the cliff face to land on top of Itagaka's command post, where, after a brief fire fight, they killed the surprised Japanese commander.

The Japanese fought back with their customary bravery – but without central control their responses were unco-ordinated. Later in the day the 304th Infantry Regiment also came ashore from landing craft. It took the paratroopers and the 304th until the end of February to clear the island. The Japanese, however, refused to surrender, preferring to blow themselves to shreds in Corregidor's labyrinthine tunnel complexes. The Americans suffered just on 1000 casualties, but counted 4417 Japanese bodies, taking only 19 wounded Japanese prisoners.

## AFTERMATH AND CONSOLIDATION

By the fall of 1945 the victorious Allied powers could display a wide variety of elite special forces; the extraordinary demands of the war had shaped their formation. Even though their deeds commanded widespread admiration, the traditional military hierarchies tended to view them with a mixture of resentment, suspicion and mistrust.

The special forces in combination numbered over half a million men – scarcely an "elite" in the technical sense. Of these special forces, probably the least successful were the U.S.S.R.'s Naval Infantry and the V.D.V. The Naval Infantry had carried out about 100 or so small landings, most of which were unopposed, and had usually been

employed as conventional infantry. The performance of the V.D.V. in an airborne role had also proved disappointing and, after a series of catastrophes, this had been disbanded in the summer of 1942. Reformed in 1943, the V.D.V. served mainly as conventional infantry, carrying out only one airborne operation, which also ended in disaster. After this the Soviet defense ministry ordered the disbandment of the Naval Infantry, while the V.D.V., now starved of funds and aircraft, was placed into a reserve category.

The elite forces of the United States had been more successful, but the cuts implemented by the War and Navy departments were no less severe. Units like Edson's and Carlson's raiders, Darby's Rangers, and Merrill's Marauders had effectively already ceased to exist. But the army now also broke up the remaining ranger battalions, and also smaller units like the Alamo Scouts. Only the airborne forces survived: initially the War Department had intended to disband the 82nd and retain the 101st, but a storm of protest developed in the press and in Congress. The 82nd could boast longer service and more battle honors than the 101st, so the decision was reversed and the "All Americans" were kept on.

In Britain the situation was rather different. The special elites, although resented by the conventional military hierarchy, had more political influence and power. David Stirling, now back from Germany, lobbied hard for the retention of the S.A.S., but on 8 October 1945 it was disbanded. Bob Laycock was equally determined to keep the army commandos, but on 25 October 1945 he too was forced to announce to his brigade that he had lost his battle. It was not, however, the end for the commandos. Whitehall decided to retain the Royal Marine Commandos, and to transfer 3 Commando Brigade, then serving in the Far East, to the Royal Marines. At Mountbatten's urging, the green beret was now officially adopted as the headdress for the Royal Marine Commandos. The situation for the airborne forces was by no means hopeless either. The 1st Airborne Division was disbanded, as were the dangerous and by-now obsolete glider forces, but the 6th Airborne Division was retained.

Elite special forces were at the center of some very heated debates in 1945; indeed, their role still provokes intense controversy among military historians. The contending factions do, however, agree on many points: all acknowledge that elite reconnaissance units like the British Long-Range Desert Group, the Australian Coastwatching Service, and the American Alamo Scouts, repaid the investment in them many times over. Disagreements emerge over the larger forces. Military historians concur that many of their actions – even the failures – were magnificent and inspiring. But the critics assert that war is not about grand gestures, but about defeating the enemy. They argue that the creation of elites siphoned off many of the most highly motivated and most intelligent in the services – men who would have been important as senior N.C.O.s and junior officers – and concentrated them in units in which the prospects for survival were low. Operations Husky and Market Garden, the exploits of Liversedge's raiders, and the saga of Wingate's Chindits and Merrill's Marauders take on a rather different complexion if viewed as the unnecessary waste of thousands of intelligent junior leaders. The use of elites in operations of this sort was simply not cost-effective.

However, elites do have their defenders, who recognize that while airborne and amphibious operations could often prove expensive, the possible gains involved justified the risk. British losses in the entire Arnhem operation, for example, were only one-sixth of British losses for the first day of the Somme in 1916. Often elites more than justified their existence in terms of cost-effectiveness. For example, the S.A.S. raids in North Africa conferred aerial superiority on the Eighth Army sooner than the R.A.F. could have achieved by acting alone; the commandos at St. Nazaire put paid to any plans that the Germans might have had to send *Tirpitz* on a North Atlantic cruise; 2 Para at Bruneval brought back vital technical information which would have taken months to duplicate by other means. Furthermore, the rangers at Cabanatuan almost certainly saved hundreds of American lives; while the 503rd Parachute Regiment completely surprised the Japanese on Corregidor, shattering an otherwise formidable defense which would have decimated any more conventional amphibious assault. These, say defenders of elite special forces, are only a few of the many hundreds of similar operations which amply justify the creation of elites.

# CHAPTER VI

# Elite Operations in Conventional and Guerrilla Warfare, 1946-75

## FROM DESTRUCTION TO RESURRECTION

For a brief period in the mid-1940s it looked as if elite specialist forces would soon be a thing of the past. They had emerged as the product of a particular set of historical circumstances: nations at war had developed elite units in response to the failure or perceived failure of their conventional armed forces. But the end of the war brought change. The Europe of 1949 witnessed the emergence of two powerful military alliances which faced each other across the "Iron Curtain." Both the embryonic North Atlantic Treaty Organization forces and the opposing Warsaw Pact forces stressed the need to maintain large, conventional armored and motorized divisions. The British and the Americans thought largely in defensive terms; they had no need for the sort of special force which could spearhead an advance. The Soviet Union's offensive strategy relied on massed artillery and armor; special forces would simply get in their way. The Cold War, in which the postwar alliances remained frozen in hostility, endured through intermittent meltings and refreezings until 1991, when the Warsaw Pact and the Soviet Union finally collapsed.

## THE KOREAN WAR

The impact of World War II on another continent – Asia – had very different consequences for the development of special forces. Although Japan was ultimately defeated, for a brief period she was the con-

queror of large areas of east and Southeast Asia. This Eastern humiliation of the West boosted indigenous nationalist and communist movements in their determination to prevent the Europeans, Americans and their protégés from re-establishing their previous dominance. As a result, Asia saw continuous warfare from 1945 until 1975: warfare which ranged from conventional assaults with massed armor, such as in Korea in 1950 or South Vietnam in 1975, to low-intensity guerrilla war, such as that conducted in Malaya from 1948 to 1960 or parts of South Vietnam from 1960 to 1965. It was during 30 years of war in Asia that the armies of the West rediscovered the need for elite special forces within their ranks.

### U.S. Marines at Inchon

In the summer of 1950, American and South Korean forces in South Korea, hard-pressed by the North Korean communist forces, were clinging on to the perimeter around the port of Pusan. Despite intense opposition from the Joint Chiefs of Staff, General Douglas MacArthur, the American commander, chose not to launch a counteroffensive from Pusan. Instead he planned to land the 1st Marine Division 100 miles north of Pusan, at the port of Inchon on the west coast of Korea. Washington, however, felt that the operation was altogether unsound: the approach to Inchon was dangerous – hidden reefs, and a high-to-low tide variation of almost 32 feet made navigation difficult. Once the marines entered the harbor, they

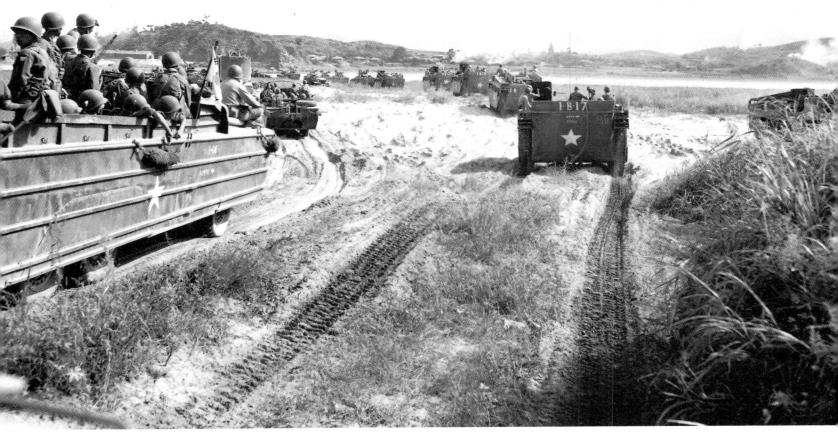

would find no beaches to land on, merely a high harbor wall and an exposed mole. The landing seemed to spell disaster. Even if the marines did get ashore, there was every likelihood that, like the Allied forces at Anzio, they would rapidly be bottled up.

Despite these misgivings, on 15 September 1950 landing craft brought the 5th Regiment, 1st Marine Division, up against the Inchon harbor wall. The North Koreans, believing (like the U.S. Joint Chiefs of Staff) that the approach was untenable, had not bothered with heavy defenses. Thus, when hordes of U.S. marines surged over the wall, which they scaled with grappling irons, lines and ladders, some 2000 startled defenders were taken completely by surprise. The unstoppable marines pushed inland, and on 17 September overran Kimpo airfield on the road to Seoul. A week later they reached Seoul itself, cutting across the retreat of many communist units fleeing north from the Pusan perimeter.

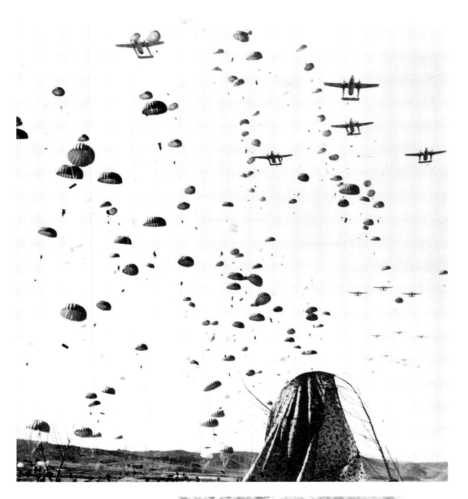

### Paratroopers at Sukchon

MacArthur, determined to annihilate the North Koreans, kept up the pressure. On 20 October the 187th Regimental Combat Team took off from Kimpo in 40 C-47s and 76 of the new C-119 ("Flying Boxcars") and dropped on Sukchon, an important road and rail junction about 40 miles north of Pyongyang, the capital of North Korea. As at Inchon, surprise was total. The 187th suffered only 44 injuries in the descent, and had effectively managed to block the communists' retreat. Thirty thousand North Korean troops were caught between the paratroopers to the north, and the U.S. 1st Cavalry Division and 27th British Commonwealth Brigade advancing from the south. In the battle which followed, the paratroopers took more than 4000 communist troops prisoner.

### Commandos at Chosin

MacArthur's forces seemed on the very edge of victory. But on the night of 25-26 November some 300,000 communist Chinese troops launched an offensive south from the Yalu River, the border between North Korea and Manchuria. On the eastern side of the peninsula, eight Chinese divisions surged south-

ABOVE: On 20 October 1950 the 187th Regimental Combat Team descended on Sukchon in North Korea, a move which helped trap many of the retreating North Korean forces.

RIGHT: The Royal Marine (Independent) Commando plants demolition charges along North Korea's main east-coast railroad line in early November 1950.

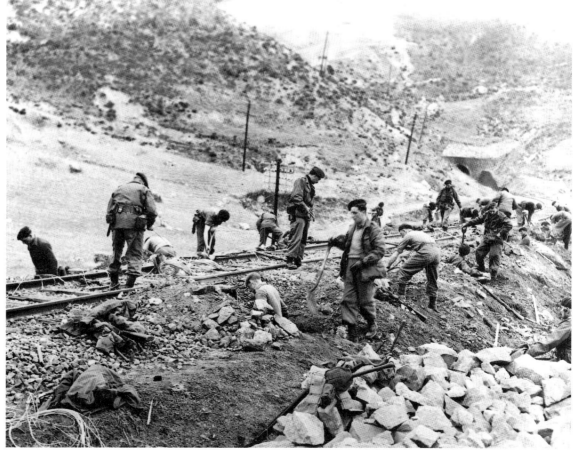

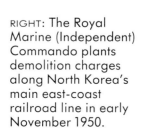

east and surrounded the 1st U.S. Marine Division on the Chosin Plateau. By this time British and other forces committed to the United Nations Police Action in Korea had begun to arrive in the peninsula, including 41 (Independent) Commando, which had been conducting small-scale harassing raids off the east coast of North Korea. The 1st Marine Division needed reinforcements, and 41 (Independent) Commando, comprising the best troops close at hand, were ordered to land at Hungnam, which was still in American hands. Between 29 November and 2 December the British commandos infiltrated and fought their way through overwhelmingly superior Chinese forces to reach the beleaguered Americans at Hagaru on the Chosin reservoir; the advance had cost 65 dead, missing and wounded.

Within 72 hours of their arrival MacArthur ordered a complete withdrawal south and evacuation by sea via Hungnam. The commandos, along with the 5th U.S. Marines, now formed the rearguard for what the 1st Marine commander Major General Oliver Smith announced was an "attack in another direction." Indeed, the American

marines and British Royal Marine commandos had to fight their way through dense Chinese concentrations until, on 9 December 1950, they reached the Hungnam perimeter.

## THE REBIRTH OF THE S.A.S.

The conflict in Korea soon settled into a deadlock not unlike that of the Western Front during World War I, in which trench lines manned by around one million men on both sides snaked across the peninsula. Meanwhile, in Southeast Asia, both Britain and France had deployed substantial forces to Malaya and Indochina respectively, to combat communist-inspired insurgencies.

By 1950 the British in Malaya seemed locked in a stalemate. They had contained, but could not defeat, the largely Chinese Malayan guerrillas. The Commander in Chief of Far East Land Forces, General Sir John Harding, therefore sent for one of Britain's foremost unconventional soldiers, Michael Calvert, now a brigadier on the staff in Hong Kong. By this time many Chinese squatters had been resettled in protected villages, but the guerrillas, perhaps several

ABOVE: On 6 December 1950 the U.S. 1st Marine Division began its "attack in another direction." American carrier-based fighter-bombers dropped napalm on the suspected Chinese communist positions which flanked the marine columns as they withdrew from the Chosin plateau toward Hungnam on the coast.

thousand strong, had withdrawn to the jungle-clad mountains of central and northern Malaya where they occupied aboriginal tribal villages. From these secure areas they re-emerged whenever the security forces relaxed their vigilance. Harding gave Calvert a roving brief: he was to travel Malaya, talk to anyone he liked, and then report back on how to solve the problem.

Four years earlier Calvert had joined Stirling in a vigorous campaign to retain the S.A.S., but had succeeded in securing its survival only as a territorial unit, 21 S.A.S. Thus Harding was not altogether surprised at Calvert's proposed solution: a new, S.A.S.-style force, the Malayan Scouts. The scouts would consist of specially trained men capable of operating in the jungle in small parties for weeks at a time. Their task would not only be to track down the guerrillas, but also to isolate them utterly by winning the "hearts and minds" of the locals. Calvert called for volunteers from S.A.S. territorials (home-guard members) and reservists in Britain, accepted some volunteers from forces already in Malaya, and made a trip to Rhodesia, whence he returned with enough volunteers from the wartime L.R.D.G. and S.A.S. to form an entire squadron. In May 1952, with Churchill once again prime minister of Britain, the pretense was dropped and the Malayan Scouts were officially designated 22 S.A.S.

Calvert established a base camp at Johore Bahru, where the volunteers were put through highly realistic training: for example, men armed with air rifles stalked each other through the jungle, their only protection being fencing masks to prevent them from being blinded. Calvert wanted to develop not just jungle-fighting techniques, but also qualities of endurance and self-reliance. The men needed above-average levels of both intelligence and judgment, since they would be far more than mere commandos: they would have to acquire the combined skills of diplomat, medical practitioner and social anthropologist. The S.A.S.'s method was to move deep into the jungle, where they lived for long periods – three to four months was not uncommon. Here they began the work of befriending aboriginal tribes and separating them psychologically from the guerrillas. Furthermore, the locals were an excellent source of information: they knew the highlands and

could monitor enemy movements. Acting on this information, the S.A.S. could thus track guerrilla bands, ambush them, and direct R.A.F. air strikes onto their camps.

So successful was the S.A.S. that an "unconventional warfare" fraternity developed within the armies of the British Commonwealth during the early 1950s. By 1955 the Rhodesians of C Squadron S.A.S. were due for rotation; an obvious source for the replacement squadron was New Zealand, whose army had supplied the wartime L.R.D.G. and the S.A.S. with many men. The New Zealand S.A.S. was duly formed and trained during 1955. A squadron served in Malaya from December 1955 until December 1957, during which time the "Kiwis" spent all but six months on jungle patrols, tracking down and destroying two notoriously resilient guerrilla bands. Fiji, which had previously supplied the Americans in the Solomons with a number of Alamo-type patrol groups, now gave 22 S.A.S. additional manpower. Australia was also approached. In the mid-1950s the new Governor-General of Australia, Lieutenant General Sir William Slim, and his son, Captain John Slim (then serving with 22 S.A.S.), sounded out Australian politicians and officers at various levels and found them remarkably resistant to the idea. Australia was happy to send a regular battalion to Malaya in 1955, but – like the Americans and the Soviets – the ultra-egalitarian Australians harbored a deep-seated suspicion of military elites. However, Australian attitudes changed as reports of the New Zealand successes began to circulate. The Australian government came to realize that communist-inspired guerrilla wars were going to affect the countries to their "near north" for some time to come; accordingly, in June 1957, Australia, too, formed a S.A.S.

By the early 1960s the S.A.S. had come to resemble a modern version of the Knights Templar – a multinational brotherhood of thinking warriors who had discovered many of the secrets of unconventional operations. Bradbury Lines in Hereford, England, the headquarters of 22 S.A.S., became the spiritual and intellectual mainspring of the Commonwealth S.A.S. It also attracted new pilgrims, men such as the American Charles Beckwith, and the West German Ulrich Wegener, who would in time establish their own versions of the S.A.S.

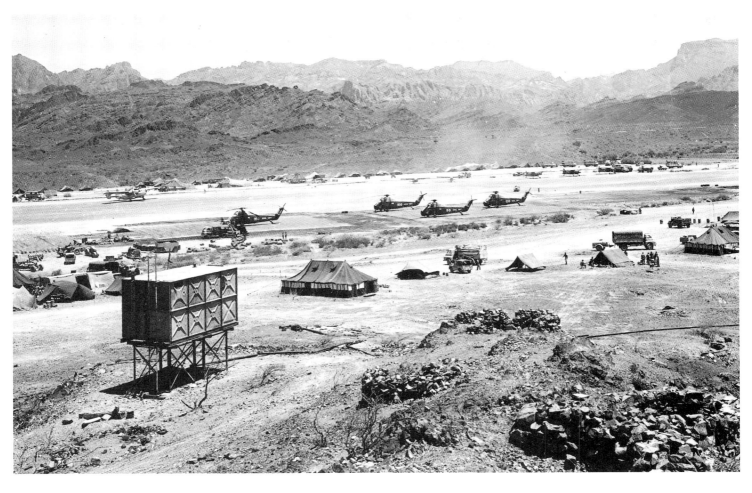

## COMMANDOS, PARAS AND COUNTERINSURGENCY

Unlike the reborn S.A.S., Britain's paras and Royal Marine commandos had not initially been trained for this type of subtle counterguerrilla warfare. Their primary role was as assault troops, and their units carried battle honors like St. Nazaire and Oudna. The only chance they had to practice their traditional role came in Operation Musketeer in November 1956, the Anglo-French response to Egyptian President Nasser's seizure of the Suez Canal. On 5 November 3 Para dropped onto and secured Port Said's Gamil airfield, and then fought its way into the city. Early the following morning, 3 Commando Brigade (consisting of 40, 42 and 45 Royal Marine Commandos) stormed ashore and, with 3 Para attacking from its right flank, quickly overwhelmed Egyptian resistance. It was a classic operation, but it was the only time that many commandos had, or indeed would, come ashore under fire. It was also the last occasion on which a British para battalion jumped into action.

The paras and commandos witnessed a great deal of active service during the post-war years, but it was almost entirely confined to policing and counterguerrilla operations. Elements of both forces were stationed in Palestine between 1945 and 1948, tasked with the hopeless job of protecting the Arabs and the Jewish settlers from their own and each other's terrorists. In Cyprus between 1954 and 1959 paras and commandos did, however, manage to contain Greek terrorists and keep the peace between the Greek majority and Turkish minority populations. During the 1950s the commandos were also regularly deployed in Malaya in counterguerrilla operations, and from the late 1950s onward, commandos, paras and the S.A.S. saw extensive service in various parts of southern Arabia.

## CONFRONTATION

Although the British had declared the campaign in Malaya at an end in 1960, within two years the region was again in crisis. Sukarno, the procommunist, ultranationalist leader of Indonesia, violently opposed British plans to federate British North Borneo (Sabah) and Sarawak with Malaya to form the new state

ABOVE: Royal Navy Wessex helicopters at Habilayn airbase in Radfan, South Arabia, in the early 1960s, which conferred considerable mobility on the Royal Marines' 45 Commando. Commando and para operations in the Aden Protectorate went on intermittently from 1958 until the final British withdrawal in 1967.

ABOVE: Borneo, 1964. They are dirty, crumpled, and unshaven, but their weapons are spotless; the three troopers of a four-man S.A.S. "stick" return to base after patrolling in the "general area" of the Sarawak-Kalimantan border.

RIGHT: During the early days of the confrontation, the Wessex helicopters aboard the Royal Navy's commando carrier, H.M.S. Albion, gave the Royal Marine commandos much greater flexibility than they had enjoyed in the earlier campaign against communist terrorists in Malaya.

of Malaysia. Indonesia therefore embarked on the *Konfrontasi* – a strategy of giving economic and military support to indigenous dissidents, and of infiltrating Indonesian regular units into the disputed territories. So successful was this strategy, that on 8 December 1962 4000 poorly armed rebels overran much of the small, oil-rich sultanate of Brunei, in the process capturing hundreds of British and European civilians. The British did not wait to negotiate: spearheaded by a Royal Marine commando force they struck back with devastating force. In one now-famous action, Captain Jeremy Moore and his commando company crammed themselves into two lighters and chugged up a river at night through rebel-held territory to the town of Limbang, where many of the Europeans were being held. At dawn the commandos stormed ashore, quickly overwhelming rebel positions and releasing all the hostages unharmed.

For many armies that would have been the end of the story. But the British knew that driving a few thousand poorly armed and poorly led rebels into the jungle might cause a serious insurgency. Early in January 1963,

therefore, A Squadron 22 S.A.S., under the command of Major Peter de la Billière, flew into Brunei. During the next six months they followed a by-now well-practiced routine: they located, isolated, ambushed and drove the surviving rebels into Indonesian Borneo.

By August 1963 the British had secured the situation in Brunei; but within the month Sukarno embarked on a much larger campaign – the military and political destabilization of the new Malaysian Federation. A Squadron S.A.S. was now spread out in the jungle-clad mountains along the 900-mile border between Sabah and Sarawak, and Kalimantan, the Indonesian part of Borneo. Once again the S.A.S. acted as the eyes and ears of the other forces, but its resources were so overstretched that Indonesian infiltrators managed to make some successful penetrations. The British requested S.A.S. reinforcements from New Zealand and Australia but, while the New Zealanders immediately began training, the Australians were more recalcitrant. At this stage they were reluctant to upset Indonesia, with whom they would have to live long after the British had withdrawn from Asia. However, by the end of 1964 Australian attitudes had hardened as a result of Indonesian amphibious and parachute attacks along the western coast of the Malay Peninsula, which troops of the 3rd Battalion Royal Australian Regiment had had to fight off. The distinction betwen Malaya and Borneo thus soon evaporated and, early in 1965, Australian and New Zealand S.A.S. squadrons arrived in Borneo, ready to reinforce the hard-pressed British.

It proved a fruitful partnership. Even though the "body-count" figures for 1965 were not in themselves impressive (107 Indonesians killed for the loss of four Commonwealth S.A.S. troops), the S.A.S. achieved more far-reaching results. They patrolled deeply into the jungle for weeks at a time; many went much farther into Indonesian territory than the authorized 10,000 yards, and one Australian patrol set a record of 89 days. Thereby the S.A.S. won over the trust of the Iban and Dyak tribes, making it almost impossible for the Indonesians to infiltrate without detection and subsequent S.A.S. ambush.

Borneo witnessed an extraordinary concentration of British and Commonwealth elites: in addition to the S.A.S., the com-

mandos and paras were also deployed. Like Malaya, this was not a war of pitched battles; there were, however, some striking exceptions. One such occurred on 27 April 1965, when an Indonesian battalion attacked a small fort at Plaman Mapu, which its scouts had assured it was held by fewer than 40 British soldiers. Shortly before dawn the Indonesians put down a barrage of mortar, rocket, and heavy machine-gun fire, behind which the infantry surged forward. By mid-morning they were forced to break off the attack after suffering more than 300 casualties. There were so many dead and so few fit survivors that corpses were simply pushed into a river near the Indonesian border. The Indonesian commander was convinced that he had walked into an ambush, and that Plaman Mapu had been garrisoned by several British companies. But in fact his scouts had been right all along: the fort

ABOVE: Spending weeks at a time in the jungle, the S.A.S. developed close contacts with the local people. Here an Iban scout helps an S.A.S. trooper to locate the trail of Indonesian infiltrators.

had been held by just 34 men, a platoon of 2 Para.

## BATAILLON ETRANGER DE PARACHUTISTES

In the first 20 years after World War II the British Army in general, and British elite forces in particular, could boast some substantial achievements. But even at the height of the long-drawn-out Malayan Emergency they had never had to deal with more than about 8000 guerrillas. The French faced a very different situation when they returned to Indochina early in 1946. The Vietminh had formed a large, sophisticated army, equally adept at guerrilla or conventional operations. By 1951 it could field 120,000 regular soldiers, backed by a regional militia of perhaps twice that strength. In 1951 the French Expeditionary Force numbered only 152,000, of whom fewer than half were French, supported by about 120,000 locally recruited Vietnamese. Man for man, the Vietminh outnumbered the French by a considerable margin; equipped with artillery supplied by the new People's Republic of China, it was also beginning to outgun them. Indeed, the only area of undisputed French

superiority was in the air.

## Bac Con

The French got the campaign off to a promising start. On 7 October 1947 a squadron of old German JU 52s flew over Bac Con in Tonkin and deposited three companies of French paratroopers on top of the Vietminh headquarters. The political leader of the Vietminh, Ho Chi Minh, left his headquarters in a hurry, abandoning piles of correspondence awaiting his signature.

Bac Con taught the French a valuable lesson: they had narrowly failed to destroy the Vietminh because they had too few paratroopers. Yet since French law forbade the employment of conscripts in Indochina, the expansion of paratroop forces could come only from converting part of the French Foreign Legion into airborne units, and legionnaires volunteered enthusiastically. The 1st "Bataillon Etranger de Parachutistes" (1st B.E.P.) was ready for action in 1948, and by 1950 France had four B.E.P.s, organized into two regiments.

The Foreign Legion had always recruited a large number of Germans, particularly after 1945. The Legion's regulations officially prohibited the enlistment of former Waffen S.S. members, but the screening process does not seem to have been particularly rigid. One volunteer recalled:

They made us raise our left arm to reveal on the armpit the tattoo which denounced [sic] the veterans of the Waffen S.S., and the blood group to which they belonged. Several among us had curious little superficial wounds precisely under this left armpit.

About two-thirds of the B.E.P.s were German, and many were former S.S. Fallschirmjäger – excellent material, which Foreign Legion training welded into truly formidable units. An English volunteer, Henry Ainley, wrote that: "the Foreign Legion was brilliant at two things – killing and dying well, both of which the legionnaires did frequently and with *éclat*."

The B.E.P.s excelled in operations similar to Eban Emael, Arnhem or Corregidor, but they were not the right sort of troops to defeat the Vietminh's type of revolutionary war. If sniped at from a village, the paratroopers tended to lay waste to everything in the vicinity, killing perhaps 10 Vietnamese for every dead paratrooper. The B.E.P. was either unaware or indifferent to the fact that this may have been precisely the result intended by the Vietminh. While the Foreign Legion paratroopers were certainly no fools, their philosophy of pacifying through fear could prove counterproductive: fear can give way not to cowed submission but to resentment and hatred.

BELOW: Dien Bien Phu in late November 1953. The attitude of French forces during their first days in Dien Bien Phu is exemplified by the insouciance of the paras standing in the open watching the landing of reinforcements. But such confidence was misplaced. The Vietminh was already moving heavy artillery into the hills in the distance.

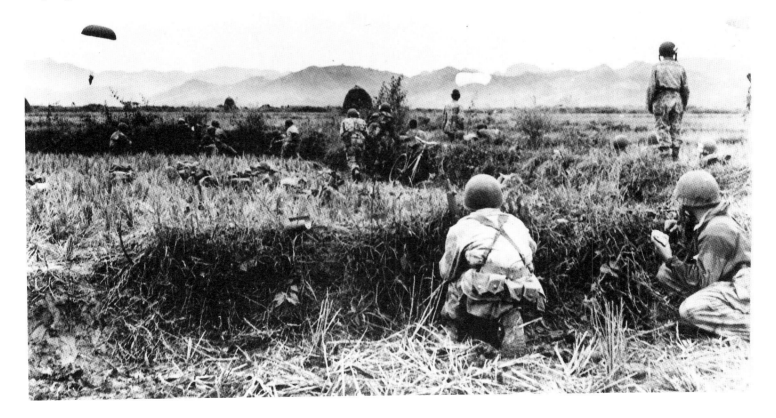

### Dien Bien Phu

The B.E.P.'s actions resulted in the strange paradox of a lost war, studded with legendary, near-mythological battles. In October 1950 the 1st B.E.P. was virtually wiped out while saving a French column trapped by the Vietminh during an attempt to withdraw from northwestern Tonkin to Hanoi along Route Colonial 4. The most famous battle of all, however, began on 20 November 1953, when paratroopers dropped onto and occupied an old Japanese airstrip built in a valley on the Tonkin-Laos border at Dien Bien Phu. The French commander, Brigadier General Christian de la Croix de Castriès, deployed his forces into 11 strongpoints surrounding the airfield – Simone, Claudine, Françoise, Elaine, Dominique, Béatrice, Gabrielle, Anne-Marie, Huguette, Isabelle and Natasha – all named, it was rumored, after the general's past and present mistresses. Dien Bien Phu was intended to be a *base aéroterrestre* in the heart of Vietminh-controlled territory, which would be supplied entirely from the air. De Castriès

wanted the Vietminh to attack so that French airpower and his own 28 field guns could destroy them in a set-piece battle. The Vietminh's military commander, General Vo Nguyen Giap, rose to the occasion: in the first weeks of 1954 he moved 200 guns and four regular Vietminh divisions into the hills around Dien Bien Phu.

Giap's forces opened fire on 13 March 1954, and kept up a more or less constant bombardment for the next eight weeks. Vietminh shells made craters in the airfield, forcing the French to drop reinforcements and supplies by parachute. This was a desperate business: hundreds of Vietminh antiaircraft guns hosed lead and shrapnel over Dien Bien Phu, shooting down or badly damaging 169 aircraft, about half the total strength of the French air force. During the siege, battalion after battalion of legionnaire paratroopers volunteered to jump into the beleaguered fortress. The most spectacular drop came on 9 April, when the 2nd B.E.P. descended through a hail of Vietminh fire, the paratroopers responding while still aloft with

BELOW: Some of the 11,000 troops of the Dien Bien Phu garrison who fell into the hands of the Vietminh on 7 May 1954. Only 4000 survived to be repatriated.

grenades and submachine guns. Though their casualties were heavy, a day later they were thrown into an assault against Elaine, which had fallen to the Vietminh at the end of March. The battle swayed to and fro, Elaine changing hands several times, until it was finally retaken by the paratroopers. Two weeks later the 2nd B.E.P. tried to retake Huguette from the Vietminh. The battalion, already under strength, suffered 150 casualties, and was merged the following day with the survivors of the 1st B.E.P. to form a single unit.

Massed Vietminh attacks finally overwhelmed Dien Bien Phu on 7 May. The garrison had grown to 15,000, and all but 75 had been killed, wounded or captured. Of those captured, only 4000 were ever repatriated. Although Dien Bien Phu was a defeat for France, it was a victory for the Foreign Legion, particuly for the B.E.P.s, whose reputation rapidly assumed epic proportions. Unlike the collapse of France in 1940, on this occasion national honor had been saved by the supreme sacrifices of an elite.

## ALGERIA
The success of revolutionary insurgency in Indochina sparked off nationalist insurgency in Algeria, launched by the *Front de la Libération Nationale* (F.L.N.). According to French law, Algeria was not a colony but an integral part of France. It had a large European immigrant population, numbering some one-and-a-half million; it was, of course, also the physical and spiritual home of the Foreign Legion (which had been formed in Algiers in 1831). Nearly all Legion officers were convinced that without Algeria the Legion would cease to exist: this was a war they would fight to the death to win. Since French law regarded Algeria as part of France, French conscripts were sent there in large numbers. By 1957, electrified barbed-wire fences, minefields, and well-garrisoned strongpoints crisscrossed the country, comprising the *quadrillage* system which allowed French garrisons to detect all but the smallest movements of the F.L.N. Once movement was noticed, airborne forces were called into play. After their impressive performance in Indochina, the B.E.P.s had been expanded into regiments. They no longer jumped into action, but swooped down in American-supplied twin-rotor "Shawnee" transport helicopters, their land-

ings supported by multiple machine guns blazing from heavily armored, single-engined Sikorsky helicopters, known in French as the "Pirates."

In a strictly military sense the Foreign Legion's embryonic "air cavalry" was a great success. But the B.E.P. came in for sharp criticism from officers of the *Sections Administratives Specialisées*, whose job was to live and work in Muslim villages and win the trust of the Arabs. One 10-minute visit from the "Shawnees" and "Pirates" could destroy in a stroke their years of patient and careful work at pacification.

### The Battle of Algiers
By 1957 the F.L.N., having been flushed out of the countryside, began a campaign of terror-bombing the European areas of Algiers. The Europeans reciprocated by conducting their own bombing campaign in the Arab Kasbah; within a few weeks the city was in chaos. The police were unable to cope, and in desperation the mayor turned to the military, who in turn sent in Brigadier General Massu and the 10th Colonial Para Division. Massu quickly located the source of the problem: a small group of terrorists operating from among the Kasbah's teeming 400,000-strong population. The police had failed because they could not get information regarding this group. Massu's division, however, sealed off the Kasbah, and the legionnaire paratroopers worked systematically through the district, house by house, room by room, arresting and detaining thousands of suspects.

Massu did not have time for lengthy interrogations, and, needing information quickly, he ordered suspects to be tortured until they talked. In a very short time Massu had built up a complete picture of the F.L.N.'s structure in Algiers and had eliminated it; in all, some 3000 Arabs died at the hands of Massu's men, either in raids or under torture.

### The Praetorian Guard
Massu was completely open about his interrogation techniques. He even submitted himself to lengthy periods of torture, with electrodes being placed on various parts of his body, to prove that it had no long-term ill effects. Indeed, many of his officers and N.C.O.s followed his example. His divisional chaplain, Father Delarue, went so far

OPPOSITE PAGE, TOP:
Small teams of U.S.
Special Forces, soon to
be known as "Green
Berets," arrived in
South Vietnam late in
1961. At this early stage
of the war they were
still armed with M1
carbines, and some of
the Americans had
adopted the French
floppy tropical hat,
wearing it "cowboy
fashion" with the sides
turned up.

as to make a passionate defense of torture, arguing that: "there is no clean war; sometimes it is a combat of one good against another good, if not one evil against another evil." The combination of Massu's self-imposed suffering and Delarue's sophistry could have been produced by a medieval crusading order; it certainly went down badly in the Paris of Simone de Beauvoir and Jean Paul Sartre. A storm of protest erupted throughout metropolitan France, which plunged the Fourth Republic into yet another crisis: this one terminal. On 13 May 1958 Massu and other officers of France's military elite in Algeria declared themselves the new government, set up a Committee of Public Safety, and began the process which would see the final collapse of the Fourth Republic and the coming to power of General Charles de Gaulle. For the first time in the twentieth century, the military elite of a Western nation had transformed itself into a praetorian guard.

## THE UNITED STATES: THE REBIRTH OF THE SPECIAL FORCES

During the 1950s American officers had watched the British and French campaigns very closely. They reached two quite contradictory conclusions: some observers argued that the United States desperately needed a force like the British S.A.S., while others wanted to create divisions of "air cavalry."

A 2500-man special-force unit had been created in 1952, designed primarily to act as "stay behind" guerrillas in Western Europe against the threat of a Soviet invasion. These men were excellent material: all "triple volunteers," in that they could only volunteer for the Special Forces after first volunteering for the army and then the airborne forces. They developed a very strong *esprit de corps*, symbolized in their purchase from a Munich tailor of bottle-green berets which then became their unofficial headdress. In 1956 the Special Forces fell foul of the commander of Fort Bragg in North Carolina, General Paul D. Adams, when they completely disrupted the administration and logistics of a major maneuver. Adams consequently forbade the wearing of the green beret on pain of court martial, which, if anything, increased the Special Forces' sense of being an elite. Their main problem was that they enjoyed a very limited role as yet.

From the mid-1950s onward, American

Special Forces officers had served on exchange with the S.A.S., and from 1960 Hereford, England, became almost a place of pilgrimage for the Americans. Indeed, American Special Forces officers were already thinking of adopting an S.A.S.-style counterinsurgency role when, on 6 January 1961, the Secretary of the Soviet Communist Party, Nikita Khrushchev, flung down a gauntlet to the United States, declaring that: "the U.S.S.R. and its allies would support just wars of liberation and popular uprising." A few weeks later John F. Kennedy was inaugurated as president of the United States and, over the next 18 months, initiated a dramatic shift in American policy on how to respond to communist-inspired insurgency. In June 1962 he outlined his approach in a graduation address at the U.S. Military Academy at West Point:

> This is another type of war, new in its intensity, ancient in its origins – war by guerrillas, subversives, insurgents, assassins; war by ambush instead of by combat; by infiltration instead of aggression, seeking victory by eroding and exhausting the enemy instead of engaging him. It requires – in those situations where we must encounter it – a whole new kind of strategy, a wholly different kind of force, and uniform, a new and wholly different kind of military training.

### The Green Berets

By the time Kennedy gave this speech, America already had "a wholly different kind of force" with a new uniform. On a visit to the Special Warfare Center at Fort Bragg the previous year, the president had been greatly impressed by the Special Forces and their plans for counterinsurgency operations. Senior army generals accompanying Kennedy were less happy: they were outraged when, during an inspection, William P. Yarborough (now a full colonel and the Center's commander) marched onto parade wearing the long-forbidden green beret. It was a seemingly minor incident, but one filled with symbolic significance. Yarborough could have faced a court martial: he certainly would have done so had some senior generals had their way. Kennedy, however, was delighted, and within days an executive order had confirmed the green beret as the official headdress of the Special Forces. Within a few months the Special

OPPOSITE PAGE,
BOTTOM: By 1964, when
this picture was taken,
the war was going
badly for the
Americans. Here a U.S.
Special Forces officer
and N.C.O. engage in
a terse discussion with
a South Vietnamese
soldier.

Forces themselves had become widely known as the "Green Berets."

## The Civilian Irregular Defense Group Program

In 1961 the first Green Berets arrived in South Vietnam, primed to combat communist insurgency by using the techniques of the British S.A.S. Small teams of Green Berets settled into Montagnard villages throughout South Vietnam's rugged, thinly populated central highlands region. Their aim was to win the loyalty of the Montagnards, the first step in the creation of a chain of fortified, well-defended villages blocking the main entrance routes of the Ho Chi Minh Trail into South Vietnam. These activities – known as the Civilian Irregular Defense Group Program – proved extremely successful. The Green Berets and the Montagnards got on very well together, and by 1964 they had established 40 fortified camps. However, as the war dragged on, some Green Berets tended to "go native" and began behaving like tribal warlords.

## Mike Forces

The Vietcong (V.C.) and the North Vietnamese Army (N.V.A.) found the activities of the Green Berets irritating in the extreme. However, the isolated Montagnard villages were excellent targets, each one a potential

RIGHT: An American
Special Forces N.C.O.
inspects the perimeter
defenses of Nam Dang
in the central
highlands, a town
frequently attacked by
the Vietcong.

BELOW: An important
role for the U.S.
Special Forces was
training the South
Vietnamese. Here, a
Special Forces N.C.O.
instructs Army of the
Republic of Vietnam
(A.R.V.N.) troops in the
use of hand grenades.

mini Dien Bien Phu. Throughout the 1960s
the V.C. and N.V.A. launched literally hun-
dreds of attacks against the villages; some
were immediately successful, but most re-
sulted in lengthy sieges. Unfortunately, the
Green Berets soon discovered that calls for
assistance frequently went unanswered: the
South Vietnamese forces had little love for
the Montagnards and did not really mind if
the V.C. and N.V.A. exterminated a few of
the hill people's villages, while the thinly
stretched American forces often took some
time to reach the scene. The Green Berets
were thus forced to create their own rescue
units, known officially as mobile reaction
teams, but universally called by the code-
name "Mike Forces." A particularly warlike
tribe, the Nungs, formed the backbone of
the Mike Forces – they became, in effect, the
Gurkhas of the Green Berets.

ABOVE: With the arrival of substantial numbers of U.S. regular forces in South Vietnam in 1965, U.S. Special Forces attached to A.R.V.N. units were used extensively as liaison officers. Without their familiarity with both U.S. and A.R.V.N. procedures, accidental clashes between the two armies would have been much more common than they actually were.

LEFT: A Green Beret trains volunteers of the Civilian Irregular Defense Group to use the M-79 grenade launcher, a very effective weapon in close-quarter fighting.

ABOVE: Heavily
involved in inshore
blockading operations,
the U.S. Navy created
its own
reconnaissance/
raiding units, the Sea-
Air-Land (or S.E.A.L.)
teams. A S.E.A.L. team
is seen here on
operations in the flat
country of the Mekong
Delta.

## "Diggers" and "Kiwis"

On many occasions the American Special
Forces in Vietnam felt their isolation from
the mainstream activities of the American
Army. The only other troops fighting
"their" sort of war and sharing something of
their outlook were the elites of the armies of
Australia and New Zealand. The Australian
Army Advisory Training Team (known
throughout Australia simply as "The
Team") arrived in South Vietnam in 1962.
At any one time throughout the 1960s and
early 1970s the team comprised about 100
officers and N.C.O.s, sometimes attached in
small units to the Green Berets and Montag-
nards, but more usually to units of the South
Vietnamese Army. It was in this latter capa-
city that team members sometimes single-
handedly had to carry out tasks assigned to
companies. As a result, the team suffered 155
battle casualties, a high number for a very
small unit. Its members also won 118 British
Commonwealth decorations for gallantry,
including four Victoria Crosses.

## The S.A.S. in Vietnam

The Australian S.A.S. arrived in South Viet-
nam in 1966, followed three years later by the
New Zealand S.A.S. They usually operated
in four-man groups, independent of other
units, specializing in long-range penetration
patrols which occasionally lasted for up to 80
days. Australia and New Zealand sent a total
of 600 S.A.S. troopers to South Vietnam,
who carried out 1300 patrols over a five-year
period. Their casualties were very light:
again, they acted as the eyes and ears of
larger units, and were trained to avoid rather
than seek a fight. But they often had to fight,
and during the course of their patrols they
killed 600 N.V.A. and V.C. soldiers, none of
which were recorded as dead unless a trooper
had actually been able to place his foot on an
enemy body. The probability is that they
killed many more.

## "Air Cav"

The American Special Forces and their Aus-
tralian and New Zealand counterparts may

have achieved some striking successes, but they played only a small part in the conduct of the Vietnam War. Another American elite, the airborne forces, arrived in Vietnam very early in the conflict. Indeed, the enduring symbol of the war in Vietnam is the "Huey" helicopter in flight over jungle and paddy field, a motif which has been used in so many movies since the 1970s that it is now a cliché. The first American helicopters, 32 "Shawnees," and 400 men of the 57th Transportation Company, arrived in South Vietnam on 11 December 1961, and were in action just 12 days later. Almost four years passed before the U.S. committed its newly created Airmobile formation, the 1st Cavalry Division (more commonly known as the 1st Air Cav), to Vietnam. In October 1965 the Air Cav flew into An Khe, about midway between Da Nang and Saigon, an area of intense V.C. activity.

### The Ia Drang Valley

The Air Cav was assigned a roving commission over the rugged central highlands, where land communications were difficult. Flying in for an opposed landing, the helicopters adopted a stepped "V" formation, gunships flying in the front and at the sides, protecting the troop transport in the middle, and shooting up the landing zone before the

transport put down.

The first major action was a rescue mission. In mid-October 1965, four N.V.A. regiments attacked and besieged a Special Forces camp at Plei Me in the Ia Drang Valley, close to the border with Laos. On 27 October the 1st Air Cav descended; they saved the camp but then had to fight a series of bitter running battles down the valley, which lasted throughout November. The Air Cav estimated that they killed 1800 N.V.A., but nothing like that number of bodies were subsequently discovered. They themselves lost 55 helicopters, either by being shot down or damaged.

Although dramatic in appearance, Air Cav operations were plagued by difficulties. The enemy could usually escape if he wanted; if he decided to fight, it was invariably on ground of his own choosing, where it was difficult for helicopters to put down. The helicopter was certainly less vulnerable to ground fire than the paratrooper, but losses were still very high.

### U.S. Marines at Da Nang

Another enduring image of the Vietnam War are the landing craft of the 9th Marine Expeditionary Brigade grinding onto beaches near Da Nang on 8 March 1965, ramps descending, followed by the marines wading

BELOW: On 8 March 1965 the U.S. marines came ashore on the beautiful, white, sandy beaches of Da Nang. Looming ominously in the background are the cloud-shrouded, jungle-covered mountains of the Annamite Chain. It was here that the marines would have to do much of their fighting.

ashore. To some of the American television audience watching the scene the following evening on the network news programs, it all looked very familiar: a rerun of Guadalcanal and Iwo Jima. However, the war in South Vietnam was very different. The enemy was found to be as tenacious as the Japanese, but in many ways more skillful, and the marines found it very difficult to come to grips with him except at a time and place of his own choosing.

The marines deployed throughout Quang Tri Province, the northernmost in South Vietnam, setting up fire bases to control movement across the so-called De-Militarized Zone (D.M.Z.) which separated North from South Vietnam. Most N.V.A. infiltration came around the western end of the D.M.Z. through the mountains of Laos. It was here, in the corner where South and North Vietnam met Laos, that the Special Forces had already set up a camp in the village of Lang Vei. The U.S. Marine 26th Regiment now constructed a much larger fortified base a few kilometers to the east, near the town of Khe Sanh, whence they began to harass communist movement by means of artillery fire and fighting patrols.

### The Siege of Khe Sanh

To the North Vietnamese it seemed as though Lang Vei and Khe Sanh could become another Dien Bien Phu. After months of patient preparation, in the spring of 1967 three regular N.V.A. divisions began a series of probing attacks against both bases. On 4 May Soviet-built North Vietnamese PT-76 light tanks overran part of the Lang Vei perimeter – the first time that armor had been used by communist forces. The Green Berets managed to repel this attack, but only just: they and their Montagnard allies suffered 50 percent casualties. By January 1968 the N.V.A. had both bases under siege. American and South Vietnamese forces tried to break through from the east, but were beaten back. In the United States the press openly discussed the possibility of another Dien Bien Phu, but the difference between 1954 and 1968 was that the Americans possessed overwhelming air power. During the last 70 days of the siege the U.S.A.F. dropped 96,000 tons of bombs on N.V.A. positions around Khe Sanh – more than 1300 tons each day – turning the jungle-clad hills into a cratered moonscape. At the end of March, the 1st Air Cav swept west along

BELOW: The first marines ashore at Da Nang on 8 March 1965 form a "defensive perimeter," and are photographed by waiting American newsmen. As the marines were to discover in Somalia 27 years later, the landing was the easy part of the operation.

Highway 9 to Khe Sanh, systematically clearing N.V.A. roadblocks and strongpoints, its first units reaching the beleaguered marines on 8 April 1968.

Khe Sanh was an attritional battle in which the marines' staying power and the air forces' fire power destroyed three enemy divisions. It was an American victory. Unfortunately, the high command now decided to abandon Khe Sanh, and made the outcome of the battle seem very much like a defeat – at least as far as the American public was concerned.

### Hue

On the night of 30 January 1968, as fighting raged around Khe Sanh, Vietcong and N.V.A. forces launched attacks on targets throughout South Vietnam. It was the height of the Tet festival, the celebrations for the Buddhist new year, and the onslaught caught the Americans and South Vietnamese off their guard. North Vietnamese regular battalions scored a major success in overrunning the old imperial capital of Hue, a city on the coast, about 50 miles north of Da Nang. Both sides were aware of Hue's immense symbolic significance and, in an effort to win

ABOVE: Khe Sanh, April 1968. A marine prepares to zip a dead colleague into a body bag. The publication of pictures like this, and the simultaneous decision to abandon Khe Sanh, led many Americans to conclude that the marines had suffered a defeat.

LEFT: Marines of A Company, 1st Battalion, 1st Marine Regiment, fire from the window of a house near the citadel during the battle to retake Hue from the Vietcong and the North Vietnamese in February 1968.

back the city, the N.V.A. poured 11 regular battalions into the city, while the marines, hard-pressed elsewhere, sent three under-strength battalions north, accompanied by 14 generally reluctant South Vietnamese bat-talions. The battle to retake Hue began on 31 January and ended on 2 March, with the marines finally raising the Stars and Stripes over the smoking ruins of Hue's citadel, the last pocket of N.V.A. resistance. The South Vietnamese later complained that the marines had raised the American and not the South Vietnamese flag, but in fact it had been the marines who had done the fighting and the dying.

In all, 317,400 marines served in "Nam" – a substantial expansion in numbers from the early 1960s. (This expansion did not entail the same diminution in quality which characterized so many U.S. Army units after 1969.) Of these 317,400 marines, more than 13,000 were killed and 88,600 wounded: one marine in every three became a casualty. Although the marines never comprised more than eight percent of total American forces in South Vietnam, they suffered 25 percent of the total casualties, and departed from South Vietnam with their combat reputation en-hanced rather than diminished.

### Hill 937

The month-long battle to recapture Hue was one of the toughest in the Marine Corps' history. Airmobile forces had also faced some very hard battles. One of the most famous was the reconstituted 101st Air-borne's attack on Hill 937 at the head of the A Shau Valley in May 1969 – a geographic feature known locally as Ap Bia Mountain. On 8 May the 101st's 3rd Brigade flew by helicopter up to the foot of Ap Bia, expecting that a few fighting patrols would cause any N.V.A. forces on the mountain to withdraw. Four days and several fruitless assaults later, it was clear that the N.V.A., well dug in and in considerable numbers, had no intention whatever of leaving Ap Bia.

The task of launching a full-scale assault to take the mountain fell to Lieutenant Colonel Honeycutt's 3rd Battalion of the 187th Regi-ment. On 12 May Honeycutt's men advanced halfway up the mountainside before they were forced back. On 14 May they went up again, this time with close air support from helicopter gunships. Just as victory seemed within grasp, gunships opened fire by mistake on the advancing 3rd Battalion, reducing its attack to a shambles. Honeycutt, wounded three times, was now

BELOW: Many American veterans of Vietnam remember not just the horror, but also the beauty of the country. A U.S. marine patrol moves through a field of wild flowers south of Da Nang. They are aware of the beauty which surrounds them, but have not let their attention wander from the tree line, where the Vietcong might be waiting.

hellbent on taking the mountain, which he had begun to view with the same obsessiveness that had marked Captain Ahab's pursuit of Moby Dick. The 3rd Battalion attacked again and again and again; it took 10 assaults over eight days before the survivors were able to stand on the shattered crest of Ap Bia. Three-hundred-and-sixty men from the battalion's original 600 had been killed or wounded. Had Ap Bia been a turning point in American fortunes it would have been remembered as a triumph of American will. However, only one week after they had taken it, the 101st were ordered to abandon Ap Bia and the A Shau Valley to the N.V.A. The Airborne's subsequent bitterness over this pointless massacre was mirrored in their cynical nickname for Ap Bia: "Hamburger Hill."

### Son Tay

During the final years of the Vietnam War most American actions bore some resemblance to Hamburger Hill: battles not without heroism, but ultimately a futile waste of life. Many American units degenerated into indiscipline and defeatism. Yet the events of the night of 20-21 November 1970 revealed an exceptional example of American courage. Six large troop-carrying helicopters took off from Ta Khli air base in Thailand and flew northeast: their objective, the rescue of captive American airmen held in a camp at Son Tay, only 25 miles northwest of Hanoi, in the heart of North Vietnam. Aboard the helicopters was a special force of 85 heavily armed Green Berets under the command of Colonel "Bill" Simmons. Shortly after 0200 hours on 21 November, three helicopters carrying Simmons and about half the raiding force set down in a compound which they at first thought was the prison camp. In fact, they were 400 yards south of their objective, but the compound still proved an excellent target, since it housed hundreds of Soviet and Chinese technicians. The Green Berets charged into the midst of the dazed foreign advisers, cutting down dozens with automatic 12-bore shotguns and M-79 grenade launchers. Meanwhile, the other helicopters reached the prison camp, shot up the guard towers, and set down on the parade ground. Everything was quiet: too quiet. In fact, the North Vietnamese had moved the prisoners to another location a few months earlier, a move not spotted by U.S. intelligence.

The Green Berets' operation – one of great technical brilliance and extreme daring – was

BELOW: The 101st Airborne Division tensely prepare for action in Vietnam.

ABOVE: Special Forces on a long-range penetration patrol late in the Vietnam War. Although very many units were still performing brilliantly, some senior officers and much of the press had turned against the Green Berets.

dogged by the same extraordinary bad luck that had marked so many of America's best-planned actions during the Vietnam War. If the Green Berets had returned with the prisoners, the Son Tay raid would have been hailed as a brilliant operation. As it was, a now largely hostile American news media dismissed it as just one more military fiasco.

### The Myth of the Green Berets

The Son Tay raid was a last flourish for the Green Berets. Senior officers brought up in a more orthodox military tradition had never liked them, and had resented their special relationship with President Kennedy. After Kennedy's assassination, a Green Beret was placed on his grave, and the Green Berets mounted a guard of honor. For many years to come, other American units would refer derisively to the Special Forces as "Jacqueline Kennedy's Own Rifles." The jealousy of the conventional soldiers was fueled by the American media's near-adulation of the Special Forces in the early 1960s. Press articles and television documentaries consistently portrayed them as supermen – the very embodiment of all that made America strong and decent.

Inevitably, the public perception of the Green Berets began to change. The American public wanted an American military hero who was a "man of action," straightforward and unsubtle, not a devious strategist who would prefer to outwit rather than outfight his enemies. The Green Beret was thus to be transformed from the intellectual warrior who could beat the dedicated communist guerrilla at his own game, to a hybrid of U.S. ranger, paratrooper, and U.S.M.C. raider. Early in 1966 Sergeant Barry Sadler, a Special Forces medic and would-be country-and-western singer, composed the *Ballad of the Green Beret*, which in the early months of 1966 sold half a million copies. The lyrics –

Silver wings on my son's chest,

Mean he's one of America's best

– were risible. Even though the song proved enormously popular in America's Midwest and the Bible Belt, it exposed the Special Forces to much ridicule within the U.S. Army itself. To make matters worse, two years later, John Wayne and company descended on Fort Benning in Georgia, and, with pine forests substituting for tropical jungle, made the embarrassingly bad *The*

*Green Berets*, in which tough old Colonel Wayne and a small Special Force detachment appeared to dispose of most of the population of Southeast Asia.

Unfortunately, by this time too many Green Berets were trying to live up to John Wayne's image of them. During the 1960s the Special Forces had expanded rapidly – from 1800 to 10,000. Inevitably, there had been a decline in the quality of some of the manpower. The training attrition rate of 90 percent in 1960 had fallen to 30 percent by 1964, and there was a steady drop in the average age of the Green Beret: from highly experienced men in their early to mid-30s, down to rather immature boys in their early 20s. Some rear-echelon Green Berets in Saigon created a bad impression, hanging around bars, sporting elephant-hide boots, tiger-skin-patterned camouflage capes, and long bowie knives, and brawling with all and sundry. Predictably, the American media soon turned on the image which was largely of its own creation. Furthermore, the unpleasant aspects of some operations, in particular the elimination of double agents, made the Green Berets vulnerable to media witch-hunts.

In the summer of 1969, the new U.S. commander in South Vietnam, General Creighton Abrams, an expert in armored warfare, with a deep-seated antipathy to the Special Forces and their operations, ordered the arrest of eight Special Force officers who had been implicated in the assassination of one Thai Khoc Chuyen, an alleged double agent. It seems clear that Abrams used this particular incident (by no means unique in this, or in any other, counterinsurgency campaign) to help the American media and judicial process take the Special Forces apart. Indeed, over the next three years Abrams did his best to wind the Special Forces down. The depth of his dislike was reflected in his decision not to attend the Special Forces' last parade at Nha Trang before the Green Berets left South Vietnam in 1971. The following year Abrams succeeded General Westmoreland as U.S. Army Chief of Staff. Within a few months he had set in motion plans which would lead to the demotion of the Special Forces' function to a purely training role. Future operations along the lines of Son Tay would soon be the preserve of more conventional units of the U.S. forces.

ABOVE: A Special Forces soldier, ostensibly dressed and camouflaged to blend in with the jungle. In fact, camouflage had by this time come to resemble war paint. It served an important psychological function for the men, but it also made it much too easy for the numerous critics of the Special Forces to dismiss them as psychopaths. By the late 1970s Hollywood was producing films such as *Apocalypse Now*, which reinforced this image.

### The Mayaguez Incident

The latter stages of the Vietnam War had a corrosive effect, not just on the Special Forces, but on other American elite units as well. A salutary demonstration of the decline of U.S. capability came in the final weeks of the conflict. Phnom Penh and Saigon fell to the communist forces in April 1975. On 12 May Cambodian patrol boats seized the American merchant ship S.S. *Mayaguez* in the Gulf of Thailand and forced the crew at gunpoint to sail to Koh Tang Island off the Cambodian coast. The United States denounced this as an act of piracy, and the new American president, Gerald Ford, ordered elements of the 3rd Marine Amphibious Force in Okinawa to fly to Thailand to mount an operation to retake the ship.

This was a tall order: the marines had just returned, virtually exhausted, from a grueling maneuver. Moreover, they needed time to carry out a detailed reconnaissance. But time was something that the Ford administration did not have. On 15 May three companies of marines therefore launched a heliborne assault on Koh Tang Island, believing it to be only lightly defended. They flew straight into an ambush: more than 300 Cambodians, well dug in and armed with heavy machine guns, poured a stream of armor-piercing bullets into the first wave of helicopters. The Cambodians damaged or destroyed seven of the first eight helicopters, and pinned the marines on the landing zone. Marine reinforcements ran into equally heavy fire. Only the timely arrival of the U.S.A.F. saved the Americans from complete disaster. It strafed and dropped bombs on the Cambodians, including a 15,000-pound Daisycutter, the largest conventional bomb in the U.S. arsenal. Of the 250 marines involved in the operation, 68 were killed or wounded. In addition, the Cambodians had destroyed or badly damaged 12 valuable heavy-lift helicopters.

By the mid-1970s, the condition of America's elite forces mirrored in microcosm the state of the American forces in general. They were fast approaching rock bottom. Soon there would be nowhere else to go but up.

### SPETSNAZ

Throughout the 1950s the Soviet Union had closely monitored the rise of Western specialist elite forces. Soviet analysts concluded (correctly) that their capitalist enemies had developed elite forces in response to counterrevolutionary wars raging against imperialist oppression throughout the Third World: battles which the Soviet Union believed it would never have to fight, at least in theoretical ideological terms. Yet the Soviets did use special forces in a not dissimilar way in their "bandit suppression" operations. Airborne forces and troops from the Ministry of the Interior's Dzerzhinski Division were employed to "eliminate deviant elements" in Lithuania, Latvia and Estonia. In addition, the U.S.S.R. employed specialist units of the K.G.B. (a descendant of the Cheka), but these mainly combated the "antisocial activities of criminal gangs." By the end of the 1950s, the K.G.B. had become expert in dealing with the hijacking of Aeroflot passenger aircraft. However, the hijackers were usually criminals or dissidents trying to escape the Soviet Union, not (as was later the case when hijacking spread to the West) political terrorists intent on prolonged negotiations.

Many of those in the U.S.S.R.'s political hierarchy remained deeply uneasy about the creation of elite special forces. But during the mid-1950s attitudes began to change as the U.S.S.R. tried to compete across the globe with Western nations. Guards Tank and Motor Rifle divisions had proved adequate in projecting Soviet power across the inner German border, but could not be used in situations which demanded nothing less than a full-scale conventional attack. One pressing problem was the chronic volatility of satellite nations: armored formations bloodily suppressed riots in East Germany in 1953 and a full-scale revolt in Hungary in 1956.

All these factors shaped the creation in the late 1950s of the "Voyska Spezialnoye Naznachenia" (special-purpose troops) – soon abbreviated to "Spetsnaz." The Soviets established a training camp by the Havel River near Fürstenberg in East Germany, and by 1959 the first recruits were being put through a training program which was probably more rigorous than that experienced by either Britain's S.A.S. or the U.S.A.'s Special Forces. Nearly 20 percent of some early intakes were injured or killed, although this rate did begin to fall in the mid-1960s. Like Britain's S.A.S., the officers commanding Spetsnaz avoided publicity and selected

recruits by invitation. The selection process itself was not unlike that for the S.A.S., except that Spetsnaz troops were judged partly on the ideological purity of their beliefs. Whatever their private beliefs (and the volunteers were invariably of above-average intelligence and education), they were outwardly dedicated communists.

Spetsnaz grew to a strength of almost 14,000: roughly eight times the size of the U.S. Special Forces, yet certainly still counting as an elite, given the enormous size of the U.S.S.R's armed forces. Indeed, they quickly adopted the trappings of an elite, wearing a modified version of the Soviet airborne uniform: a maroon beret and a distinctive striped T-shirt worn under a jacket. But the need for anonymity demanded conventional uniforms or plain clothes for operations in the field. Their training was intended to equip them for a variety of roles, ranging from assault storm troopers, through "dirty tricks" operations in the style of the Brandenburgers, to the provision of training for the Soviet Union's allies.

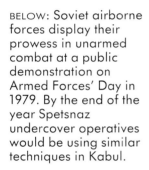

BELOW: Soviet airborne forces display their prowess in unarmed combat at a public demonstration on Armed Forces' Day in 1979. By the end of the year Spetsnaz undercover operatives would be using similar techniques in Kabul.

## Prague

Throughout the early and mid-1960s rumors circulated among Western intelligence agencies about a Soviet special-operations force, but the information was sparse and often contradictory. Western suspicions were confirmed when, on 20 August 1968, Spetsnaz launched its first major operation: the spearheading of the Warsaw Pact invasion of Czechoslavakia, a Soviet satellite whose reformist communist government Moscow no longer considered reliable. At 2300 hours a Soviet cargo aircraft claiming to be suffering engine failure made an emergency landing at Prague airport. Before the aircraft had even come to a halt, Spetsnaz units jumped from the cargo hold and rushed the control tower. The bewildered Czechs offered no resistance. With the airport now secure, Soviet Antonov transports began flying in to unload troops.

Meanwhile, in Prague, other Spetsnaz units, who had infiltrated Czechoslovakia during the previous weeks, seized the radio and television stations, the telephone ex-

change, and the offices of the main newspapers. At 0400 hours Spetsnaz units broke into the central committee building where Alexander Dubček, Czechoslovakia's prime minister, and his cabinet were meeting. Again, there was no resistance. Spetsnaz troops stormed into Dubček's office, held the prime minister and his cabinet at gunpoint for five hours, and then spirited them away to Moscow. By the evening of 21 August Czechoslovakia was firmly back in the Soviet camp. In contrast to the Hungarian operation in 1956 during which 25,000 Hungarians and 7000 Soviets had been killed, the reoccupation of Czechoslovakia was virtually bloodless. From his villa in Spain, where he had remained in exile after the war, Otto Skorzeny pronounced the performance of the Spetsnaz in Prague as "brilliant": high praise indeed from an expert.

### Wider Still And Wider

Over the next 10 years the U.S.S.R. sent Spetsnaz teams to more than 19 countries in Latin America, Asia and Africa to train and advise the forces of friendly governments. On rare occasions they encountered Western forces. One such incident was the Green Beret raid on Son Tay in North Vietnam, where rumors circulated that some of the Soviet casualties were Spetsnaz. Another incident occurred in Angola on 4 May 1978 when South Africa's newly formed 44 Para Brigade descended on a S.W.A.P.O. guerrilla camp codenamed "Moscow," and inflicted heavy casualties on Cuban and Soviet advisers. A year later, the Rhodesian S.A.S. located K.G.B. and Spetsnaz advisers in Lusaka, the capital of Zambia but, because of diplomatic developments, were ordered not to eliminate them. In August 1981 South Africa's Pathfinder Company (recruited in November 1980 from recently disbanded Rhodesian special forces like the S.A.S. and Selous' Scouts) raided deep into Angola, capturing one Spetsnaz trooper and killing several others. In the mid-1980s American Special Forces operating with the Contras in Nicaragua were also reported to have clashed with Spetsnaz.

BELOW: During the 1970s Soviet airborne forces frequently practiced large-scale assault drops, in which armored fighting vehicles, as well as paratroopers, descended by parachute. Originally designed to fight against N.A.T.O., these forces saw extensive active service during the 1980s in Afghanistan.

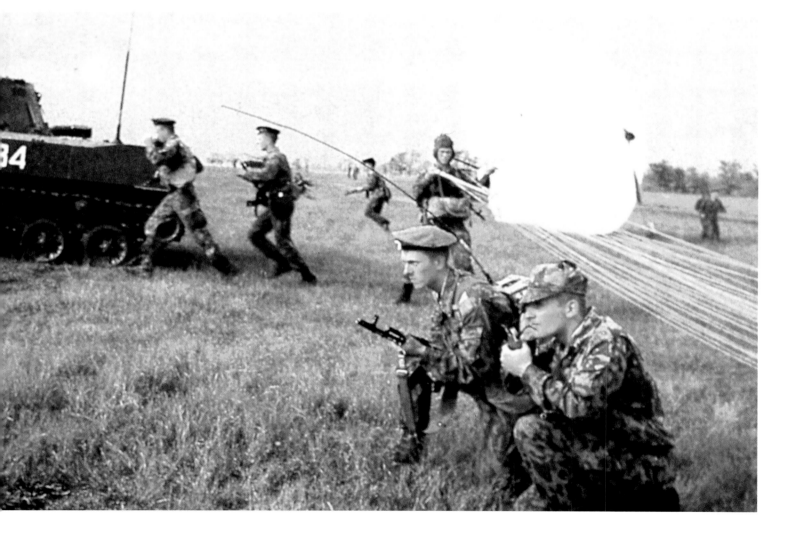

# CHAPTER VII

# New Challenges and New Responses: Elite Forces and Counterterrorism, Assault and Intervention Operations, and Peacekeeping, 1968-94

By 1968 the struggle between Israel and various Palestinian guerrilla organizations had been going on for 20 years, fought out in the dense bush of the Jordan Valley and the mountains and wadis of the Sinai. In the early 1950s Colonel Yehudah Harari, founder of Israel's paratroop forces, formed a specialist antiguerrilla commando company – Unit 101 – which carried the war to the enemy. Led by a very able young commander, Ariel "Arik" Sharon, Unit 101 specialized in reprisal and pre-emptive strikes, and was subsequently incorporated into Israel's paratroop forces.

This conflict attracted very little notice in the Western media until 23 July 1968. On that eventful day, a three-man squad of the Popular Front for the Liberation of Palestine (P.F.L.P.), a radical splinter group which had broken away from the P.L.O., hijacked an El Al Boeing 707 at Athens airport and forced the captain at gunpoint to fly to Algiers. Taken by surprise, Israel's government quickly acceded to the hijackers' demands that Arab prisoners held in Israel's jails be handed over in exchange for the 35 passengers and crew aboard the Boeing. Israel's capitulation, however, encouraged the terrorists to make further assaults. On 26 December 1968 two P.F.L.P. gunmen opened fire with machine guns and grenades on an El Al passenger aircraft as it taxied down the runway at Athens airport; several passengers were injured and one was killed. Two days later, 150 Israeli paratroopers flew by helicopter to Beirut airport, placed ex-

plosive charges on 14 Arab airliners, destroying 13 (one charge failed to detonate). The entire operation took just 29 minutes.

The Athens and Beirut incidents seemed at first to be merely an intensification of a long conflict. But in retrospect they were clearly the opening exchanges in a struggle between international terrorists and elite special forces which continues to this day; one which has affected virtually every country in the world. The emergence of international terrorism in the late 1960s was a complex phenomenon. Marxist urban guerrillas in Latin America, European "New Left" groups – most notably West Germany's Baader-Meinhof Group and Red Army Faction, Italy's Red Brigade, and France's *Action Direct* – and "irredentist" nationalist groups like E.T.A. in Spain, the I.R.A. in Northern Ireland and the P.L.O. in the Middle East, began to co-operate closely and develop a system of "subcontracting" operations. The P.F.L.P.'s successful taking of hostages to force Israel to capitulate to their demands established the pattern for terrorist activities over the next two decades.

### Black September
In September 1970 the P.F.L.P. pulled off another stunning operation. Between 6 and 9 September, the terrorists succeeded in hijacking an American, a Swiss and a British airliner, forcing their crews to fly them to Dawson Field, a disused R.A.F. airstrip in Jordan. To secure the release of the crews

and passengers, the Western governments involved promised, via the Red Cross, to meet P.F.L.P. demands that they free certain convicted terrorists held in prison. For nearly two weeks the negotiations dominated the world's media and, on 15 September, the terrorists gave the television cameras the photo opportunity they had been waiting for. They evacuated the aircraft and then blew them up.

Thus three Western nations – one of them a superpower – had shown that they had no means of responding other than by giving in to terrorist demands. King Hussein of Jordan, fearful that his country was about to be taken over by Palestinian refugees in well-armed gangs, used the Dawson Field incident as an excuse to be rid of them. On 17 September 1970 the Jordanian Army therefore launched an all-out assault on the Palestinian training camps. The fighting went on for weeks and resulted in the deaths of more than 7000 Palestinians and, a year later, the wholesale expulsion of the survivors into Syria and Lebanon.

Over the next few years new ultraradical groups emerged: Black September, Abu Nidal and Hezbollah. Hussein had saved his own kingdom, but in so doing had unwittingly unleashed a far greater threat on the international community.

### The Munich Olympics, 1972

Western nations were unable to handle hostage-taking: a fact underlined with painful clarity on 5 September 1972, when eight Black September terrorists stormed the Israeli teams' sleeping quarters in Munich's Olympic Village. The terrorists killed two Israelis, held nine hostage, and demanded the release of 234 prisoners held in both West Germany and Israel. West Germany was prepared to meet the terrorists' demands, but Israel refused. Very much against their better judgment, the Germans launched a hurriedly planned and under-rehearsed rescue operation. The result was a massacre: five terrorists and nine Israeli athletes dead. Just over a year later terrorists took over the Saudi Arabian embassy in Paris, holding hostage the Saudi ambassador, his staff, and many visitors to the building. The French avoided the mistake made by the Germans: they gave in.

BELOW: Prelude to tragedy: Munich, 5 September 1972. Armed German police drop into position on a terrace directly above the apartments where nine members of the Israeli Olympic team are being held hostage by Black September. Although their equipment is good, it is clear from their approach to the operation that the police have not been trained in counterterrorist techniques, a fact which was to be all too apparent only a few hours later.

### The European Response – G.S.G. 9 and G.I.G.N.

Of all the potential victims of hostage-taking, only Israel had worked out a consistent policy, having decided not to give in under any circumstances, and to use elite special forces to exact revenge. But Western nations could not adopt such an openly uncompromising position. The only way to avoid having to give in to every fresh terrorist demand was to create special forces which could respond rapidly and flexibly to each new situation. Britain's S.A.S. was already *in situ*, although Hereford now also established a specialist counterterrorist wing, offering help to West Germany, France and the United States. The West German government tasked Colonel Ulrich Wegener to create a new force specializing in anti-terrorist work, "Grenzschutzgruppe Neun" (G.S.G. 9) [Border-Protection Group 9]; this became operational in 1973. France soon followed the same pattern: the "Groupe d'Intervention Gendarmerie Nationale" (G.I.G.N.) consisted at first of only 15 men, who volunteered from the "Gendarmerie Nationale" for special antiterrorist duties, but was soon rapidly expanded.

### The American Response – Delta Force

The hijacking crisis of the early 1970s occurred at the time when U.S. Army Chief of Staff General Abrams was busily reducing the Special Forces. He had no intention of allowing the Green Berets to be resurrected as a rapid-response force to terrorism. It was clear, however, that the United States needed some sort of specialist unit, but Abrams was determined that it should belong to the military mainstream.

On 20 December 1973 he therefore notified General William E. Depuy, head of the new Training and Doctrine Command (T.R.A.D.O.C.), that he intended to resurrect the rangers. One battalion was to be formed immediately, followed by two more during the course of 1974. Depuy's job was to define a role for the rangers. He soon became convinced that ranger battalions, although excellent as raiders, would use too many men and too much equipment to be suitable for counterterrorist activities. With the support of Charles Beckwith, a former Special Forces colonel who had also served with the S.A.S., Depuy set out an alternative guideline. Counterterrorist forces should be

no more than company strength, should be trained constantly to counter typical terrorist incidents, and should accept as volunteers only those who had proved their maturity and self-reliance.

For a time Abrams blocked developments, but his spell as Chief of Staff finished in 1976. In 1977 his successor, General Bernard W. Rogers, approved Beckwith's plans to recruit and train the new unit, to which Beckwith gave the name of his old Special Force unit in Vietnam: Delta Force.

### Elites Versus Terrorists – Djibouti

From the mid-1970s onward, elite special forces scored some notable successes in the war against international terrorism. They also suffered some humiliating failures, but the terrorists soon learnt that they could no longer go unchallenged.

One of the new antiterrorist elites was first tested on 3 February 1976. Four members of the Somali Coast Liberation Front (F.L.C.S.) hijacked a school bus carrying 30 French children from the air base in the French colony of Djibouti to a school in the town's port area, and drove it until stopped by a roadblock only a few hundred yards from the Djibouti-Somalia frontier. The terrorists' demands were brutally simple: unless France agreed to the immediate independence of Djibouti, they would start cutting the children's throats.

While the local French commander kept the terrorists talking, a G.I.G.N. team flew out from France. Early on the morning of 4 February the team, several of whom were equipped with FR-FI sniper rifles, moved into position around the bus. At 1400 hours a meal containing tranquilizers was sent to the bus. Ninety minutes later all the children were lying down asleep, leaving the hijackers standing. The G.I.G.N. then opened fire, cutting down all four terrorists. Unfortunately a fifth Somali, entering the bus from the Somalian side of the border, managed to kill a little girl before he too was shot dead. Somali troops, who had been watching from across the border, immediately opened fire on the bus and the G.I.G.N. rescuers. They soon realized their mistake, however, when the battalion of Foreign Legion paras covering the G.I.G.N. opened up with everything they had. Indeed, officers had trouble in restraining the paras from launching a direct attack on Somali positions.

## Entebbe

On 27 June 1976 four terrorists (two members of the Baader-Meinhof Group and two from the P.F.L.P.) boarded an Air France Tel Aviv-to-Paris flight during its stopover at Athens airport. Shortly after takeoff the terrorists took the aircraft over, forcing the captain to fly to Entebbe airport in Uganda. As soon as the Ugandan president, Idi Amin, heard of the hijack, he ordered troops to surround the airport. However, when the hijackers were later joined by other terrorists who were allowed through the line of troops, it became clear that Amin's men had no intention of helping the 258 crew and passengers: instead they were making the airport secure for the P.F.L.P. and the Baader-Meinhof Group. There followed a week of intense negotiations, during which the hijackers demanded the release of prisoners held in five different countries. They established their good intentions by slowly releasing batches of hostages. By the end of the week only 103 remained, all of whom were Jewish and, as ever, Israel had stuck to its policy of refusing to negotiate.

On 3 July a crack force of Israeli paratroopers – Colonel Jonathan Netanyahu's Unit 269 – boarded four C-130 Hercules transport aircraft at Ophira air base in the Israeli-occupied Sinai Peninsula. Literally skimming the surface of the water, they flew south down the Red Sea, and then turned southwest across Ethiopia to Uganda. The first Hercules landed at Entebbe at just after 2300 hours. It taxied toward the control tower and lowered its rear cargo ramp, down which drove a large black limousine. Through the windows, above a medal-encrusted uniform, could be seen the broad, impassive countenance of a black face: Idi Amin, to all intents and purposes, but in reality one of the heaviest officers in the Israeli Defense Forces, his face covered with camouflage cream. The trick almost worked: the limousine carried "President Amin" and his escort to within 40 yards of the old terminal building, before Ugandan sentries opened fire. Israeli paratroopers, shouting at the hostages to lie down, burst into the terminal building and shot down everyone still standing. All the terrorists and two hostages were killed, and less than an hour after they landed the Israelis were airborne once more.

The operation had been a stunning success: 100 hostages saved, and only three

dead: two killed in the air terminal, and a third, Mrs. Dora Bloch, an elderly lady who had been moved to hospital before the rescue, brutally murdered on her sickbed. Unit 269 suffered just one casualty: Colonel Netanyahu who, shot dead by a sniper as he covered the evacuation, joined that select band of warriors immortalized in death at the moment of their greatest victory.

## Mogadishu

On 13 October 1977 four Palestinian terrorists – two men and two women – boarded a Lufthansa Boeing 737 at Majorca and hijacked it. Over the next five days they forced the captain to fly in a great semicircle around the eastern Mediterranean and the Persian Gulf, before landing at Mogadishu airport in Somalia.

The terrorists, acting on behalf of the Baader-Meinhof Group, demanded the release of several of the group, who were being held in West German jails, along with a number of Palestinians being held in Turkey. To

ABOVE: His eyes blanked out to prevent identification, a wounded and tired Israeli paratrooper of Unit 269 is helped out of an ambulance for treatment, after his return from the raid which rescued 100 hostages held at Entebbe airport in Uganda.

show that they meant business, they shot the aircraft's captain dead and dumped his body on the runway. Negotiations continued for several days until, at 1730 hours on 18 October, a converted Lufthansa 707 landed and taxied to within 2000 meters of the hijacked airplane. On board were 26 members of Germany's G.S.G. 9 and two members of the S.A.S.

While Somali soldiers distracted the attention of the terrorists in the cockpit, the G.S.G. 9 men approached the emergency exits and placed rubber-coated alloy ladders along the side. They then blew open the doors, the S.A.S. threw in stun grenades, and the G.S.G. 9 men poured into the aircraft, killing three and capturing one terrorist, and rescuing all the hostages unharmed. It had taken just a few minutes.

## TEHRAN

By the late 1970s a string of successful hostage rescues led some Western governments to believe that they had seen the worst of the terrorist threat. The only Western power that had not yet been the target for a major terrorist attack, the United States, proceeded to recruit and train Delta Force at an

almost leisurely pace. On 4 November 1979, however, America's turn came at last: in far-off Tehran a mob of militant Revolutionary Guards and students, followers of the Ayatollah Khomeini, stormed the American embassy and took 66 members of staff hostage. A revolutionary committee then issued its demands to Washington: the embassy and its staff would be held until such time as the Carter administration sent the exiled Shah, then undergoing medical treatment in the United States, back to Iran to face trial by a revolutionary tribunal.

While publicly ruling out the use of force to redress the situation, behind the scenes all was activity. Within 48 hours of the seizure, Washington had ordered Beckwith to begin planning a rescue operation. The problems were immense – the operation would bear little resemblance to Djibouti, Entebbe or Mogadishu, or, for that matter, Cabanatuan in 1945 or Son Tay in 1970. The nearest friendly base to Tehran was 500 miles to the west in Turkey, but diplomatic problems meant that the only possible staging area was the old R.A.F. station on Masirah Island, off the cost of Oman, 800 miles south of Tehran. It would involve covering hundreds of miles

BELOW: Tehran's Revolutionary Guards claimed that they had occupied the American embassy on 4 November 1979 on behalf of the oppressed and exploited of the world. To underline this point they released all the American women and Afro- and Hispanic-American males after the carefully staged press conference seen here, keeping only the "true oppressors," the white American males. In fact, among those released were highly skilled diplomatic and military staff, who were able to give Delta Force planners a clear picture of Iranian dispositions.

of hostile territory, descending into a city of four million generally very unfriendly inhabitants, snatching the hostages from under their very noses, and then flying hundreds of miles back again to safety. It was the sort of operation which half terrifies and half tantalizes commanders: the possibility of failure was very high, but success would bring everlasting fame. It was, quite simply, one of the most daring military operations of the twentieth century.

Although security was very tight, other services got to hear of the rescue mission (now codenamed Operation Eagle Claw), and pushed their way into it. By the spring of 1980 it was no longer a purely Delta Force operation, for aspects had been shared out among the rangers, the marines, the air force and the navy. The operation eventually involved 27 different agencies, all of which had some say in determining how 106 members of Delta Force, 83 rangers, the crews of eight U.S.M.C. Sea Stallion helicopters and six U.S.A.F. C-130s would actually carry out the rescue. Since the days of T.E. Lawrence and von Lettow Vorbeck unconventional warriors had known that missions of this sort

required, above all, a simple plan and a clear chain of command. Operation Eagle Claw had neither: the complexity of the full plan defied description (even a short summary came to several typed pages), and the chain of command seemed to place at least four officers in charge at any one time. In addition, communication procedures were hopelessly confused, mainly because no one service was prepared to concede primacy to any of the others.

### Disaster at Desert One
Shortly after dusk on 24 April 1980, six C-130 transports (three carrying Delta Force and ranger troops and three loaded with extra fuel) took off from Masirah and flew northwest at dangerously low altitudes. Later that night, the aircraft put down on a supposedly deserted airstrip, codenamed Desert One, in the middle of the Dasht-e-Kavir Desert, about 200 miles southeast of Tehran. It was here that Delta Force and the rangers intended to rendezvous with the U.S.M.C. Sea Stallion helicopters which were flying from the U.S.S. *Nimitz*, sailing in the Gulf of Oman, in which they would then make their

ABOVE: U.S. Marine Corps Sea Stallion helicopters, painted in desert camouflage, undergo final maintenance checks on the flight deck of U.S.S. *Nimitz* on 24 April 1980. Events were to show that these maintenance checks should have been much more thorough.

ABOVE: At dusk on 24 April a Sea Stallion lifts off the *Nimitz*'s flight deck, as others wait in line, for the flight to Desert One and the rendezvous with Delta Force and the rangers.

descent on Tehran. Unfortunately Desert One was not quite as remote as U.S. intelligence had supposed. A road ran by the airfield and, within a few minutes of landing, Delta Force had stopped a local bus and had taken 43 bewildered Iranian civilians prisoner. Then a gas tanker came along the road. The rangers attempted to flag it down and, when it failed to stop, put an antitank missile into it. The resulting explosion was impressive: a pillar of flame shot hundreds of feet skyward – doubtless an excellent navigational beacon for the Sea Stallions, and for anyone else who happened to be within 50 miles or so.

The helicopters, too, had been experiencing problems. They had flown into a huge dust storm, 200 miles across and 6000 feet high, which reduced visibility to only a few feet. In addition, because they were designed to operate over the sea, their engines had not been fitted with dust filters. One pilot was forced to abandon his machine, another turned back for the *Nimitz*, and a third eventually arrived at Desert One in an unserviceable condition. Beckwith now made a

fateful decision: he decided that five helicopters did not give him a sufficient margin of safety to carry out the operation with a reasonable hope of success, and he therefore aborted the mission. As the helicopters refueled and taxied to take off, the rotor blade of one sliced into the flight deck of a C-130; both transport aircraft and helicopter erupted into an enormous fireball. The helicopter crews were forced to abandon their machines and scrambled to board the surviving C-130s.

The following day Iranian patrols discovered four fully operational Sea Stallions, and the burned-out wreckage of yet another Sea Stallion and a C-130. And they found, too, in the wreckage, eight charred bodies which the Iranians soon gleefully displayed for the benefit of international television crews. It was the end of Carter's presidency and of Beckwith's military career, and for the United States it was yet another humiliation. It had come almost five years to the day after the *Mayaguez* shambles; America's elite forces, it seemed, had yet to shake off the miasma of Vietnam.

## PRINCE'S GATE

By a cruel irony, only five days after the debacle at Desert One was exposed on the world's television screens, six armed terrorists of the Democratic Revolutionary Front for the Liberation of Arabistan (an oil-rich, predominantly Arab province in southwest Iran) seized the Iranian embassy and 26 hostages at Prince's Gate in London. Even before they had received the official summons, B Squadron 22 S.A.S. (the counterrevolutionary warfare unit) had left Hereford for the capital.

Unlike G.I.G.N., G.S.G. 9, or Delta Force, the S.A.S. had so far avoided publicity. Their role in the Mogadishu rescue had been noted in the specialist press, but probably the majority of the British public had little idea of who they were or what they had been doing. In fact, after a successful but largely unreported campaign in Oman between 1970 and 1975, the S.A.S. had been sent to the so-called "bandit country" of South Armagh in Northern Ireland. Within months, their presence was registered in a rapid decline in the number of terrorist incidents in that part of the province. The annoyance of various republican terror gangs in the area was reflected in their constant attempts to smear the S.A.S. as the British government's assassins; the media, however, both British and foreign, took very little notice. All this was soon to change, for Prince's Gate would propel the S.A.S. from the shadows into the glare of publicity.

While police negotiators maintained contact with the terrorists, the S.A.S. men were at work drilling pin-sized holes through the walls of the embassy from neighboring buildings, through which they inserted miniature microphones and microscopic cameras. Gradually they built up a picture of the location of terrorists and hostages within the building, and they prepared a plan of attack accordingly. The operation was accelerated when, on 5 May, the terrorists shot dead the press attaché to the embassy and rolled his body down the front steps before the watching television cameras. Furious at this affront in the heart of London, Prime Minister Margaret Thatcher ordered the S.A.S. to attack. Watched by millions of television viewers, at 1900 hours a group of S.A.S. men in gas masks and balaclavas abseiled down from the roof, while another group made a frontal assault, using shaped charges to blow in the embassy's shuttered windows. Next, the S.A.S. men lobbed in

BELOW: At 1900 hours on 5 May 1980, millions of television viewers sat transfixed as the black-clad S.A.S., their heads encased in balaclavas, abseiled down the front of the Iranian embassy in Prince's Gate in London, bringing to an end a six-day siege.

BELOW: While the
television cameras
remained focused on
the front of the
embassy, newspaper
photographers
managed to get a
close-up of the S.A.S.
in civilian clothes,
firing tear-gas
canisters into the first-
floor rooms of the
embassy.

stun and C.S.-gas grenades, and then systematically cleared room after room with short bursts of submachine-gun fire. In just 17 minutes it was all over – five terrorists killed and one captured. Only one hostage was killed, shot by a terrorist before the S.A.S. could reach him.

The entire operation had been captured on television, and over the next few hours it was beamed around the world. The black-clad S.A.S. men were suddenly famous – the pride of the British and the envy of many other nations. Some Americans were positively green with jealousy, voicing the opinion that had the S.A.S. gone to Tehran they would have succeeded. But the comparison between Prince's Gate and Eagle Claw was hardly fair, as the S.A.S. themselves pointed out. The Prince's Gate operation had been dramatic and highly competent, but compared to Eagle Claw it had also been relatively straightforward.

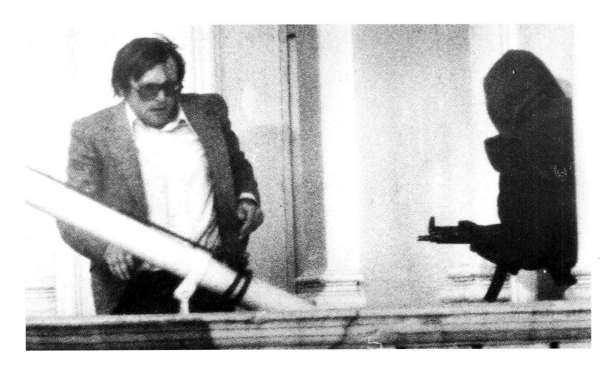

LEFT: B.B.C. T.V. hostage Tim Harris, who had been seized while visiting the embassy on 30 April, took advantage of the confusion and leapt through the French windows onto the balcony, to be confronted by a masked man with a submachine gun. For a dreadful moment Harris thought that the S.A.S. might mistake him for an escaping terrorist.

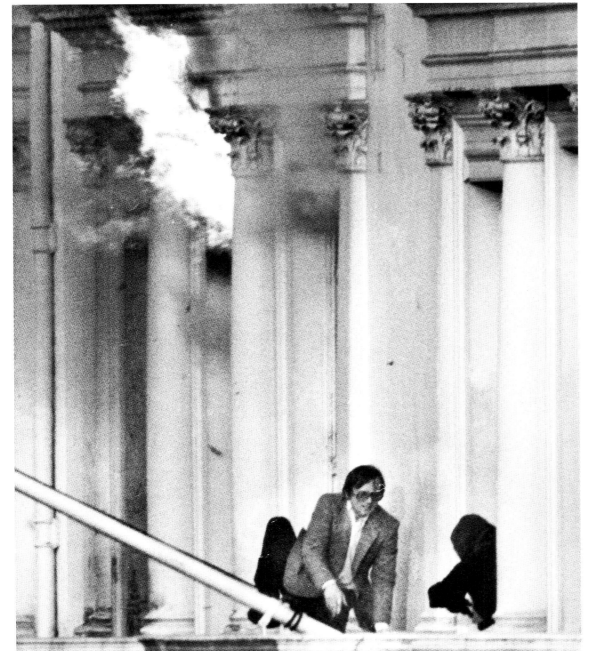

LEFT: S.A.S. stun grenades had set the embassy ablaze, and Harris needed no encouragement from the S.A.S. to leap onto the balcony of an adjoining building.

### The Achille Lauro

In the early 1980s a combination of improved security and the quick reactions of the elite special forces had considerably reduced the spate of hijacking and hostage-taking. It is often forgotten that, on 21 November 1979, U.S.M.C. guards at the American embassy in Islamabad managed to fight off and save the embassy staff from a radical Islamic mob. The fate of the Tehran embassy had served as an awful warning, and the marines were on full alert. Hijacking and hostage-taking did not, of course, come to an end – they just became more difficult.

On 7 October 1985 Delta Force was once again on the point of going into action, this time to fly by helicopter onto the deck of the cruise liner *Achille Lauro*, which had been seized by Palestinian terrorists. In the event the ship sailed into Port Said, the terrorists released their hostages, and then boarded an Egyptian airliner for Algiers. During the course of the hijacking they had killed Eric Klinghoffer, an elderly American, and President Reagan was determined to prevent their escape. U.S.A.F. fighters intercepted the Egyptian aircraft and ordered it to land at an Italian air base; suddenly the terrorists understood what it was to be hijacked.

The last major hijacking of a Western aircraft (Aeroflot flights continued to be seized with monotonous regularity) was on 5 September 1986, when Palestinians seized a Pan American Boeing 747 at Karachi airport. A detachment of Delta Force immediately took off for Pakistan, but before it landed disaster struck. The hijacked aircraft's generators failed, plunging the cabin into darkness. Believing that they were about to be attacked, the hijackers opened fire, killing 18 passengers. The remainder fled down an escape chute.

BELOW: For a time the most famous ship in the world, the Italian cruise liner *Achille Lauro* returns to its home port of Genoa on 16 October 1985, after having been hijacked for 13 days by Palestinian terrorists.

## ELITES AND THE BOMBERS

From the early 1980s onward the almost invariable failure of hijacking and large-scale hostage-taking led terrorist organizations to rely increasingly on bombing to achieve their aims. Terrorists scored a bloody success in Beirut, where two Western elite forces, the United States Marine Corps and the French Foreign Legion paratroopers, had arrived in the summer of 1982 as part of a multinational peacekeeping force. On the morning of 23 October 1983 a member of the Iranian-backed Hezbollah [Party of God] drove a truck loaded with 2000 pounds of explosives directly at the U.S. Marine Corps headquarters at Beirut airport. The resultant explosion reduced the four-story reinforced-concrete building to rubble, killing 241 marines and seriously injuring 71. It was the highest casualty figure for the Corps since 19 February 1945, when the marines had

stormed ashore on Iwo Jima. A few minutes later another truck bomb smashed into the headquarters of the French Foreign Legion paratroopers, the blast of which moved the nine-story building 30 feet off its foundations. The French suffered 73 casualties, including 58 dead. France and the United States lashed back in anger: 14 Super Etendard fighter-bombers strafed Syrian positions, and a few weeks later 28 U.S. Navy A-6Es and A-7Es followed up with their own attacks. However, in January 1984 the marines and the Legion began their withdrawals from Beirut, their retreat underlining the vulnerability of elite forces to this type of attack.

Terrorist bombers frequently choose elite units as targets because such attacks seem to confer a legitimacy on their actions. Western powers have found it difficult to respond effectively. The American reaction to Abu

BELOW: The crews of U.S. Marine Corps amphibious vehicles, having come ashore in Beirut harbor on the morning of 25 August 1982, found themselves in a typical Beirut traffic jam on the afternoon of the same day. The marines had not been trained for "peacekeeping," and seemed both curious and confused as they sat atop their vehicles and watched the long lines of automobiles crawl around them.

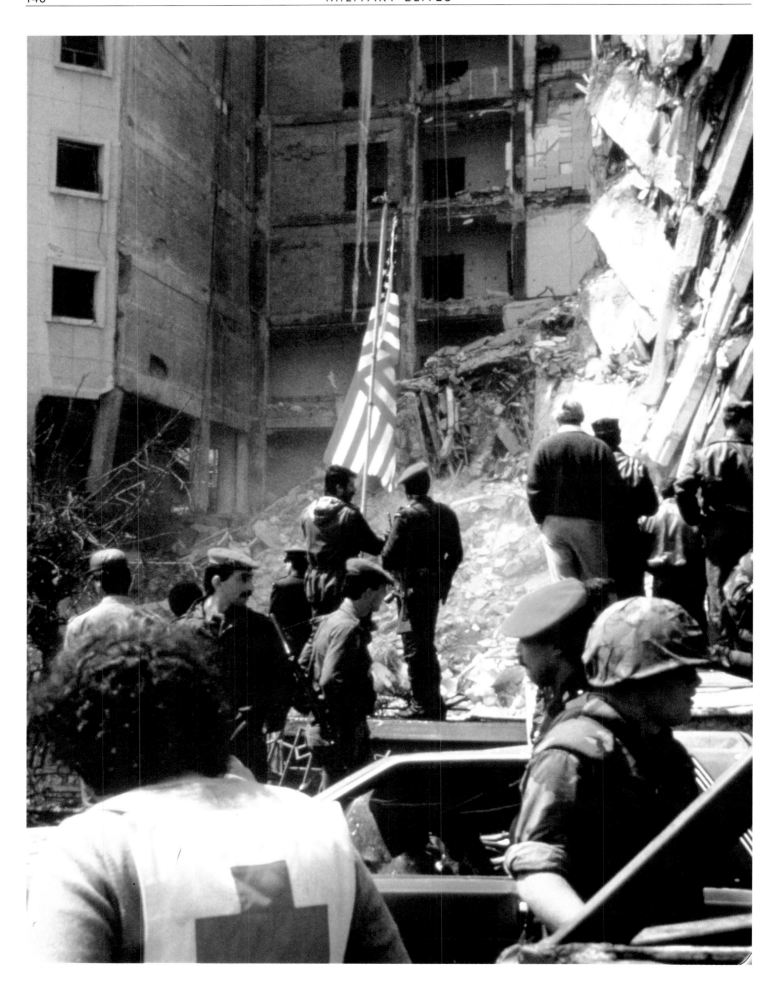

Nidal's bombing of U.S. servicemen in the La Belle disco in West Berlin on 5 April 1986 – an aerial onslaught on the Libyan capital Tripoli nine days later – earned the United States much criticism from some old friends.

The alternative to hitting back after such an incident is to launch a pre-emptive strike, but this has its own dangers. The S.A.S., which had earned universal praise in May 1980, received almost as much condemnation when a team shot dead three I.R.A. terrorists in a crowded Gibraltar street on 6 March 1988, before they had been able to plant and activate a car bomb. The only answer was for operations against the bombers to go back into the shadows; they continue as such to this day.

In their clandestine war against the terrorists, elite special forces have had some notable successes. However, because of the nature of the struggle, it is invariably the failures which make the headlines. The era of the aircraft hijacker gave away to the era of the aircraft bomber – the destruction of an Air India flight over the Atlantic in June 1985, and a Pan American flight over the Scottish town of Lockerbie in December 1988 were outrages in which no one survived. And in the early 1990s, terrorist bombers discovered new targets: on 10 April 1992 the I.R.A. detonated a bomb in the heart of the City of London, killing three and injuring 90. More importantly to the bombers, the bomb caused over $2 billion's worth of structural damage to at least 35 buildings.

Less than a year later, Islamic extremists struck on the opposite side of the Atlantic. On 26 February 1993 a large bomb was detonated in a parking lot under the 110-story, twin-tower New York World Trade Center. Of the 50,000 people who worked in the center, 1000 were injured and 5 killed. The bomb also caused immense disruption, costing hundreds of millions of dollars. On 12 March 1993 it was the turn of Bombay's financial and commercial heart. Terrorists detonated a synchronized chain of car bombs, destroying hundreds of buildings, including the city's stock exchange, and in the process killing 250 and injuring 1200.

OPPOSITE PAGE: The U.S. Marine Corps headquarters at Beirut airport around midday on 23 October 1983, a few hours after a Hezbollah suicide bomber had driven a truck loaded with 2000 pounds of explosives straight at it.

BELOW: The destruction of a New-York-bound Pan American flight 30,000 feet above the small Scottish town of Lockerbie on 23 December 1988 was the worst single terrorist act so far inflicted on British or American civilians.

ABOVE: Investigators view the rubble in the parking lot below the World Trade Center in New York, where a large bomb exploded on 26 February 1993. British journalists, used to covering I.R.A. outrages, were convinced that these particular terrorists had intended to bring the entire 110-story structure crashing down. Fortunately for New Yorkers, the force of the explosion traveled up and down, and not outward.

Four days later other terrorists hit the commercial districts of Calcutta, killing 86 and injuring 70. And then, on 24 April 1993, it was the City of London's turn again. At 1025 hours a truck containing one ton of chemical fertilizer was blown up near the Bank of England, killing one, injuring 40, and causing $1.48 billion's worth of damage.

## ELITE FORCES' CHANGING ROLE

The struggle between elite special forces and terrorism continues unabated. As special forces acquire new techniques to combat terrorism, so terrorism assumes new and different forms in response: hence the recurrent leitmotif of counterterrorist activities in the elite forces' profile. Yet since the 1970s elite forces have also played a more diverse set of roles in some very different political arenas: as quick-reaction forces in Zaïre in 1978, Grenada in 1983, or Panama in 1989; as spearheads for large-scale conventional assaults in Afghanistan in 1979, the Falklands in 1982, or the Persian Gulf in 1991; as "muscle" for the United Nations' peacekeeping operations in Somalia in January 1993; and finally, as a praetorian guard, sustaining a regime in Moscow in October 1993.

## ZAÏRE, 1978

Late in the spring of 1978, 4000 guerrillas of the Congolese National Liberation Front overran the town of Kolwezi in the mineral-rich "copper belt" of southern Zaïre. Kolwezi, the center of operations for the giant Belgian industrial conglomerate Union Minière, housed a European population (predominantly French and Belgian) of about 3000 men, women and children. The guerrillas rounded up as many Europeans as they could find (scores managed to hide for days in closets, spaces under roofs, and even under beds) and held them at prominent locations throughout the town; Kolwezi's luxury Impala Hotel housed the largest concentration of hostages. For a few hours the guerrilla leaders managed to maintain a precarious discipline, but then inevitably lost control. The guerrillas began to loot, get drunk, and then embarked upon a spiraling orgy of rape and murder.

Zaïre's President Mobutu made a desperate appeal to Belgium (the former colonial power) to restore order, but Brussels could offer nothing beyond humanitarian aid. An appeal to Paris produced more positive results, however. Since the end of the war in

Algeria the infamous French Foreign Legion 2 R.E.P. had been based in Corsica. On a number of occasions it had intervened in crises in historically French parts of Africa: notably Chad in 1969 and 1970, and in support of the G.I.G.N. in Djibouti in 1976.

On 18 May 1978 650 paratroopers of 2 R.E.P. flew into Kinshasa, the capital of Zaïre, aboard American DC8s. They immediately crammed into four C-130s, and by late afternoon were descending by parachute on the outskirts of Kolwezi. Most of the guerrillas were still running amuck in the town, and the paratroopers took them completely by surprise. Even the hardened legionnaires of 2 R.E.P. were sickened and enraged by the sights they saw as they fought their way into Kolwezi: streets littered with the bodies of some 200 black and 200 white men, women, and children, many of them horribly mutilated. In the Impala Hotel each room held a new horror. The paratroopers were not inclined to mercy: they killed at least 250 guerrillas for the loss of only five dead and 25 wounded. The guerrillas themselves crammed into cars, buses, trucks – anything that would move – and, taking 40

European hostages with them, fled toward Angola and the protection of a Cuban expeditionary force.

For several days the legionnaires followed a trail of carnage: the guerrillas had butchered all their hostages during their flight. Even though they had managed to save hundreds, the men of 2 R.E.P. felt no satisfaction: they had been too late to save the hundreds already dead. Yet, Kolwezi was a turning point for the paratroopers of France's Foreign Legion. Up to this point their reputation had been tainted by memories of the S.S. (from which many had been recruited), and the appalling atrocities they had committed in Indochina and Algeria. Now, at last, they were on the side of the angels.

### ASSAULT ON KABUL, 1979

On 24 December 1979, the U.S.S.R.'s Spetsnaz launched a very different kind of elite operation. Just after dawn two Antonov transport aircraft carrying Spetsnaz teams dressed in Afghan Army uniforms landed at Kabul airport: it was to be a replay of Prague, 1968.

BELOW: Men of the 2nd Regiment Etranger de Parachutistes on the outskirts of Kolwezi in Zaïre on 19 May 1978. The scenes they were shortly to witness sickened even the most hardened of this formidable elite.

Shortly after they had seized the airport, the first Soviet transports landed. Meanwhile, the Spetsnaz had set off for the Darulaman Palace of the Afghan president, Hafizullah Amin, passing effortlessly through numerous roadblocks guarded by surprised Afghan troops. The luck of the Spetsnaz held until they reached the palace, where they found the presidential guard, supported by eight tanks, alert and waiting. In the face of intense small-arms fire, the Spetsnaz teams, equipped with RPG-7 anti-tank rockets, advanced in short bounds, got within range of the tanks, and within a few minutes had immobilized or destroyed all eight. Other Spetsnaz units climbed the palace walls and got into the first floor and cellars. The fighting now resembled a scaled-down version of the Soviet assault on the Reichs Chancellery in Berlin on 1 May 1945. The Spetsnaz fought from room to room and floor to floor, finally reaching the top story of the palace, where they found the president in a penthouse suite. They immediately shot him dead.

The Soviets were now the political masters of Kabul. But the mountainous terrain of Afghanistan had long made its 20 million inhabitants skilled in the arts of guerrilla warfare. British S.A.S. troops in a similar position would have carried out a "hearts and minds" campaign. However, the Spetsnaz troops were not "political" soldiers trained in this form of approach; they were first and foremost "dirty tricks" assault troops, the spiritual cousins of the Brandenburgers, rather than the S.A.S.

### Afghan Quagmire

The Soviets soon discovered that it was far harder to withdraw from Afghanistan than it had been to go in. By 1980 their campaign was beginning to resemble the American campaign in South Vietnam. Soviet forces garrisoned the towns and cities and controlled the main highways – at least in the daylight hours. Year after year during the 1980s, armored columns supported by ground-attack aircraft and helicopter gunships swept up the valleys of the Hindu Kush in an attempt to bring the Mujaheddin to battle. It was now the turn of the American veterans of the Ia Drang and A Shau to watch the Soviets come to grief in the valleys of the Panjshir and the Alingar.

By the mid-1980s the Spetsnaz had grown in strength to about 25,000; approximately half were stationed in Afghanistan. They carried out long-range penetration patrols, formed quick-reaction forces to save besieged garrisons, and carried out some spectacular assaults. In March 1986, for example, a Spetsnaz unit operating in Nangarhar province scaled a sheer cliff at night to reach and wipe out a Mujaheddin observation post. Spetsnaz units also raided guerrilla camps across the border in Pakistan, and small teams infiltrated into Peshawar in order to assassinate Mujaheddin leaders in their own homes.

However, the occasional brilliant Spetsnaz operation could not disguise the fact that by the mid-1980s things were going seriously wrong with the Soviet forces in Afghanistan. Like in Vietnam, service in Afghanistan had a corrosive effect on troop morale. The Soviets showed all the signs of an army in decline: there was widespread drug-taking, drunkenness and lack of discipline. Many units began to treat orders as suggestions to be negotiated, rather than as commands to be obeyed.

The cost of the war steadily mounted: by December 1988 the Soviets had suffered 100,000 casualties, including 15,000 dead: not heavy losses by Soviet standards, but concentrated in a way which magnified their effect. Of the one million Soviet servicemen who passed through Afghanistan, about 100,000 were Spetsnaz, and about 60,000 were officers. This latter, relatively select group, many of them influential Communist Party members, suffered disproportionately high casualties and were bitterly critical of what they believed to be the mishandling of the war. The financial cost also mounted: by the late 1980s the $70 billion which Afghanistan had drained from the Soviets proved ultimately more than their failing economy could sustain.

The last Soviet units withdrew from Afghanistan early in 1989. In the late 1950s France's defeat in Algeria had destroyed the Fourth Republic, while in the late 1960s America's defeats in Vietnam had destroyed the presidencies of both Lyndon Johnson and Richard Nixon. We are still too close to the events of 1989-91 to be able to assert that the Soviet defeat in Afghanistan led to the collapse of the Soviet system; yet if not the primary cause, then Afghanistan was certainly a catalyst.

## THE FALKLANDS, 1982

When the Spetsnaz first went into Afghanistan they had been suberbly confident. Ten years and thousands of casualties later, their frame of mind on their withdrawal was very different. In the spring of 1982 Britain sent her elite forces – the S.A.S., the paras, and the Royal Marine commandos – on an expedition to the South Atlantic to recapture South Georgia and the Falkland Islands from Argentina. Unlike the Spetsnaz on entering Afghanistan, their mood was anything but confident. The decline in Britain's merchant marine and the massive cutbacks in her Royal Navy meant that the entire operation was fundamentally unsound. Success would depend both on luck and on men of extraordinary skill and boldness. Fortunately, in 1982 Britain had both.

Britain's elite forces had not operated together since Borneo in 1966. The South Atlantic campaign was almost tailor-made to

BELOW: The Royal Marine 45 Commando, accompanied by 3 Para, set out on their famous "yomp" across East Falkland Island on 29 May 1982.

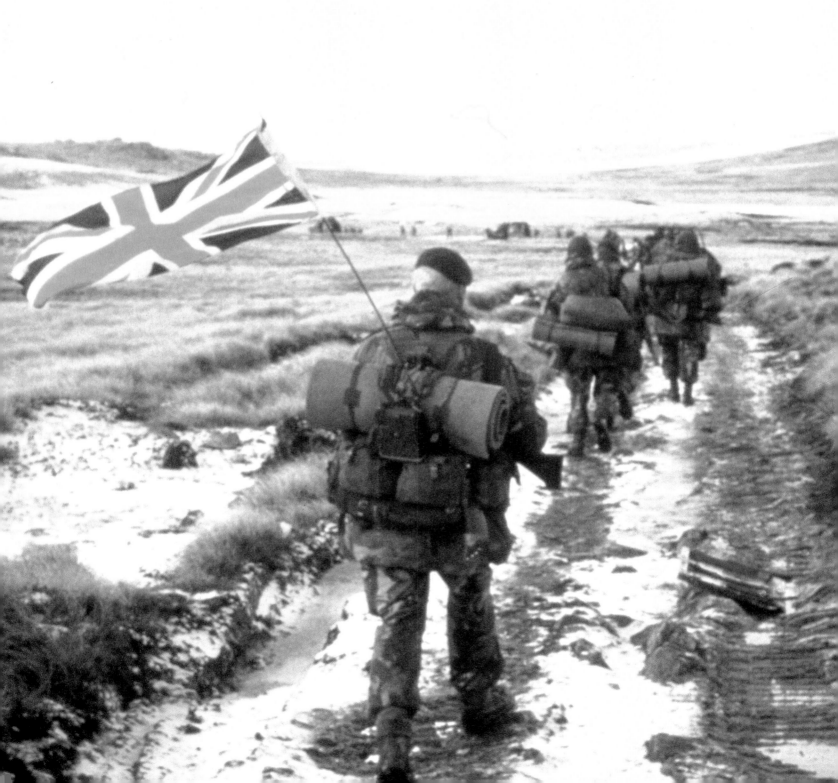

ABOVE: A para mans a general-purpose machine gun (G.P.M.G.) in the rocky mountains near Port Stanley. It is a testimony to the skill and training of Britain's elite forces that they survived in this terrain at the beginning of the Antarctic winter, let alone fought and defeated an enemy.

emphasize their strengths. Small Royal Marine garrisons at Stanley and on South Georgia had set the scene: their violent resistance to the initial Argentine landings made a nonsense of the Argentine protestations of a peaceful occupation. Next came the turn of the S.A.S.: the commander of the S.A.S. Group, Brigadier Peter de la Billière, and the commander of 22 S.A.S., Lieutenant Colonel Michael Rose, were brought into the planning process at a very early stage, and their forces assigned vital reconnaissance roles.

Long before the main landing, S.A.S. teams were ashore, beaming information via satellite link directly to the British headquarters at Northwood in England. In addition, after some hair-raising helicopter crashes in "whiteouts," on 25 April an S.A.S. team under Major Cedric Delves captured the Argentine garrison at Grytviken in South Georgia. Two weeks later, Delves led an S.A.S. raid on an Argentine airfield on Pebble Island, off the north coast of West Falkland Island, which destroyed 11 Argentine ground-support aircraft.

### Darwin-Goose Green

The Royal Marine commandos and paras came ashore at San Carlos Water on 21 May 1982. Only two months earlier 2 Para had paraded for the near-legendary "Johnnie" Frost at Aldershot, part of the commemoration of the fortieth anniversary of the Bruneval raid. In the 40 years since, 2 Para had added Oudna, Arnhem and Plaman Mapu to its reputation: actions which testified to its quite extraordinary fighting prowess.

On 28 May 450 men of 2 Para launched a frontal assault on 1500 dug-in Argentine troops who were protected by a minefield and supported by heavy machine guns, mortars, field artillery, horizontally firing anti-aircraft guns, and ground-support aircraft. For 30 hours the paras carved their way through the Argentine positions. Casualties were heavy – their commanding officer, Lieutenant Colonel "H" Jones, was killed charging a machine-gun nest – but still the paras fought on. Running out of ammunition, and with no hope of fresh supplies, they re-equipped themselves with weapons from the Argentine positions they had overrun.

Finally, the Argentine commander, estimating that he was being attacked by an entire brigade, decided to surrender. As the 1300 or so Argentine survivors milled around the Goose Green settlement, they simply could not believe that they had been defeated by a force less than one-third of their own strength. It is now known that 2 Para's extraordinary victory plunged General Menéndez, the Argentine commander in Port Stanley, into despair. Although his forces heavily outnumbered and outgunned the British, he had already been defeated psychologically at Darwin-Goose Green. It was now no longer a question of whether the British would win, but of when.

Even before the victory at Darwin-Goose Green, Whitehall had ordered the bulk of 3 Commando Brigade to move 50 miles east to invest Port Stanley. Originally, the brigade's commander, Brigadier Julian Thompson, was to transport the troops by helicopter, but on 28 May virtually all his heavy-lift machines were still aboard the container ship *Atlantic Conveyor* when she was sunk by an Argentine Exocet missile. So 3 Para and 45 Commando had no alternative but to begin to march across the island – the famous Falkland's "yomp": a 50-mile slog through the biting wind and sleet at the beginning of an Antarctic winter across the worst terrain in the world – peat bogs, waist-high tussock grass, crenelated stone runs 500 yards or more in length, and rocky hills and mountains rising in places to more than 2000 feet. The men had to carry around 100 pounds of equipment apiece (their personal weapons, ammunition, and food) – about as much as it is possible for a fit, healthy young man to carry. Water proved a major problem: the only ready supply came from the numerous peat bogs. Sterilization tablets may have removed bacteria, but they could not remove particles of peat. Soon many men were suffering from diarrhea of such severity that they simply cut the seat out of their pants and kept on marching. During the march and the operations in the hills around Port Stanley, most marines and paras lost an average of 30 pounds of their body weight, and virtually all suffered some degree of trench foot, some extremely seriously. As a feat of physical endurance, the performance of the marines and paras had rarely been equaled and never excelled. Thanks to a rigorous physical-training program during the deployment down to the Falklands, most marines and paras landed at San Carlos in near top physical condition, the first time in history this had happened after such a long voyage.

The assaults on Argentine positions began on the night of 11 June, and went on until the morning of the 14th: 3 Para on Mount Longdon, 42 Commando on Mount Harriet, 45 Commando on Two Sisters, 2 Para on Wireless Ridge, and the 2nd Scots Guards (this "traditional" elite had reached the Falklands on 1 June) on Mount Tumbledown. The British won each of these battles. Some commentators were thus misled into depicting the Argentines as helpless teenage conscripts who caved in after the first shots were fired. Nothing could have been farther from the truth. Mounts Longdon and Tumbledown were bloody, murderous affairs, in which well-entrenched Argentines, equipped with .5-inch-caliber machine guns, well-sited mortars, and excellent night-vision equipment, inflicted heavy casualties on the British. Mount Harriet and Two Sisters were easier, but only because commando deception plans worked, allowing them to surprise the enemy. And on Wireless Ridge, 2 Para, having suffered heavy casualties at Darwin-Goose Green, put down an immense concentration of mortar and machine-gun fire, supplemented by direct fire from Scimitar and Scorpion light tanks, indirect fire from field artillery and the guns of warships, and by strafing and bombing runs from Harriers. In short, the British blew the Argentines off Wireless Ridge.

From his headquarters in Stanley, General Menéndez heard with increasing despair of the loss of one after the other of his defensive positions. But even after the loss of Wireless Ridge in the early hours of 14 June, his forces still heavily outnumbered and outgunned the British. More importantly, the Argentines had enough supplies to survive for months, whereas the British had reached the end of a very overstretched logistical system. Six days earlier the forward regimental headquarters of the S.A.S. had made radio contact with Menéndez's headquarters. Lieutenant Colonel Michael Rose, a brilliant Oxford graduate and an expert in psychological warfare, had been in daily contact with the Argentine high command and, through a lengthy series of negotiations, had been steadily undermining the Argentines'

ABOVE: 15 June 1982 and the Royal Marine commandos are back in Port Stanley, holding the flag of the British Falkland Islands, which they will shortly run up outside Government House.

will to fight on. It was after one such session on the morning of 14 June that Menéndez finally snapped. Rose had been able to convince him that, despite his own bravery and skill and that of his men, the government in Buenos Aires had given him an impossible task and had now abandoned him.

As a result of this, the British commanding officer, Royal Marine Major General Jeremy Moore, accompanied by an interpreter and a radio operator, flew by helicopter to Stanley at 1300 hours; six hours later Menéndez surrrendered his forces throughout the entire Falkland Islands. The prestige of Britain's modern elite forces now stood at an all-time high: a powerful combination of their superb physical fitness, high order of fighting skill and spirit, and subtle, near-Byzantine intelligence, had produced victory.

## REAGAN'S RANGERS: THE REVIVAL OF U.S. ELITE FORCES

The United States president, Ronald Reagan, and the Joint Chiefs of Staff followed the British campaign in the Falklands closely. The British victory provoked mixed feelings. The Americans were justifiably proud of the role their own military technology had played in securing the Falklands: they had supplied the British with excellent new equipment like the Sidewinder air-to-air missiles. Yet there was also some envy. Only two years earlier the world had watched the daring storming of the Iranian embassy at Prince's Gate. The Falklands had served to confirm that, even if Britain was supposedly in decline, it could still beat the world in the production of first-class modern elite forces. The United States had nothing but Eagle Claw, the *Mayaguez*, and the miasma of Vietnam. It hurt badly.

The Reagan administration consequently took affirmative action. It determined to create elite special forces that could both take on the Spetsnaz and rival the performance of the British elites. Money was no longer a problem: military expenditure increased dramatically. It was a particularly good time for the Special Forces, Delta Force, the rangers and similar units, who now found themselves back in favor; a favor last experienced in the halcyon days of the ideolog-

ically very different Kennedy administration. New units and new command structures were formed. An investigative commission under Senator Holloway examined Operation Eagle Claw: it concluded that failure might have been avoided had it used an elite specialist helicopter force, capable of night-flying over hostile terrain at low altitudes. The report resulted in the formation of Task Force 160, the mysterious Night Hawk unit. Another recommendation was the rationalization of the command structure, which produced a new headquarters to co-ordinate future Eagle Claws – the Joint Special Operations Command (J.S.O.C.).

## OPERATION URGENT FURY

Since the fall of 1982, the U.S. National Security Council (N.S.C.) had felt growing concern over the emergence of a radical, left-wing government on the Caribbean island of Grenada. An officer attached to the N.S.C., Lieutenant Colonel Oliver North, expressed grave fears about the presence of Cuban soldiers and construction workers on the island and urged that the U.S. launch a pre-emptive strike.

For nearly a year Washington prevaricated, but on 13 October 1983 the newly formed Grenadian People's Revolutionary Army (G.P.R.A.), supported by a Cuban Army training team, staged a coup and took over Grenada. Reports reaching Barbados suggested widespread disorder and the possibility that the 1000 American residents of Grenada, which included some 700 medical students at an American-run college on the island, might be in danger. On 20 October 1983 the Joint Chiefs of Staff met: the new J.S.O.C. wanted to mount a purely Special Forces operation, but the Commander in Chief Atlantic (C.I.N.C.L.A.N.T.) wanted a full-scale air and amphibious assault – in effect, a mini-Normandy.

The first planning sessions began on 21 October in incredible haste. One army representative, the commander of the 24th Division, Major General Norman Schwarzkopf, was not appointed to the planning team until 24 October, only 24 hours before the actual landings. He was thus unable to exercise any influence on proceedings. The eventual plan was complex: a total of 6500 U.S. personnel was to be landed in successive airborne and amphibious operations; the U.S. Marine Corps was to come ashore by helicopter and in landing craft on the northern part of the island, while the Special Forces and the 82nd Airborne were to parachute onto Point Salines airstrip in the southwest. The two forces were then to converge, thus trapping the Cubans and the Grenadian People's Revolutionary Army. Intelligence (clearly not as reliable as it might have been) estimated the army's strength at between a few hundred and 11,000.

Before light on 25 October 1983, 35 members of Delta Force parachuted onto Point Salines airfield. They were almost immediately hit by heavy machine-gun and rifle fire, and went to ground in a gully near the runway; they had taken 22 casualties, of whom six were dead. The small detachment was only saved from annihilation by the timely arrival of an AC-130 Specter gunship, which promptly strafed the Cuban and G.P.R.A. positions.

Another Delta Force operation, an attempt to land teams from nine Black Hawk helicopters on top of the heavily defended Richmond Hill Prison to release the G.P.R.A.'s political prisoners, also went badly wrong. The attack could only succeed under cover of darkness – a job for the new Task Force 160. Task Force 160 crews were

BELOW: Grenada, 25 October 1983. A look of quiet confidence on his face, a U.S. Marine Corps signaler reports to his superior officer that resistance in the northern part of Grenada is "patchy." The situation in the south was very different.

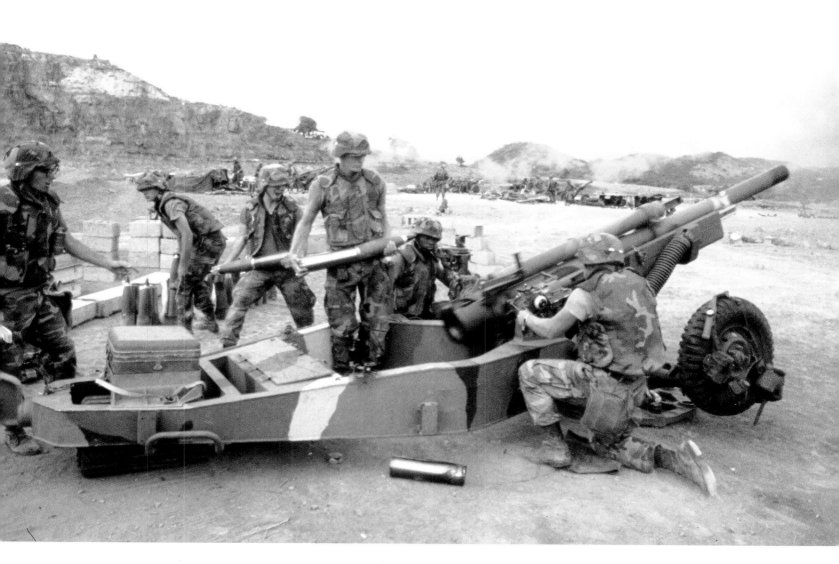

among the best trained in the world; however, the delays in assembling and fueling the helicopters meant that they did not cross the coast until well after dawn. Cuban and Grenadian antiaircraft fire immediately brought down one of the helicopters, but the remainder pressed forward, anxious to prove themselves on this, their first operational mission. The mission, however, turned into a fiasco – an airborne "Charge of the Light Brigade." Heavy fire from the thickly walled prison sent five of the helicopters crashing earthward, at which point the survivors withdrew out of range.

A ranger battalion dropped from 10 C-130s over Point Salines airstrip to follow up the Delta Force landing. The rangers should have descended simultaneously to overwhelm the defenders, but navigational difficulties meant that the aircraft arrived at different times, so that the drop was spread over two hours. The 82nd Airborne now arrived, its first transports actually landing on the runway. Unfortunately, the rangers had only

been able to clear the enemy from one end of it; the Grenadians and Cubans kept up a steady fire from the other end, making this air-landing operation extremely hazardous. During the day the rangers and 82nd Airborne managed to advance only one mile from the runway, and at dusk dug a defensive perimeter. Their luck the following day was no better. A ranger assault on the G.P.R.A.'s Calvigny barracks, about three miles east of the airstrip, ended in disaster when two helicopters hovering above the rangers collided and crashed down among them, killing four and mutilating several more. Calvigny barracks, as it turned out, was unoccupied.

The U.S. Marine Corps landings, however, were very different from this shambles. The marines were ashore by dawn and moved south rapidly against resistance which they described as "patchy." It is now evident that they were trying to prove that they could have carried out the entire operation single-handedly, and indeed they cer-

tainly could have done. The U.S. media and public, starved of military victory since the early days of Vietnam 20 years earlier, insisted on treating Grenada as a great feat of arms, but soon disquieting rumors were circulating. Only the marines were satisfied with Grenada, and it is significant that the sole movie made about the landings, *Heartbreak Ridge* (1986), dealt exclusively with the U.S.M.C.'s role. By that time the full story was out.

It is to the credit of the American military that they faced up squarely to the problems that Grenada had revealed about the employment of elite special forces. A year after the landings, Washington established a Joint Special Operations Agency to help promote co-ordination between the various forces. After another three years of intense political horse trading, the Americans finally managed to achieve both a unified political and command structure. In 1987 a new administrative office appeared within the Department of Defense: that of Assistant Secretary of Defense for Special Operations and Low-Intensity Conflict; while a new command set up camp at MacDill airbase in Florida – the United States Special Operations Command (U.S.S.O.C.O.M.). For the first time since the re-emergence of the Special Forces in the early days of the Cold War, the United States at last had a means of co-ordinating their activities.

## OPERATION JUST CAUSE

The unification of the U.S. political and military command structure happened just in time. In December 1989 Panama's self-appointed "Maximum Leader," General Noriega, grandiloquently declared his country at war with the United States. It seems not to have occurred to General Noriega that the United States might just take him at his word and act accordingly.

By mid-December George Bush, America's new president, was waiting for an appropriate pretext upon which to take action: Noriega's forces soon gave him one. On 16 December the Panamanian Defense Force (F.D.P.) opened fire on four U.S. Marine Corps officers who failed to stop at a roadblock, killing one of them. At the same time, F.D.P. troops arrested a U.S. Navy officer and his wife, who had witnessed the shootings. The United States already had substantial forces in the American-adminis-

tered Canal Zone, and, along with troops from the United States, intended to send 27,000 into the attack, of whom 4000 would be Special Forces. This was not like Urgent Fury: over the years the United States had developed contingency plans for just such an eventuality, and knew Panama very well. But an assault on Panama would certainly not be a walkover: Noriega's 15,000-strong F.D.P. was well armed, and almost resembled a large gang, most of whose members were ferociously loyal to their "boss," the "Maximum Leader."

The plan for the invasion of Panama, codenamed Operation Just Cause, was even more complex than the plan for the invasion of Grenada, but this time it worked. The Americans knew that Noriega's political and military machine was highly centralized; they were certain that if they could only neutralize Noriega the machine would collapse. Around midnight on 20 December, Task Force 160's Black Hawk helicopters carried Delta Force teams to several loca-

ABOVE: Panama, 17 December 1989. On the day following the killing of a U.S. marine at a Panamanian roadblock, a brisk fire fight broke out between the Panamanian National Guard, and the U.S. marines, seen here fighting from across the border, from the U.S.-controlled Canal Zone.

tions around Panama, where intelligence had suggested that Noriega might be found. One team just missed him, and shortly before 0100 hours Noriega and his bodyguards fled toward Panama's Torrijos airport. At exactly 0103 hours 731 U.S. rangers parachuted down on Torrijos just as Noriega's convoy came onto the runway. The first rangers to land opened fire and shot the bodyguards in the lead car, at which point Noriega's car skidded into a tight turn, and headed back into the city, his bodyguards all the while firing their submachine guns in the general direction of the Americans.

Meanwhile, the 82nd Airborne had jumped over the airfield, dropping, in addition to the paratroopers, Sheridan tanks and armored personnel carriers. American force was overwhelming, but the F.D.P. tried to put up a fight in the airport terminal, threatening to kill a number of American and Panamanian civilians trapped there. There was a tense standoff until Spanish-speaking rangers convinced the F.D.P. to surrender; 54 F.D.P. troops, many of them wounded, came out with their hands up, as did 376 very grateful hostages. Delta Force continued to

chase Noriega around Panama, finally cornering him in the Papal *Nunciatura*, the sovereign territory of the Vatican. Aware of the diplomatic repercussions of an assault on such a building, the unconventional warriors came up with a singularly unconventional solution. They surrounded the *Nunciatura* with loudspeakers and played nonstop heavy-metal rock music until, on 3 January 1990, the opera-loving Noriega, his ears ringing and nerves shattered, gave himself up.

## OPERATION DESERT SHIELD

The United States Special Operations Command was relieved that Operation Just Cause had gone well. At times it had almost seemed that America's employment of elite special forces was inevitably destined to end in disaster. But U.S.S.O.C.O.M. was very aware that Just Cause had been a special case; if America had not succeeded in Panama it could not have succeeded anywhere. The lessons of Operation Just Cause were still being analyzed when a new crisis blew up in the Persian Gulf. On 2 August 1990 the Western world awoke to the news that Saddam Hussein, the dictator of Iraq, had sent his

BELOW: Aboard a Panama-bound giant C-141 transport on the night of 19-20 December 1989, the rangers of the 1st Ranger Battalion put on their gear, check each other's equipment, and apply face camouflage.

armored divisions into the small, oil-rich, sheikdom of Kuwait. Nothing now stood between Saddam's divisions and the vast oil-fields of eastern Saudi Arabia 200 miles to the south, except a heavily outnumbered and underequipped Saudi Arabian National Guard. If Saddam so chose, within four days his divisions could be in Dharhan and Al Jubayl, giving him control of 40 percent of the world's known oil reserves.

The United States and Britain responded with vigor: soon their diplomats had stitched together a great coalition which began to assemble forces in Saudi Arabia under the auspices of the United Nations. In the aftermath of Eagle Claw, the United States had established a headquarters to control any future operations in southwest Asia – U.S. Central Command (C.E.N.T.C.O.M.), whose new commander was the former U.S. land-forces commander in Operation Urgent Fury, General Norman Schwarzkopf. Schwarzkopf proceeded to move the C.E.N.T.C.O.M. headquarters to the Saudi Arabian capital, Riyadh, where he was joined in early October by the British commander, a former S.A.S. officer with great experience of the Middle East, Lieutenant

General Sir Peter de la Billière.

In many ways the Coalition forces gathering in the Persian Gulf were elites. Among the first troops to arrive in Saudi Arabia were the United States Marine Corps and the 82nd and 101st Airborne. And there were also "traditional" elites from America, Britain and France (particularly some famous cavalry units and elements of the French Foreign Legion). Notably absent from the gathering were the French and British paras and the British Royal Marine commandos, all of whom lobbied hard for deployment, but without success. What Schwarzkopf needed was heavy armored formations; light raiding units specializing in unconventional operations at first at least seemed to have very little role to play in the "slugfest" which the general was preparing.

Schwarzkopf was a conventional soldier whose experiences in the latter stages of the Vietnam War and in the Grenada invasion had left him dubious as to the usefulness of the elite special forces. But unlike his one-time commander, General Abrams, he had not closed his mind to their employment. Special elite forces had an influential advocate in Lieutenant General de la Billière,

ABOVE: The first troops to confront Iraq's forces in Kuwait were those of the United States Marine Corps, seen here rolling up to the Saudi Arabia-Kuwait border on 20 August 1990. The marines were only lightly armed, and relied at first on their fierce reputation to keep the Iraqis north of the border.

whose arguments in their favor were supported by Major General Wayne Downing, the commander of the U.S. Special Forces. The first role assigned to the S.A.S. was to prepare plans for the rescue of the "human-shield" hostages: Westerners whom the Iraqis had captured in Kuwait, who had been moved to a number of locations – airfields, communications centers and the like – which were likely to be bombed in the event of hostilities. When Western diplomacy secured the release of the hostages, the S.A.S. put on a presentation for Schwarzkopf which convinced the general that they could perform other useful roles, such as creating diversions which could draw the attention of Iraqi forces from the main line of advance.

### Desert Storm

The American Special Forces were the first to go into action. On the night of 16 January 1991, Black Hawks of Unit 602 proved that they were invaluable if properly used, when they acted as "pathfinders" for the army's AH-64 Apache helicopters in attacks which destroyed key Iraqi air-defense radars. The helicopters quickly created a corridor through the Iraqi air-defense system; before midnight hundreds of Coalition aircraft were passing up this corridor into the heart of Iraq, which they hit with devastating force.

BELOW: The Commander of British Forces Middle East, Lieutenant General Sir Peter de la Billière, seen here at a Burns Night lunch with an officer of the Queen's Own Highlanders, was largely responsible for convincing Coalition commander General Norman Schwarzkopf that special forces like the S.A.S. and Delta Force had an important role to play in the liberation of Kuwait.

Four nights later the S.A.S. moved into western Iraq. Some teams flew in by helicopter, while others drove in across the desert on motorcycles and in specially stripped-down Land Rovers and Light Strike Vehicles. The area in which they were to operate was a hilly, boulder-strewn region, intersected by the numerous wadis which lay along Iraq's eastern borders with Jordan and Syria. It was ideal territory for the S.A.S., except for the fact that much of it was a half-mile above sea level, and that the winter of 1990-91 was the coldest and wettest in living memory. The S.A.S. had to battle against sleet and snow, and night-time temperatures much lower than any they had experienced in the Welsh Brecon Beacons. Remaining alive was difficult, let alone carrying out missions, but this is nevertheless what the S.A.S. did.

Their initial tasks – monitoring Iraqi movements along the Amman-Baghdad highway and interdicting communications – were soon supplanted by a mission of overwhelming importance. Saddam Hussein had responded to the first air attacks in Iraq by moving Scud missile launchers to the western part of his country, well within range of Israel; on the night of 17 January the first Scuds came down on Tel Aviv. Even though the initial attacks caused no direct fatalities, each one that landed raised a cry in Israel for an attack on Iraq, which is precisely what Saddam Hussein had hoped would happen. Israel's involvement would almost certainly have brought about the collapse of the Coalition, and quite possibly the collapse of pro-Western governments throughout the Islamic world. The Scud attacks, then, were threatening to transform the Coalition's limited operations to eject Iraq from Kuwait into a much broader conflict, in which the entire Islamic world would be pitted against the West. On 22 January the Scuds finally drew blood: a missile landing on Ramat Gan killed three Israelis, and Israel's Defense Force (I.D.F.) prepared for action.

### "Scud Busters"

The S.A.S.'s role now became crucial to the success of the Coalition's grand strategy. Heavy cloud over western Iraq had severely reduced the effectiveness of aerial and satellite reconnaissance in locating Saddam's missiles. S.A.S. teams now fanned out in a desperate search for the elusive launchers.

LEFT: A ground crew arms the formidable AH-64 Apache helicopter. On the night of 16 January a squadron of these machines tore a gap in Iraq's air-defense system, allowing the Coalition air forces to penetrate as far as Baghdad without being detected.

BELOW: An American "Patriot" missile sails over Tel Aviv to intercept an incoming Iraqi Scud missile. The "Patriot" looked impressive, but most Scuds were destroyed on the ground in western Iraq by S.A.S. and Delta Force raiding parties.

Several teams clashed with Iraqi patrols – one resulted in a pitched battle lasting more than four hours – but the S.A.S. succeeded in locating many launchers and in talking in air strikes. Unfortunately it often took up to 50 minutes for aircraft to reach the target area, by which time the Iraqis had launched the Scud and had driven off to a new location. The sheer frustration of watching but doing nothing led the teams to resort to the same tactics that their grandfathers had used against V-2 launchers in the eastern Netherlands in the winter of 1944-45 – they attacked the missiles themselves. Their techniques varied: some lay in wait until the very moment of the launch, when the rocket was filled to capacity with highly volatile fuel, before firing their Milan antitank missiles at it, with results that were invariably spectacular. Others attacked "Paddy Mayne style," their Land Rovers suddenly careering down on the launchers, machine guns blazing dramatically.

On 8 February 1991 heavily armed Humvees of Delta Force joined in the Scud-busting campaign. In order to minimize accidents, the Riyadh headquarters assigned the area north of the Amman-Baghdad highway to Delta Force, an area which now became "Scud Boulevard," while the area south of the highway was assigned to the S.A.S., who named it "Scud Alley." Even before the beginning of the main armored assault, the combined efforts of the S.A.S. and Delta Force had steadily forced the Scud launchers back toward Baghdad, so that strikes against Israel became increasingly ineffective. Intervention by the I.D.F. had been averted, but it had been a close-run thing.

## THE NEW WORLD DISORDER
Operation Desert Storm reaffirmed for the British and Americans the importance of elite special forces. As a result of their observations of Anglo-American activities in the Persian Gulf, the French, too, set up a unified command for special operations in June 1992 – "Le Commandement d'Opérations Speciales" (C.O.S.). The events of 1991 – the victory of the United States-led Coalition in the Persian Gulf, followed a few months later by the collapse of the U.S.S.R. – seemed for a short time to usher in the prospect of an era of peace and harmony, in which the great powers, by providing military muscle for the United Nations, would be able to establish what U.S. President Bush called a "new world order." Within a year it was clear that, far from ushering in an era of peace, the end of the Soviet Union had produced dangerous instability. Old conflicts, suppressed for nearly half a century, sprang back to life. Within Europe there was soon a growing awareness that pre-1914 structures and problems were re-emerging with terrifying rapidity. By 1992 it was clear that the world, far from being governed by a new order, was in the grip of a new disorder.

And yet, paradoxically, governments throughout the world pushed through reductions in their armed forces which had been determined in the very different climate of 1989 to 1990. It was a complex phenomenon: Western democracies were pursuing the elusive "peace dividend" which had been promised by the end of the Cold War. In addition, an international economic recession – the worst since the early 1930s – had produced pressure to lower

BELOW: Britain's Royal Marine commandos were annoyed at having been left out of Desert Storm, but they soon had a vital role to perform protecting and feeding tens of thousands of Kurdish refugees from Saddam Hussein's vengeance in northern Iraq.

defense budgets. Many nations were no longer willing or able to sustain their armed forces at pre-1989 levels. As conventional armies declined, so there was therefore a corresponding rise in the importance of elite special forces: they were small and relatively cheap, yet they still allowed the nation which possessed them to play a role on the world stage.

### From Kurdistan and Bosnia . . .

Led by Britain, France, and the United States, the period since the end of the war in the Persian Gulf has seen the constant employment of modern elite forces. Britain's Royal Marine commandos and the U.S. Special Forces deployed to Kurdistan in northern Iraq in the spring of 1991 to establish safe havens for the Kurds who had risen in revolt against Saddam Hussein.

While this operation was under way, the Balkans collapsed into chaos. France deployed its version of the S.A.S., the "Commandos de Recherche et d'Action dans la Profondeur" (C.R.A.P.) to the Balkans in 1992, ahead of the commitment of other forces, and by 1994 the S.A.S. itself was represented at the highest level, by the appointment of Lieutenant General Sir Michael Rose to command the U.N. forces in Bosnia. A master of negotiations, soon after his arrival Rose astounded observers by managing to broker a cease-fire in the besieged Sarajevo, albeit a very fragile one.

### To Mogadishu . . .

The rapid shrinking in conventional capacity means that governments have increasingly to rely on elite special forces, but there are dangers inherent in this dependence. The landing of U.S. marines in Mogadishu in December 1992 was greeted with something like rapture by many Somalis. By the fall of 1993, however, the situation had changed dramatically. The American high command in Mogadishu had identified one of the Somali warlords, General Aidid, as the source of many of their problems. On 3 October 1993 400 U.S. rangers descended by helicopter into central Mogadishu on a cordon-and-search operation to arrest Aidid. The warlike Somalis gave the rangers a hot reception: in seven hours of fighting they shot down two Black Hawk helicopters and inflicted 95 casualties on the rangers, 18 of whom were killed. They inflicted equally heavy casualties on the Pakistani and Malaysian troops who eventually managed to fight their way into the center of the city to help the rangers withdraw. The number of Somali casualties is still not known, but the International Red Cross estimated that over 200 had been killed.

Throughout the world today there are hundreds of potential Mogadishus – heavily armed communities fractured along lines of religion, culture, race, or simply traditional clan or tribal loyalties. Modern elite forces of a certain type can be employed in these situa-

ABOVE: When they landed at Mogadishu in Somalia on 9 December 1992, the U.S. Special Forces had to contend with a foe very much more formidable than General Aidid's gunmen; the moment they landed they were surrounded by the world's press, which turned a potentially dramatic moment into one of high farce.

tions – units like the S.A.S. or the Green Berets, for example; other units, which have been trained primarily for the Zeebrugges, the Eben Emaels, or the Inchons of the twenty-first century, will quite often only make a bad situation even worse.

### And Moscow

The day following the debacle in Mogadishu, the cameras of the world's television-news networks had assembled outside the Russian parliament building in Moscow to witness an assault by pro-Yeltsin forces end a rebellion by the followers of Vice President Rutskoi. What fascinated Western observers was the composition of Yeltsin's assault teams. T-80 and T-72 tanks, many driven and crewed by officers of the 2nd Taman Guards Motor Rifle Division and the 4th Kantemirov Guards Tank Division shelled the parliament building and provided supporting fire. The actual assault force seems to have been composed of two companies of Spetsnaz attached to the 27th Teplyy Stan Independent Motor Rifle Brigade, along with a brigade of the interior ministry's elite Dzerzhinski Division. In addition, Yeltsin's defense minister, Grachev, a former paratroop commander, had brought 1500 Spets-

naz troops into Moscow from the 218th Special Purpose Brigade. If the attack during the day had failed, they would have hit parliament at night, disembarking on top of the building from helicopters.

A recurring theme throughout the twentieth century has been the close relationship which has developed between particular leaders and their own special elites – for example, Hitler and the S.S. Leibstandarte, Göring and the Fallschirmjäger, Churchill and the commandos, Roosevelt and the U.S. marine raiders, Kennedy and the Green Berets, Thatcher and the S.A.S., Reagan and Delta Force. Yeltsin is now assiduously courting the interior ministry's Dzerzhinski Division and Spetsnaz. But unlike the relationship of Hitler, Churchill and others to their elites, the elite forces of modern Russia are increasingly aware that political power is slipping into their hands; they are not yet kingmakers, but already they have shown that no king can rule without them. Reliance on elite forces has always been a symptom of regimes in crisis. As political chaos and disorder spreads after the stability of the Cold War, the world will see the emergence of many more modern elite forces – and it will not always be for the good.

BELOW: The romantic image of an elite patrol – they could belong to the British paras, the Australian S.A.S., the American Delta Force, or even the Russian Spetsnaz, but they are in fact British Royal Marines commandos. A picture like this evokes a yearning in the hearts of many young men seeking excitement and adventure, but those who volunteer for such units soon learn that elites do not allow themselves to be silhouetted against the setting sun, except when ordered to do so by officers in charge of military public relations.

# INDEX

Page numbers in *italics* refer to illustrations.

# ACKNOWLEDGMENTS

The publisher would like to thank Ron Callow of Design 23 for designing this book; Clare Haworth-Maden for editing it; Susan Brown for production; Rita Longabucco for the picture research; and Ron Watson for compiling the index. The following agencies provided photographic material:

**Bettmann Newsphotos:** page 63(bottom)
**Brompton Books:** pages 7(top right and bottom left), 15(bottom), 24, 26, 38, 41, 48, 61, 67(top), 71(top), 74, 78(top), 79, 108, 109, 110, 113(both), 115(both), 135, 136, 137(top)
**Bundesarchiv:** pages 16(bottom), 22, 23, 25, 27, 34, 36, 39, 49, 50(top), 62, 77(bottom), 78(bottom)
**Collection of the Library of Congress:** page 21(bottom)
**Imperial War Museum, London:** pages 11, 12, 13, 14, 15(top), 16(top), 17, 18, 19(both), 21(top), 31, 35(both), 40, 43, 44, 46, 47(both), 50(bottom), 55(top), 57, 58, 59, 60(top), 66(both), 68(both), 72(both), 73(top), 75(both), 76(top), 80(top), 81, 89, 90, 91, 92
**National Archives of Canada:** page 54
**National Army Museum, London:** page 73(bottom)
**Reuters/Bettmann:** pages 138, 141, 142, 151, 153, 154, 155(bottom), 157
**T.R.H./Department of Defense:** pages 101(both), 118, 122, 134, 140, 150, 152
**T.R.H./Imperial War Museum:** pages 28-29, 30, 55(bottom), 65(both), 77(top), 105, 106(both)
**T.R.H./Ministry of Defence:** page 156
**T.R.H./E. Nevill:** pages 2-3
**T.R.H. Pictures:** pages 9(bottom), 107, 125, 126, 127, 143, 146
**T.R.H./Royal Marines:** pages 145, 148, 158
**T.R.H./U.S. Army:** pages 67(bottom), 70(bottom), 121
**T.R.H./U.S. Marine Corps:** pages 85(bottom), 86
**T.R.H./U.S. National Archives:** pages 71(bottom), 94(bottom), 97
**T.R.H./U.S. Navy:** pages 102(bottom), 123, 133, 149
**U.P.I./Bettmann Newsphotos:** pages 1, 8, 76(bottom), 95, 98, 117, 119(top), 129, 131, 132, 137(bottom)
**U.S. Army:** pages 52, 53, 60(bottom), 63(top), 69(both), 70(top), 80(bottom), 93(top), 94(top), 96, 114(both), 155(top)
**U.S. Department of Defense:** pages 4, 6, 9(top), 82, 83, 84, 85(top), 87, 88, 102(top), 103, 119(bottom), 120, 139
**U.S. National Archives:** pages 51, 93(bottom)
**U.S. Navy:** pages 7(top left), 116